First published in the United States of America in 2022 by
Rizzoli International Publications, Inc.
300 Park Avenue South
New York, NY 10010
www.rizzoliusa.com

Publisher: Charles Miers
Editor: Jacob Lehman
Design and Typography: Brian Roettinger (Perron-Roettinger)
Production Manager: Maria Pia Gramaglia
Design Coordinator: Olivia Russin
Design Assistant: Molly Dauphin
Managing Editor: Lynn Scrabis

2022 2023 2024 2025 / 10 9 8 7 6 5 4 3 2 1

Printed in China

ISBN: 978-0-8478-6759-2

Library of Congress Control Number: 2021953503

Visit us online:
Facebook.com/RizzoliNewYork | Twitter: @Rizzoli_Books
Instagram.com/RizzoliBooks | Pinterest.com/RizzoliBooks
Youtube.com/user/RizzoliNY | Issuu.com/Rizzoli

THE COBRASNAKE Y2KS ARCHIVE

THE COBRASNAKE Y2KS ARCHIVE

THE COBRASNAKE Y2KS ARCHIVE

THE COBRASNAKE Y2KS ARCHIVE

SERVER	TABLE	GUESTS	CHECK NUMBER
			758400

THE COBRASNAKE Y2KS ARCHIVE
THE COBRASNAKE Y2KS ARCHIVE

(aka Mark Hunter)

Can I
take your
photo?

Thank You

RIZZOLI
NEW YORK

New York · Paris · London · Milan

adams· 2100

never come back
here again instead
go to thecobrasnake.
com
it so much better
and way less corpate
feeling

Thecobrasnake

Can I Take Your Picture?

When I graduated high school, most of my friends went off to college. I went to the Troubadour. Sometimes in a threadbare vintage t-shirt, sometimes in a Lacoste polo, but always with my camera.

I started taking pictures and posting them on my website when I was just eighteen. I wanted to capture the excitement I felt going out to shows and parties with the coolest styles and the wildest characters, and I thought people might want to see this scene through my eyes. Growing up I always felt like an outsider—I was never picked for the team. But through the Cobrasnake I finally got to make my own team.

My site started to get more visitors by the day, and after a few years my camera and I were getting flown all around the world. From LA clubs to NYC dive bars, to Paris boutiques and Tokyo galleries, and eventually Sydney beaches and Beijing warehouses. Long before there was an Instagram feed to scroll through, people would refresh my site over and over again, fiending for the next update. Looking through my pictures to find themselves or their friends was a rite of passage for a generation growing up without Instagram. Now, they can look through this book.

A lot of people who look back on the Cobrasnake in the 2000s and 2010s probably think of pretty pictures of pretty people having fun at parties (and on the sidewalk outside of the parties). But to me and my friends, and the people who always followed my work, the Cobrasnake is much more.

My pictures tell the story of a time when the world felt refreshed and remixed, when style and substance converged, and when youth culture dominated and demolished—messy, irreverent, absurd. Kind of like me, and kind of like the people looking for themselves in the pictures. Kind of like us.

What I see in this book is a generation coming of age at the dawn of a new millennium that they would make their own. People wanted me to take their picture because they wanted to be part of that story.

Many of them went on to become famous and do amazing things, creating groundbreaking albums, artwork, films, clothing lines, or companies. They still inspire me as much as they did when I was a wide-eyed and goofy eighteen-year-old who couldn't wait to find out about the next cool thing.

People still want me to take their picture today. Because no one can do the Cobrasnake quite like the Cobrasnake.

Guest Check

TABLE	GUESTS	SERVER	7154-46
		TAX	
		TOTAL	

GUEST RECEIPT

TABLE	GUESTS	SERVER	7154-46

SA540A Receipt for Income Tax or Expense
Account Record

The social scene can be fun today.
02 15 25 34 28, 10

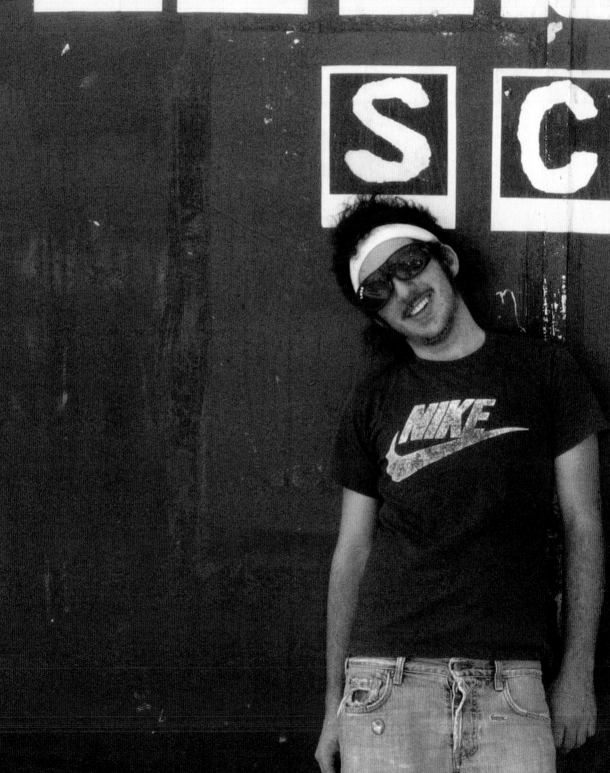

ROID
ENE

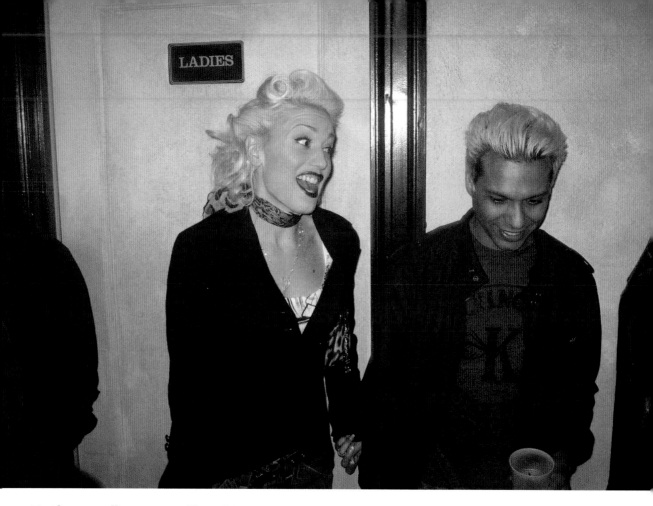

Bathroom line comedian GWEN STEFANI
and TONY KANAL trying not to pee, backstage
at the FONDA.

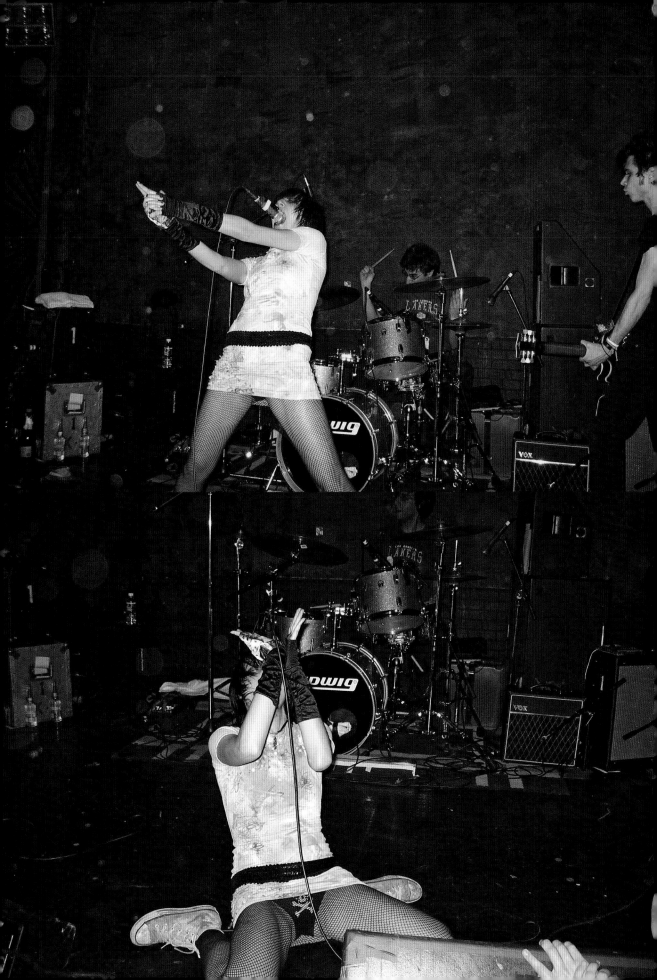

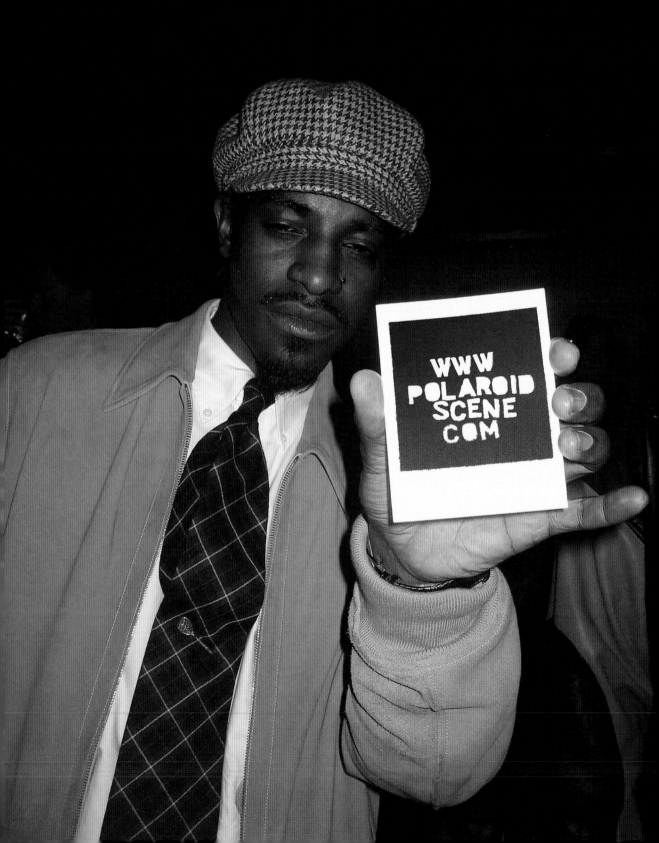

ANDRE 3000—legendary rapper, designer, newsboy cap wearer, and member of POLAROID SCENE street team. LA, 2004

MARISSA, Karaoke Queen. Koreatown, 2004

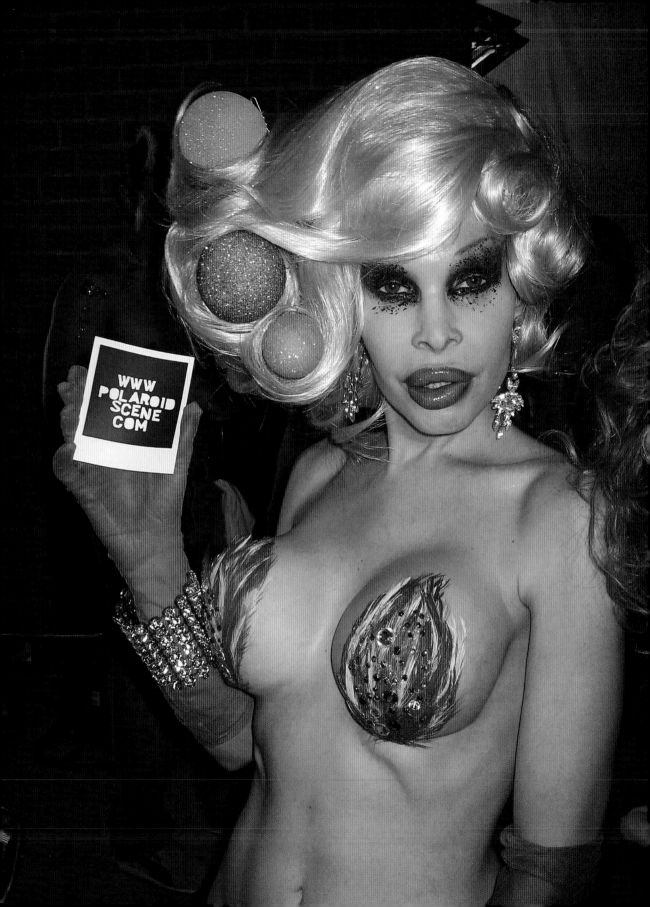

WWW
POLAROID
SCENE
COM

**AMANDA LEPORE, serving high concept Club Kid —
backstage at a HEATHERETTE fashion show. LA, 2004**

**Sweethearts of the Rodeo Drive, JENNY LEWIS
of RILO KILEY and SAM SPIEGEL. LA, 2004**

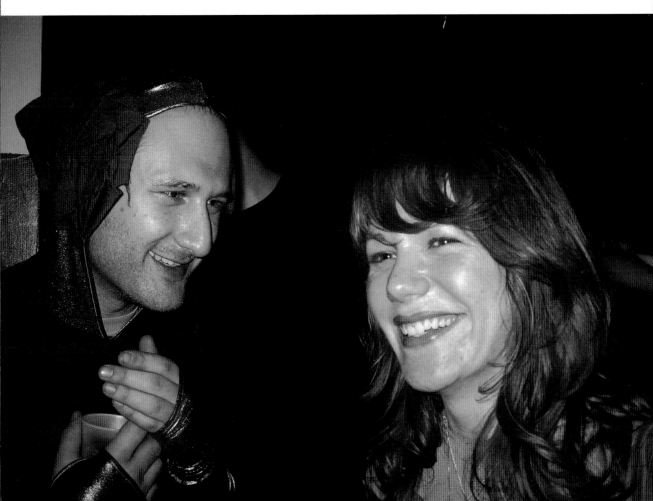

Threesome.

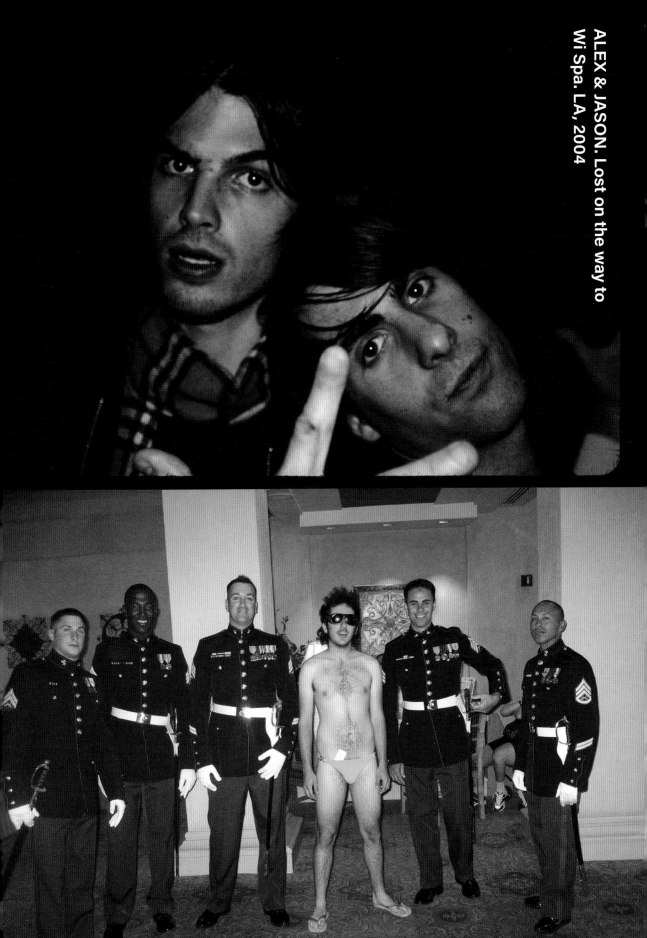

ALEX & JASON. Lost on the way to Wi Spa. LA, 2004

WATER + POWER - CALLED - WAITING... COMPLETE 🙂

- INTERNET + PHONE]
- ROLL DOWN GA
- NEO

SECURITY GATE

SORT
BEAT UP

(714) -

The holder of this card assumes all risks of accidents and expressly agrees to abide
by all orders of directions given by police or other authority in charge.

HEIGHT 5'8
WEIGHT 150
EYES BLUE
HAIR MULLET

SIGNATURE

WWW
POLAROID
SCENE
COM

POSTER

TB0924 GA GA3 18 A 15.00
 2.00
 15.00 GENAD/NO SEATING+FC
GA TROUBADOUR PRESENTS:
PP 1X KINGS OF LEON
GA3 18 AT THE
TBDA600 TROUBADOUR
21AUG03 9081 SANTA MONICA BLVD.
 WED SEP 24 2003 7:30PM

(714)

back
instead
snake.
com
etter
onpate

snake

GA GA4 64 A 17
GENERAL ADMISSN
GOLDENVOICE
SUPERGR
EL REY THEA
15 WILSHIRE BL.
AUG 9 2003 8:0

3am + 3rd ave

GA GA6 27 ADULT
SECTION/AISLE ROW/BOX SEAT ADMISSION
GENERAL ADMISSN 15.50
 * *
PHANTOM PLANET
 BEN LEE
R O X Y T H E A T R E
9009 W. SUNSET, HOLLYWOOD
THU OCT 23 2003 DRS@8PM

2004, putting my wheat paste skills to work promoting my new website. I have always liked to capture my subjects naturally, but back in those early days I was still an awkward teenager and when someone took my picture I would get nervous and pour a BUDWEISER on my head.

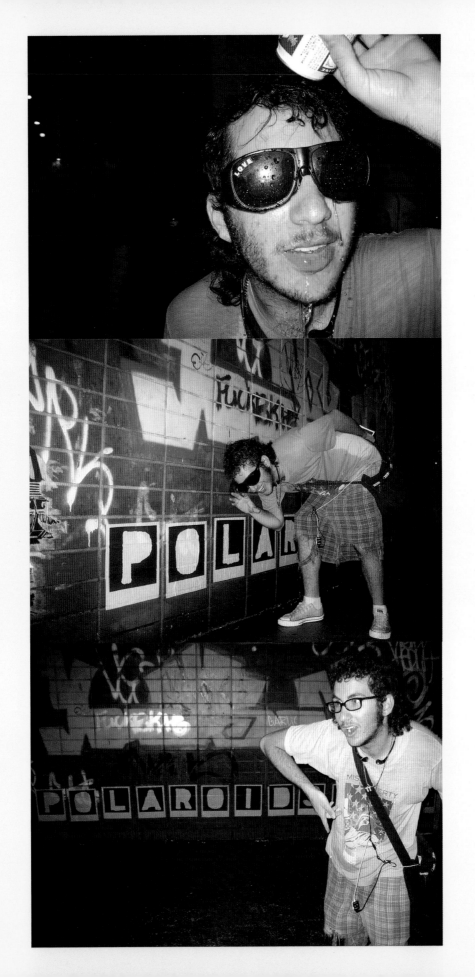

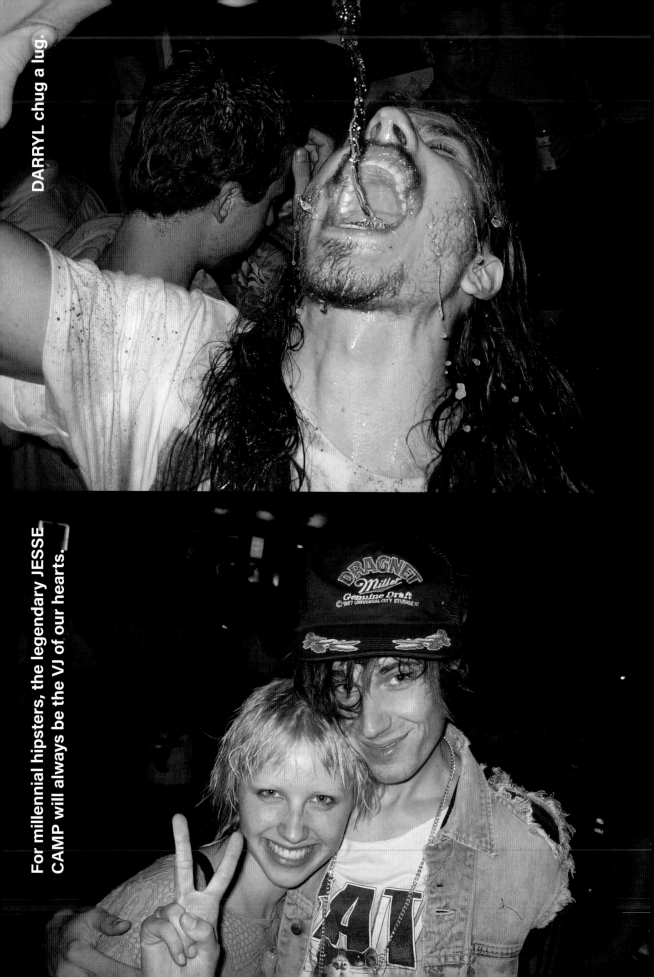

DARRYL chug a lug.

For millennial hipsters, the legendary JESSE CAMP will always be the VJ of our hearts.

TERRY RICHARDSON'S
assistant
KEICHI
mean-mugging
and
shirtless,
in
his
element.
NYC,
2004

welcome to thecobrasnake.com here you will find some stuff that is good.... with some sort of staff and the most creative people working to make you happy you better like it and get inspired to rock shit good and hard please... featuring todays best party photos, a large collection of the adventure team archive, hot emails, LAWEEKLY'S snake bites and much more more more....

To: markthecobrasnake@yahoo.com

Subject: welcome message

markthecobrasnake@yahoo.com

<markthecobrasnake@yahoo.com>

-0800 (PST)

MAR2004 TUESDAY

0078223

Metro **Day** **Pass**

Reduced

THE DARKNESS
www.thedarknessrock.com
HENRY FONDA THEATRE
6126 HOLLYWOOD BLVD. LA
SAT APR 17 2004 7:00PM

GENERAL ADMISSN +FC 1.50
GOLDENVOICE*SPACELAND
GA3 86 L 15.00
$ 15.00

HE0417 GA

CALIFORNIA
DMV
DRIVER LICENSE
B8631511
EXPIRES 07-21-08
MARK HUNTER
P O BOX 48788
LOS ANGELES CA 90048
SEX:M HAIR:BRN
HT:5-08 WT:140
EYES:BLU
DOB:07-21-82
DONOR
10/26/2004 581 32 FD/08

Date:
From: "Mark Hunter"
Subject: adventure

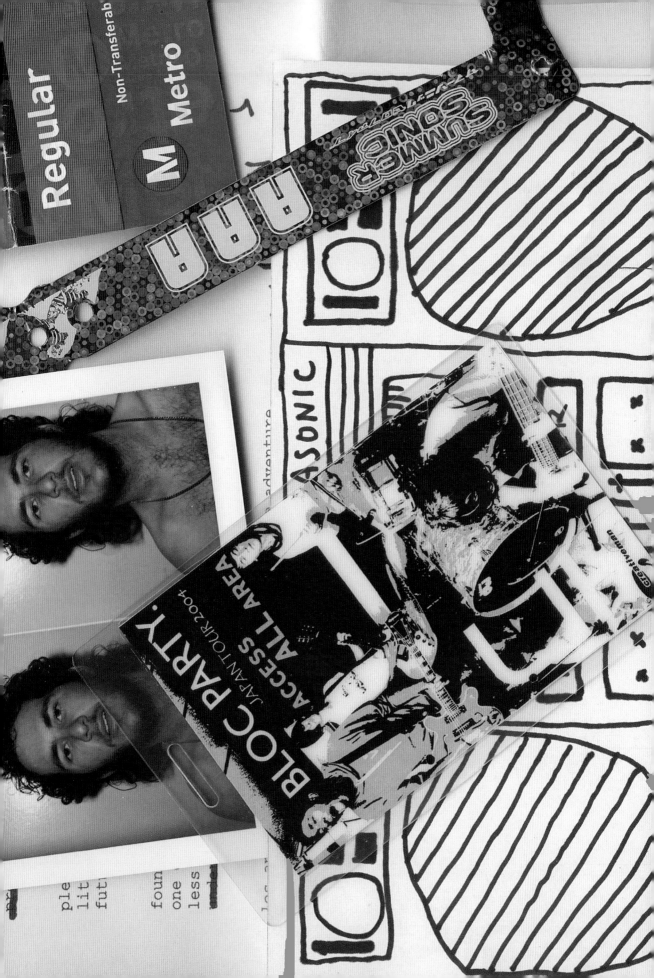

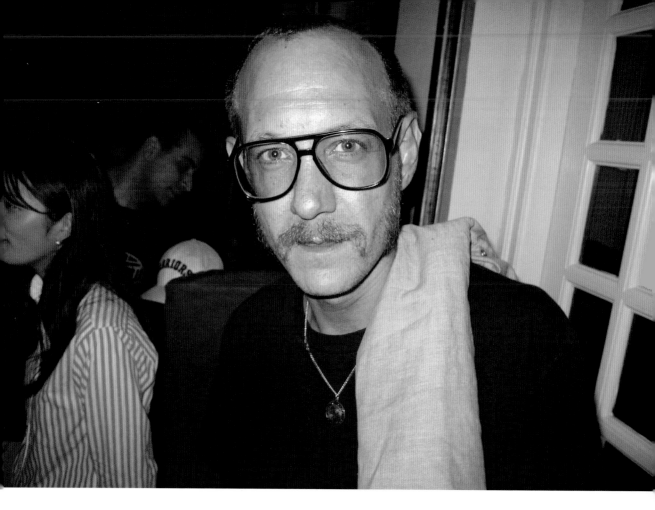

**TERRY RICHARDSON scoping out
the competition (me!). NYC, 2004**

The calendar of a young nightlife photographer on the
make: nonstop art shows, concerts, bike repair shop
appointments, and taking pictures of girls drinking beer
with really long sideburns.

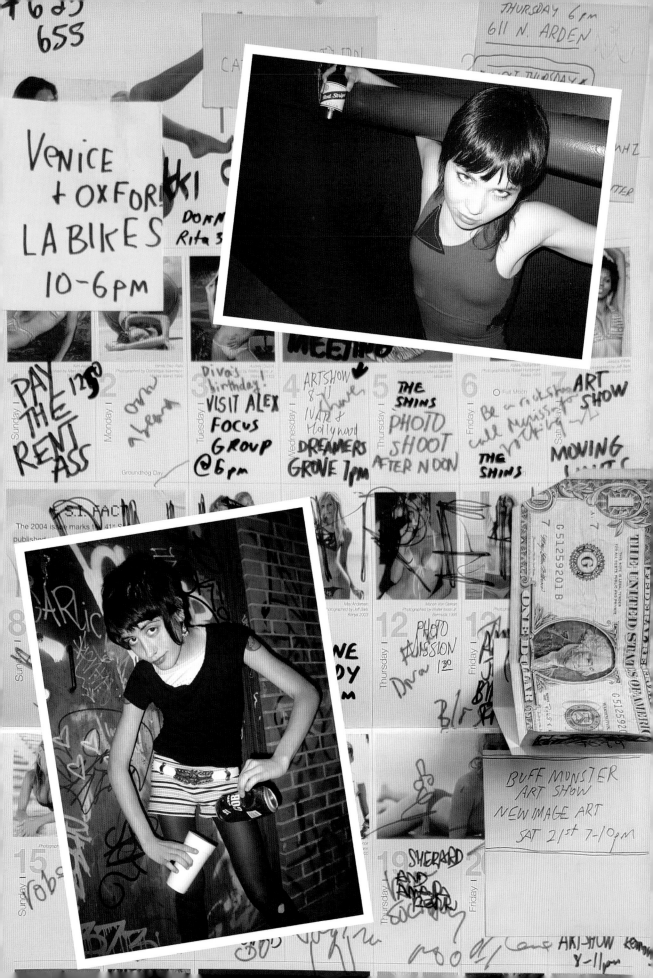

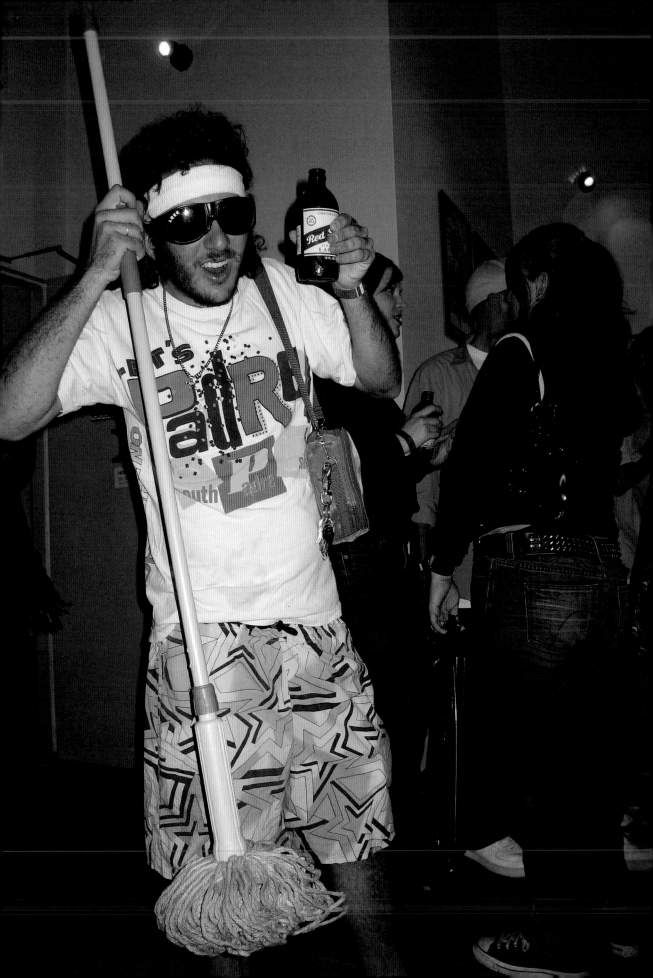

My day job back then was working at SHEPARD FAIREY's gallery, where I would pick up cases of RED STRIPE before the shows and clean up afterwards (I brought my own mop). A couple of those cases of RED STRIPE may have gotten lost on the way back from SMART & FINAL, who can really say for sure. It felt like living in a dream to be working for my hero and meeting so many cool people in the art world, but I had just graduated high school and still got really nervous at these parties. My social anxiety would manifest through wearing really loud neon outfits and hiding constantly behind sunglasses, which ironically made it seem like I was the least anxious person at every party. Fake it 'til you make it.

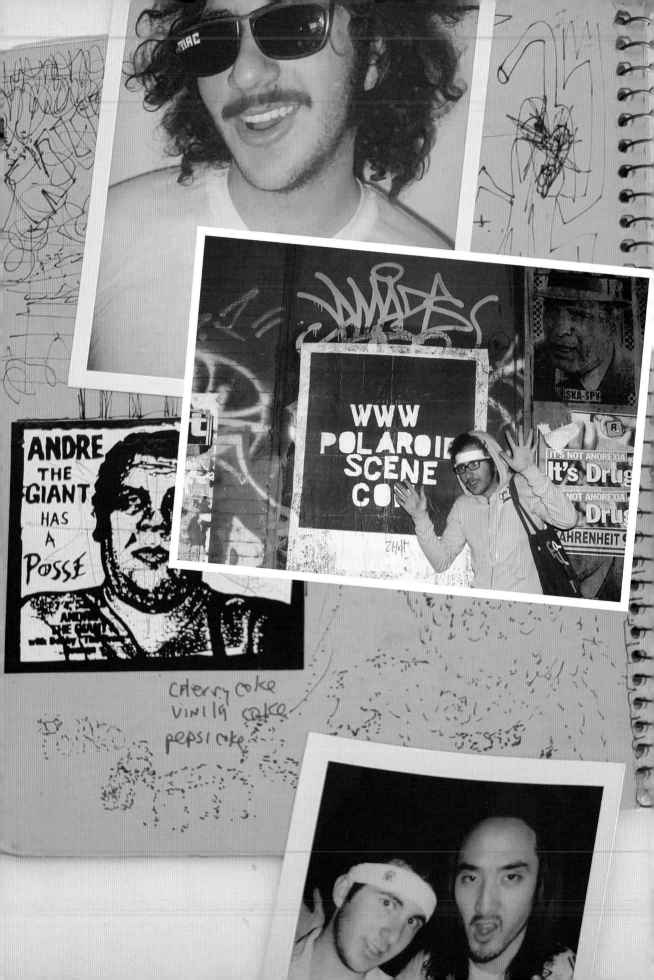

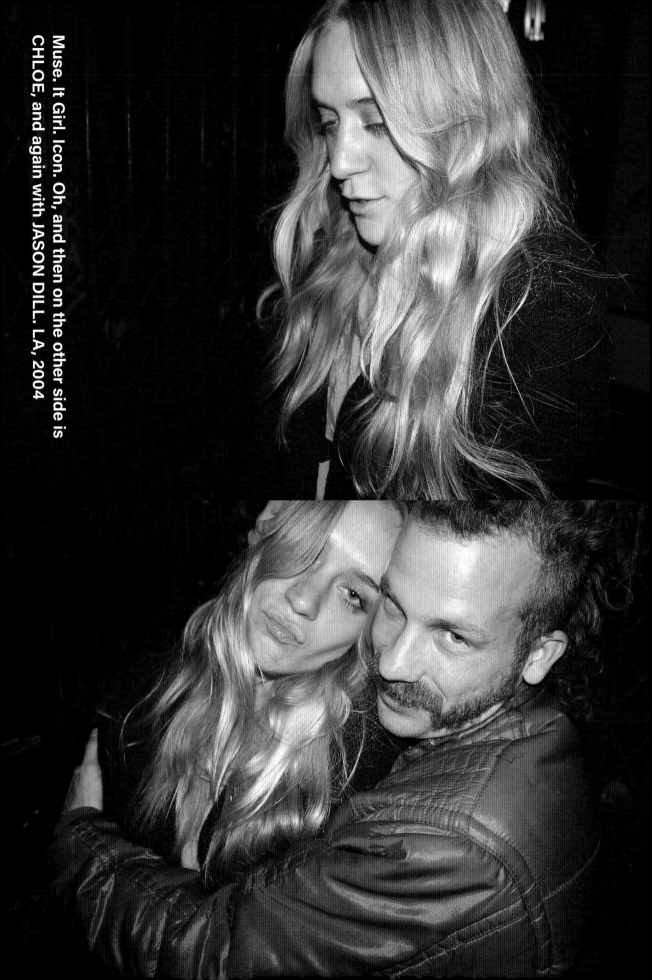

Muse. It Girl. Icon. Oh, and then on the other side is CHLOE, and again with JASON DILL. LA, 2004

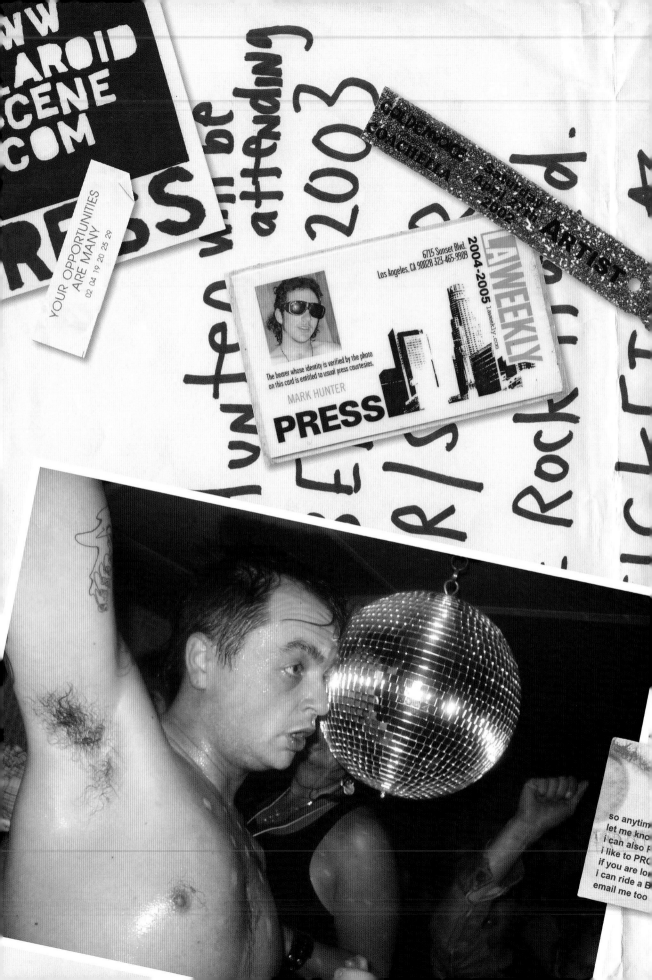

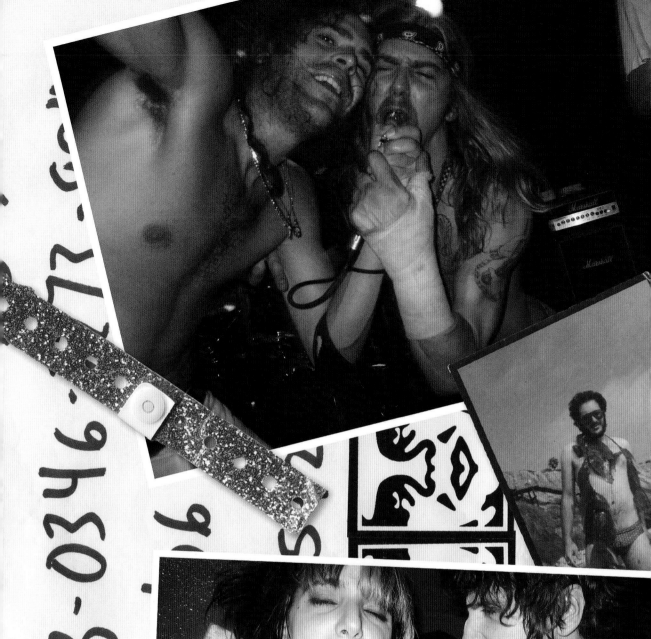

ALEXIS ARQUETTE—trash humpers. LA, 2004

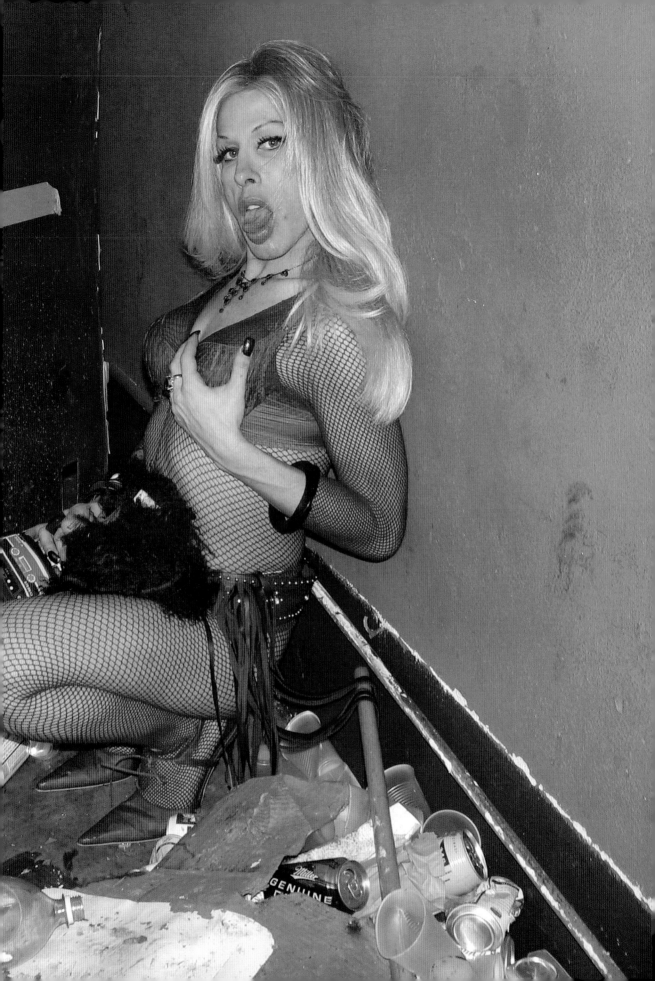

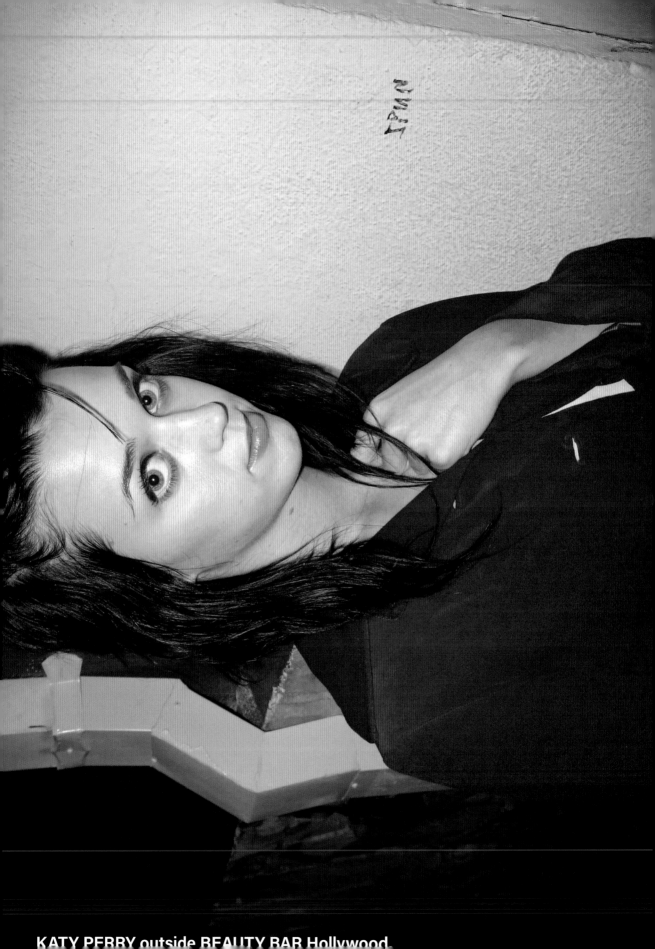

KATY PERRY outside BEAUTY BAR Hollywood.

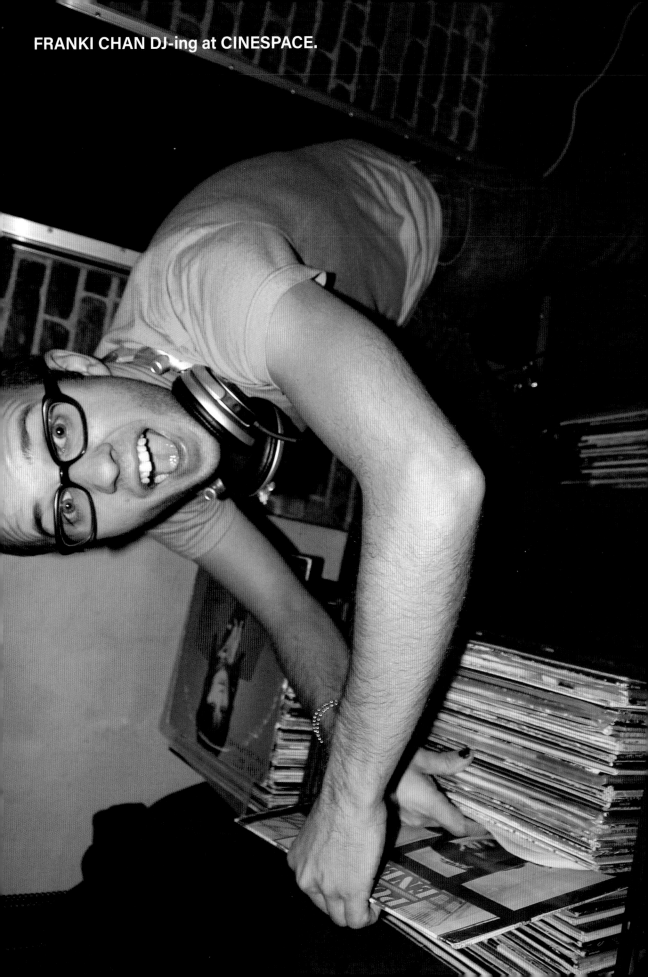

FRANKI CHAN DJ-ing at CINESPACE.

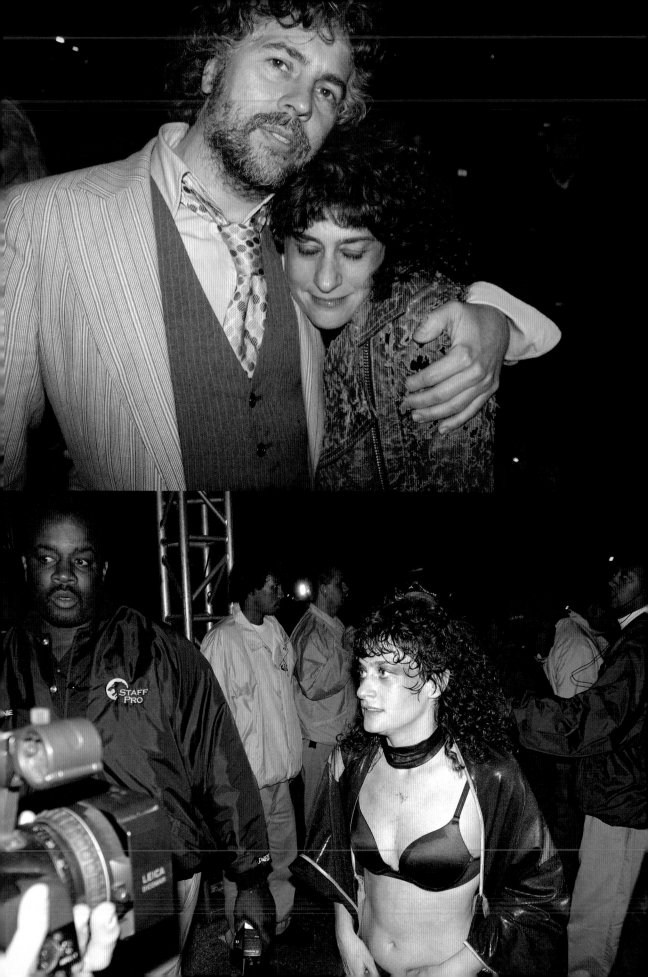

WAYNE COYNE and PEACHES, iconic artists and iconic
pink outfits, ALL TOMORROW'S PARTIES festival.

Mullet inspo, the real "Teaches of Peaches," HAR MAR
SUPERSTAR, hungry like the wolf. LA, 2004

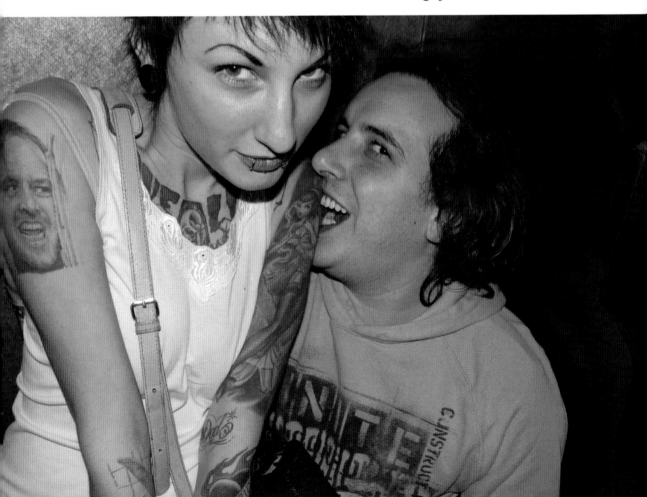

Young JEFFREE STAR before Instagram, before YouTube, when the only way to get famous was to have a picture of yourself looking really surprised posted on my website. LA, 2004

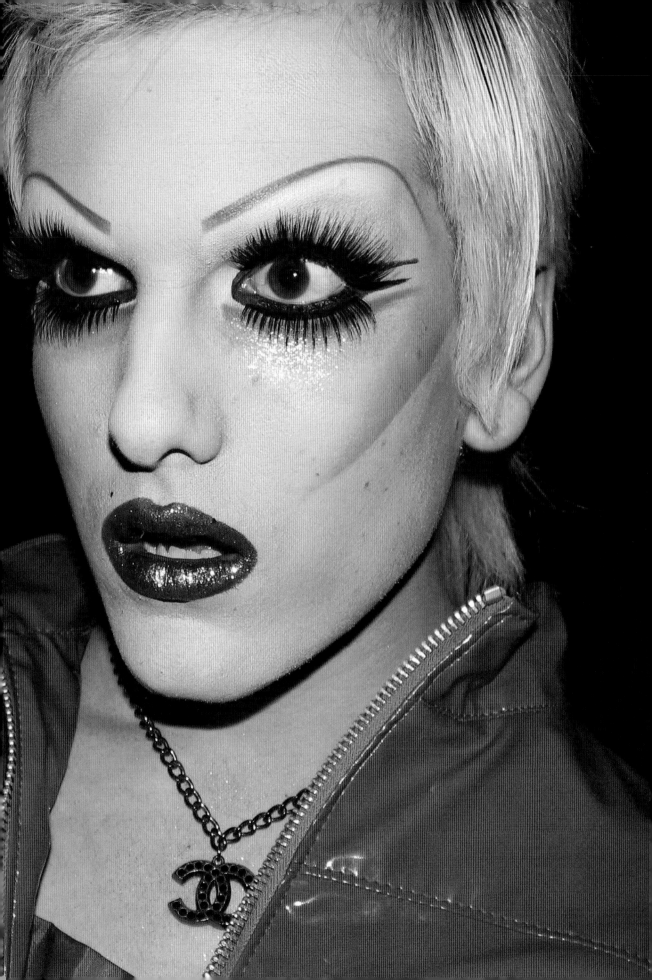

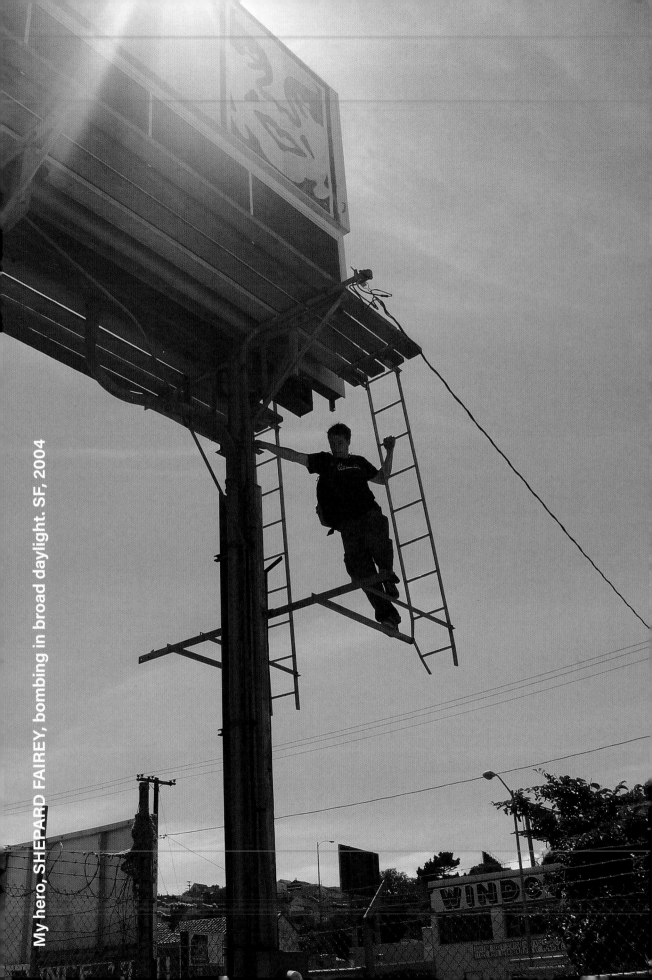

My hero, SHEPARD FAIREY, bombing in broad daylight. SF, 2004

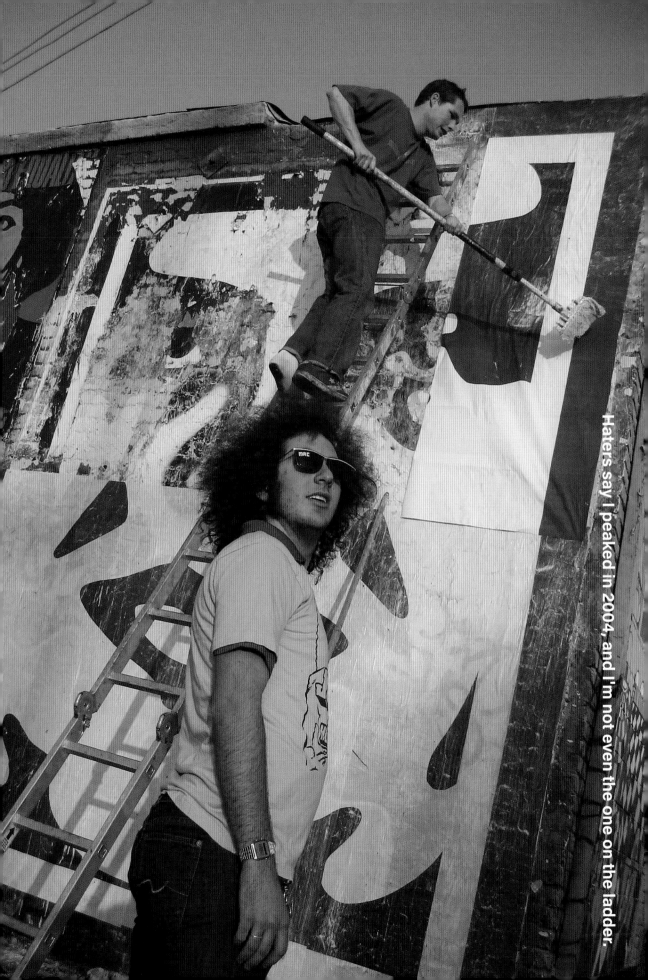

Haters say I peaked in 2004, and I'm not even the one on the ladder.

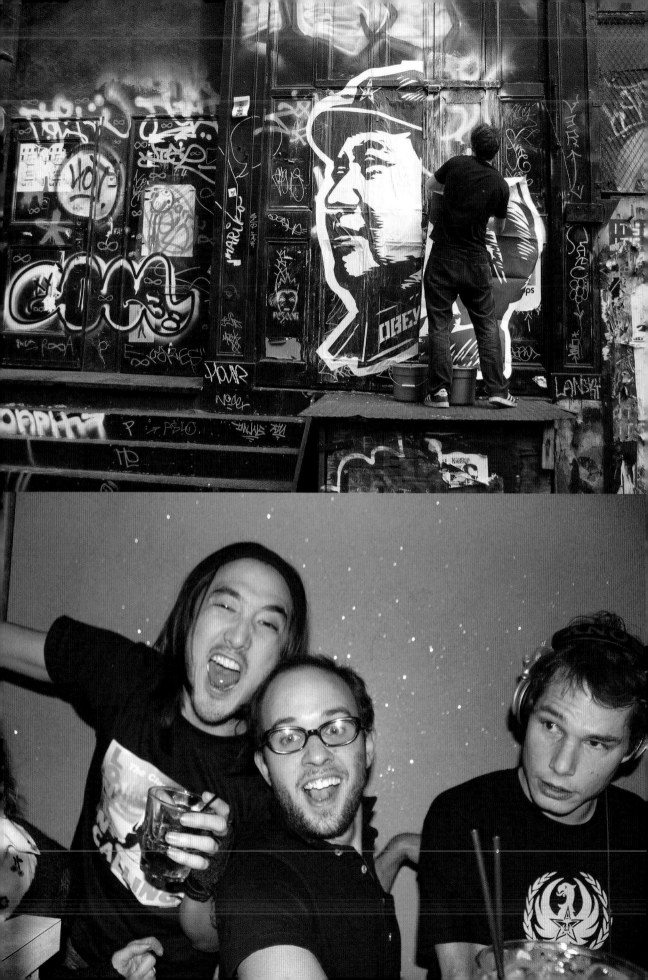

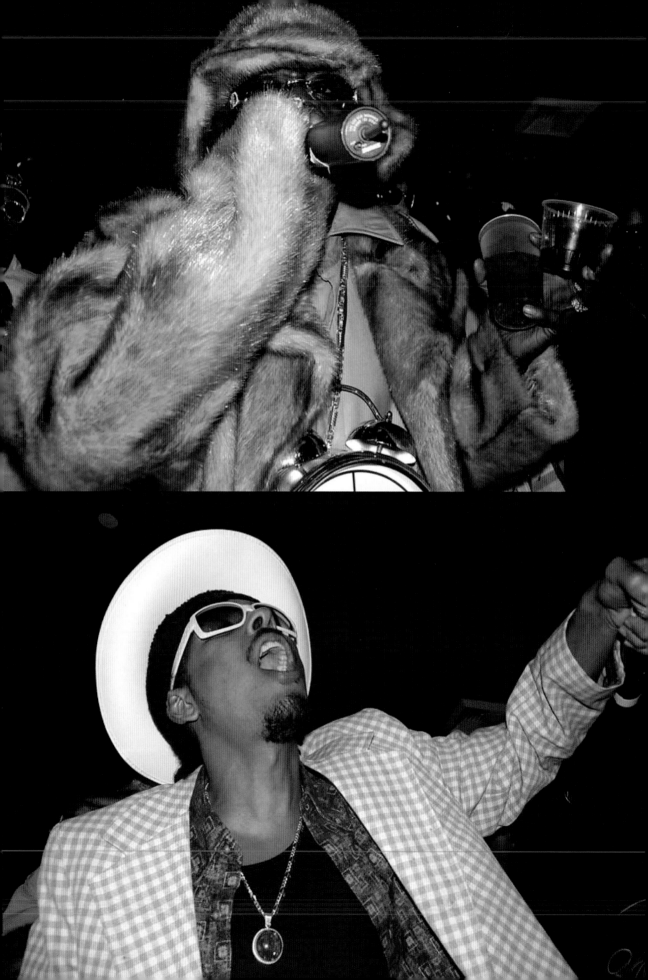

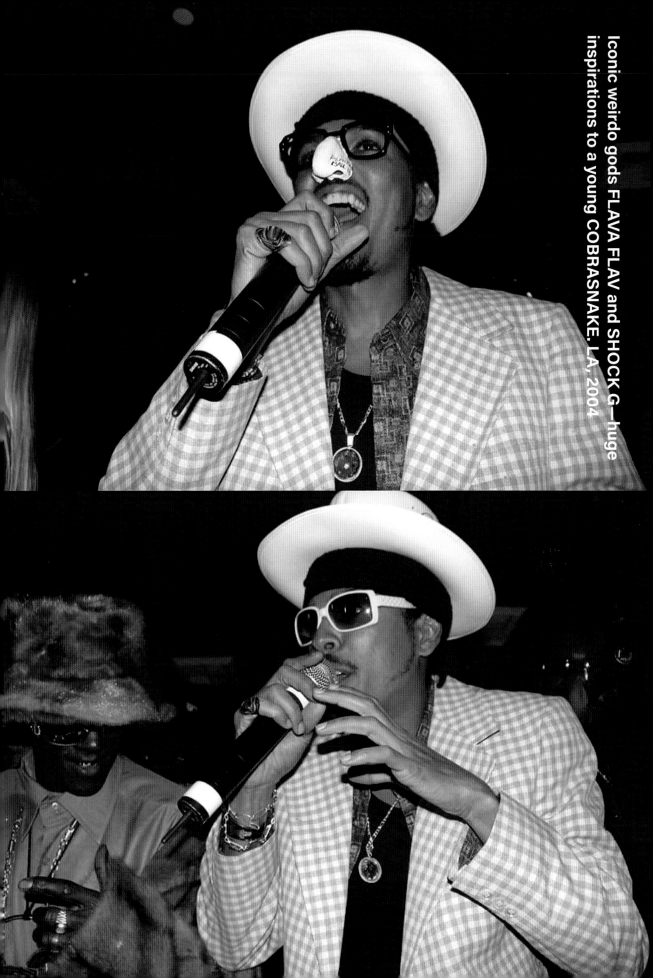

Iconic weirdo gods FLAVA FLAV and SHOCK G—huge inspirations to a young COBRASNAKE. LA, 2004

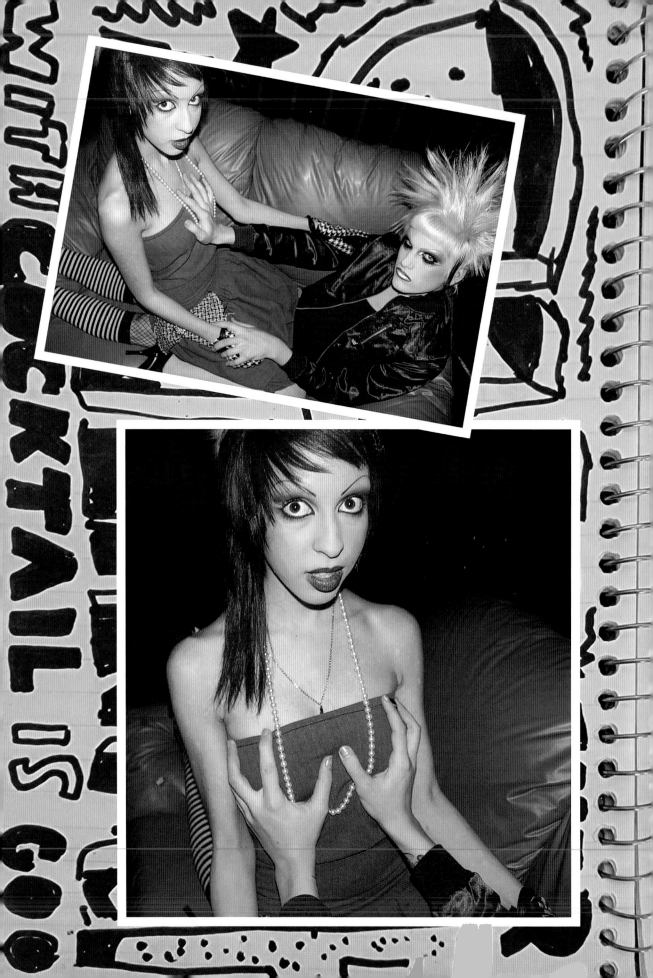

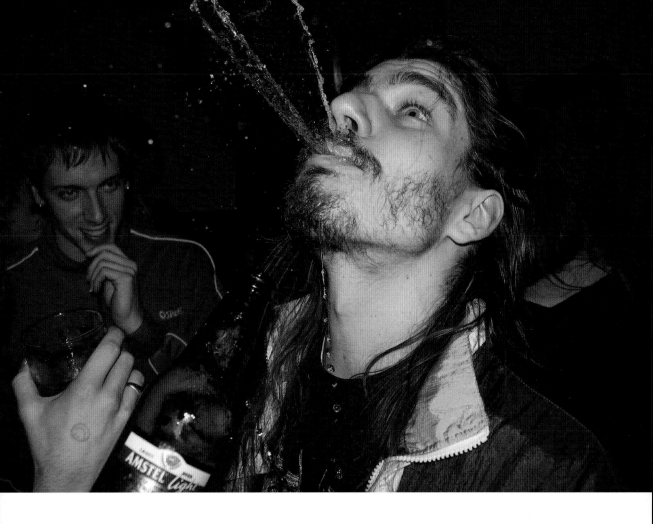

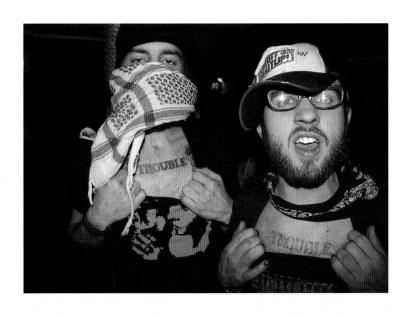

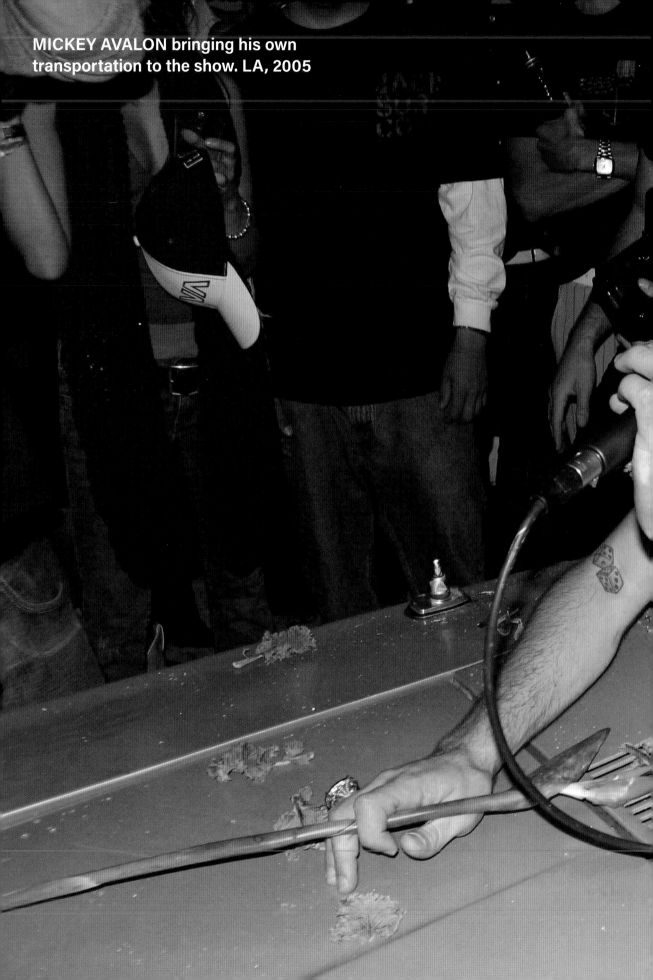

MICKEY AVALON bringing his own transportation to the show. LA, 2005

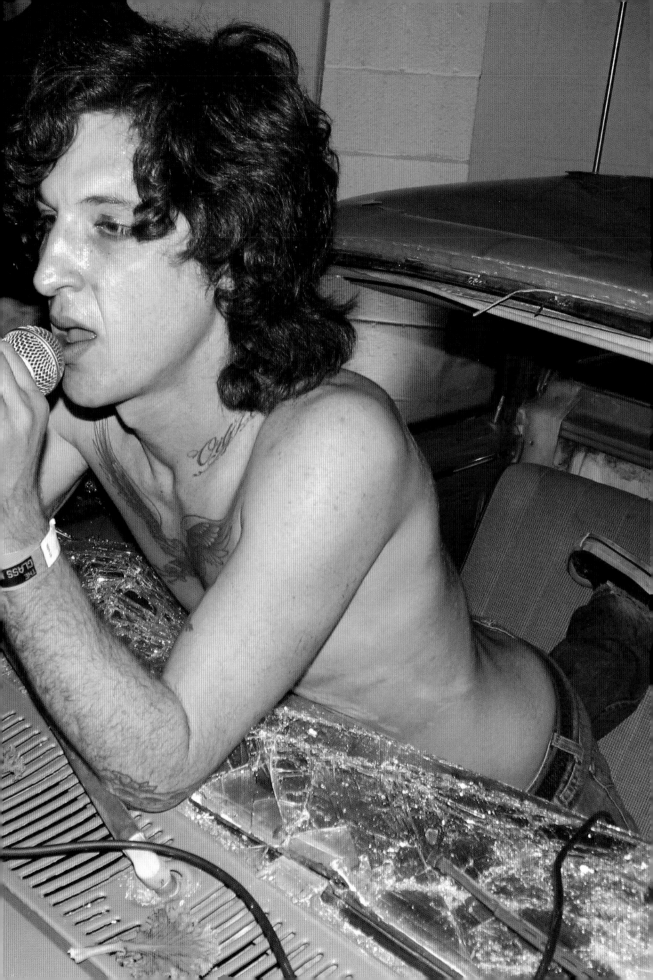

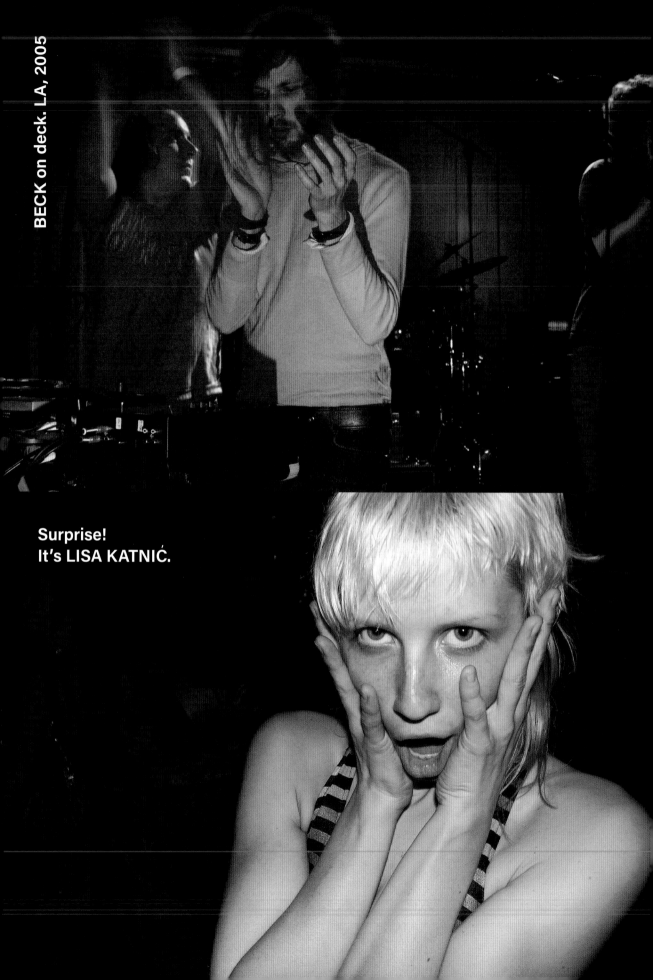

BECK on deck. LA, 2005

Surprise!
It's LISA KATNIĆ.

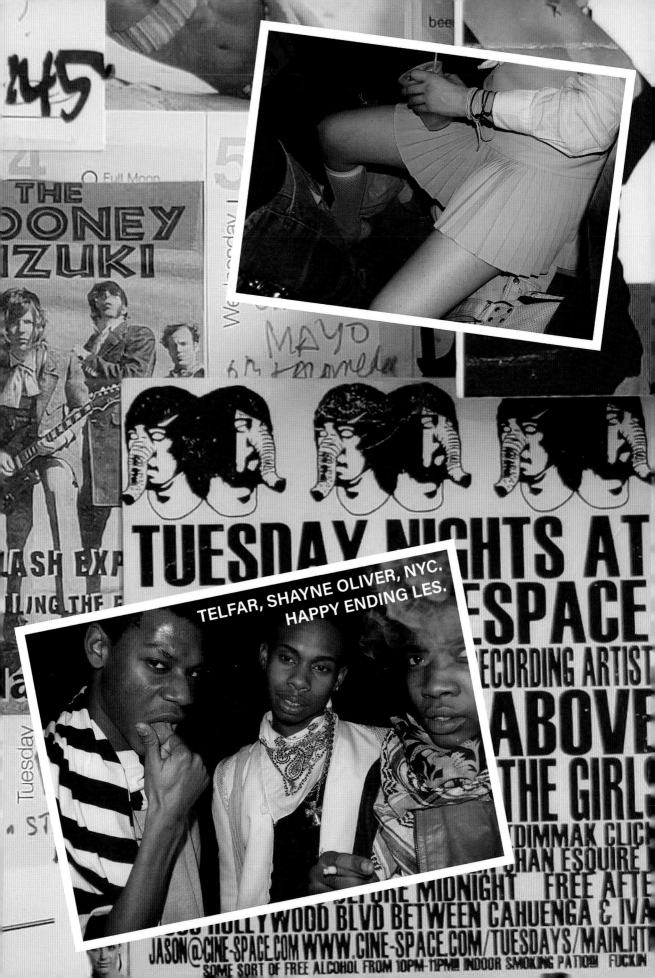

TELFAR, SHAYNE OLIVER, NYC.
HAPPY ENDING LES.

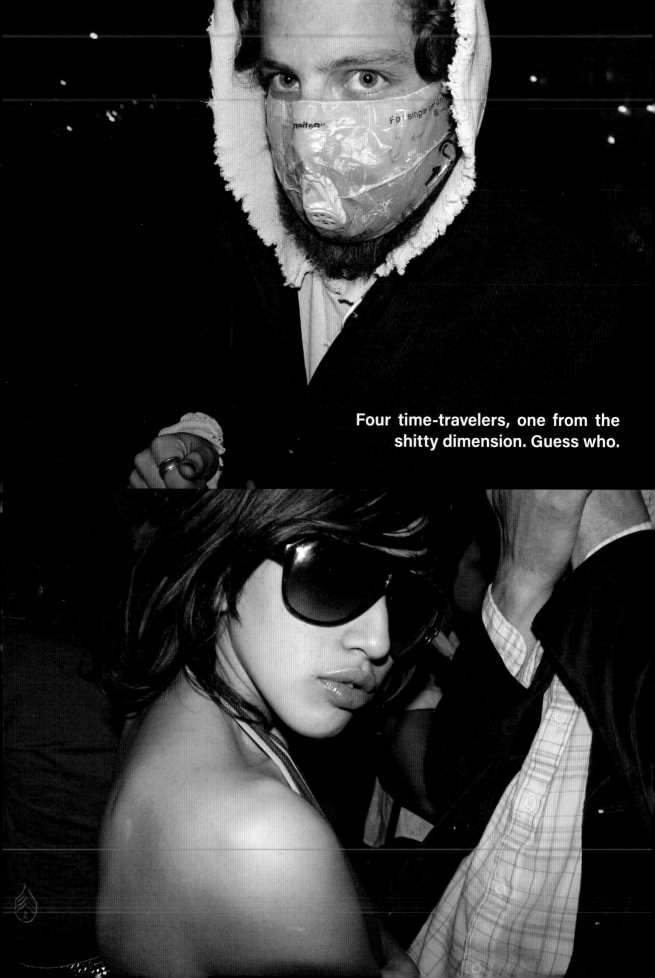

Four time-travelers, one from the shitty dimension. Guess who.

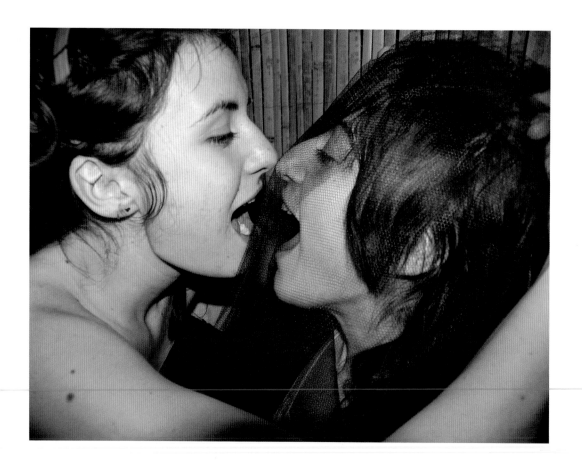

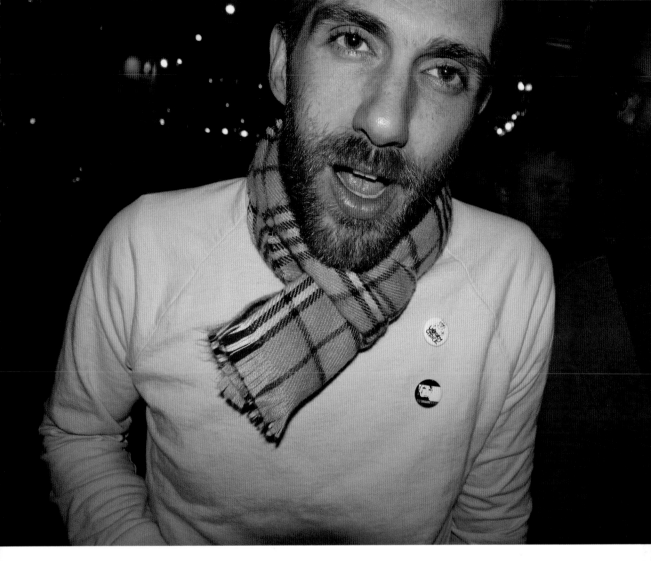

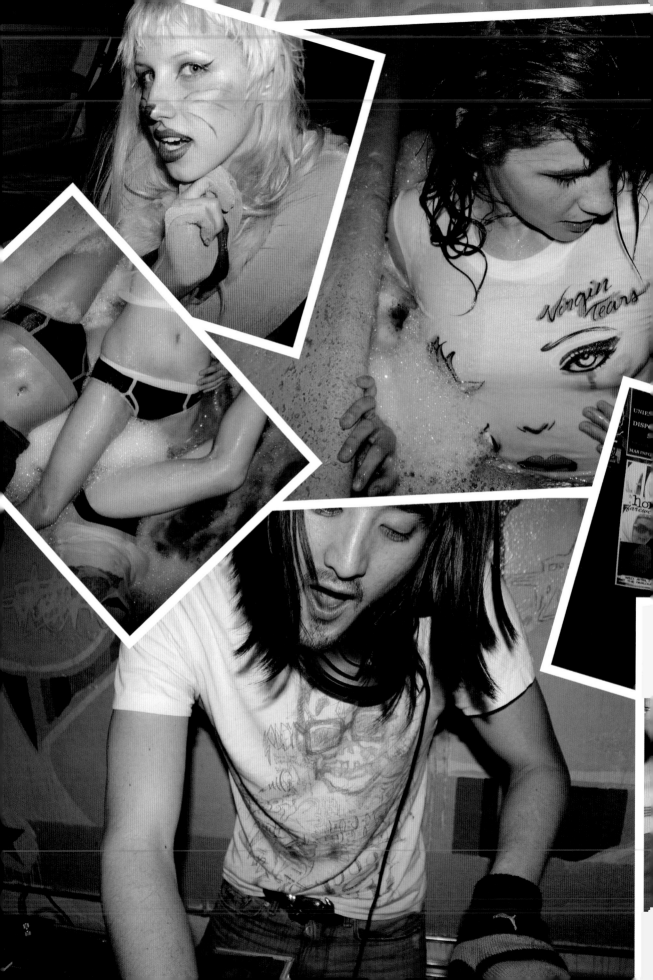

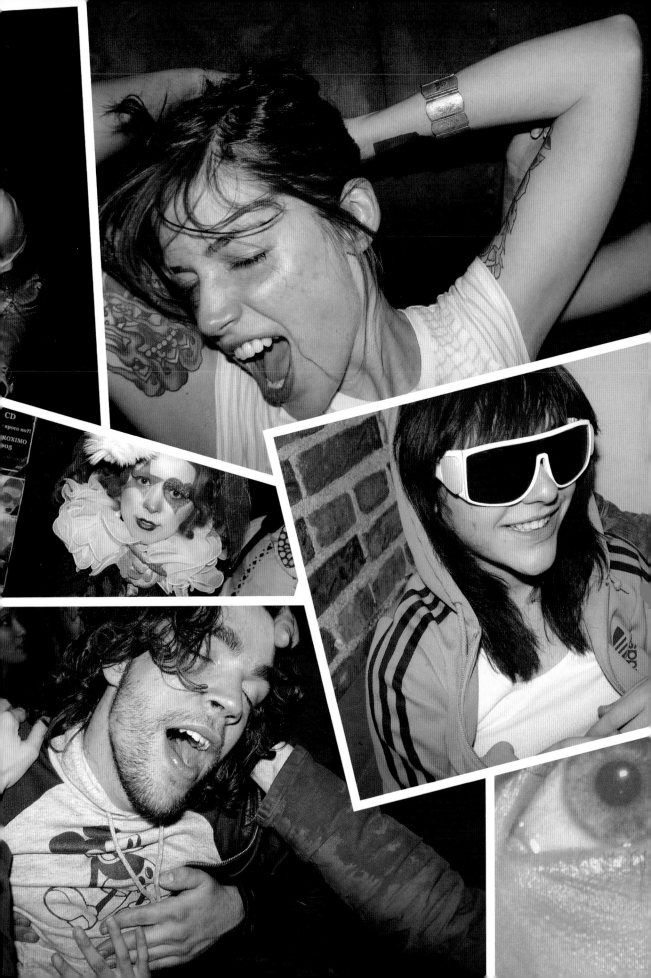

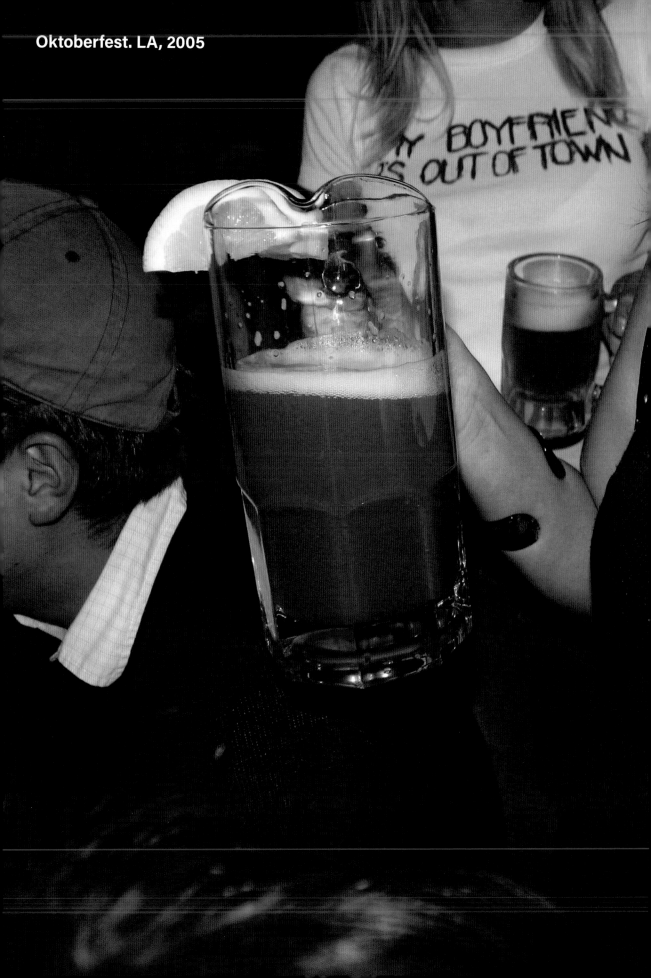

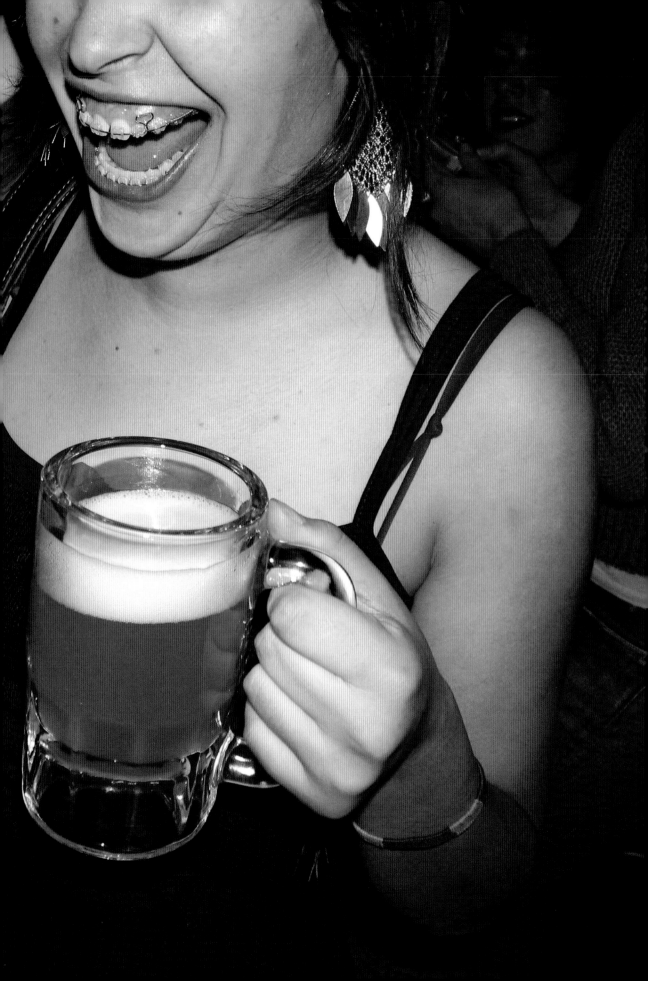

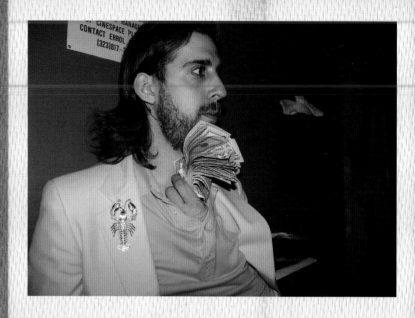

FEB 2 2 2005

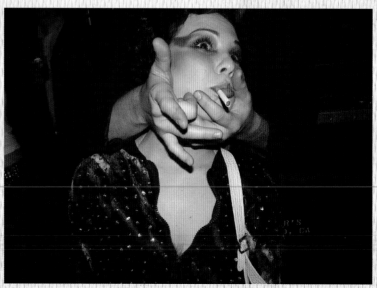

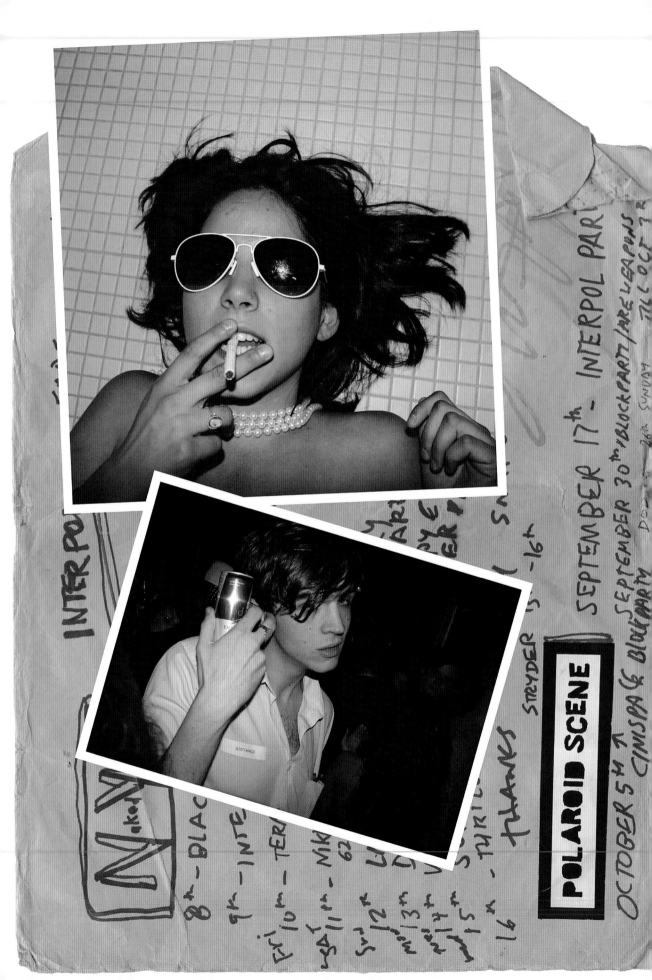

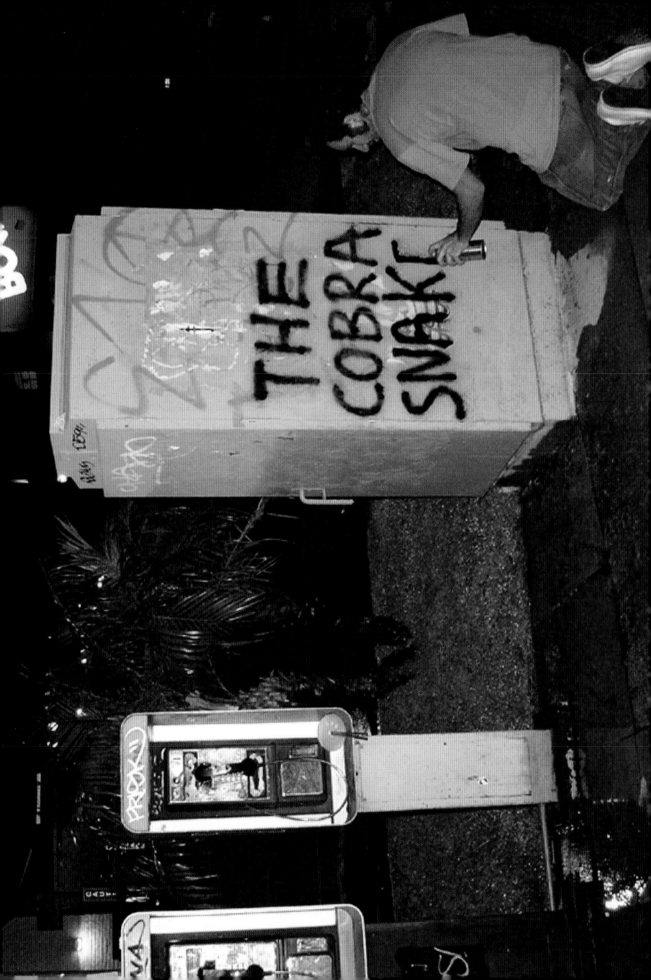

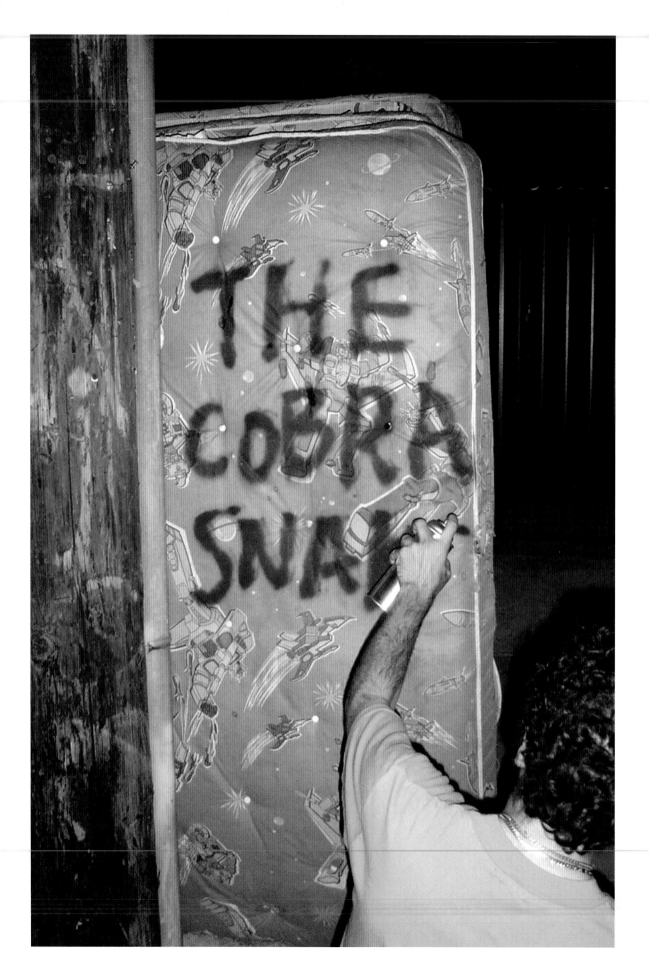

You know it's 2005 when COBRASNAKE shows up with a flip phone and a LOUIS bag full of DIET REDBULL.

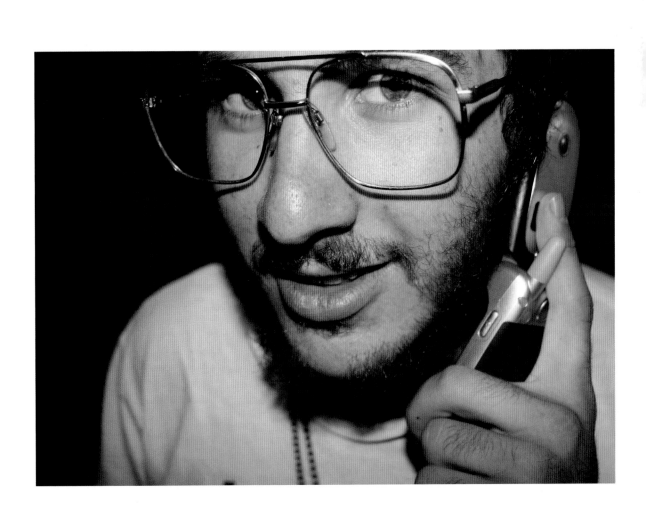

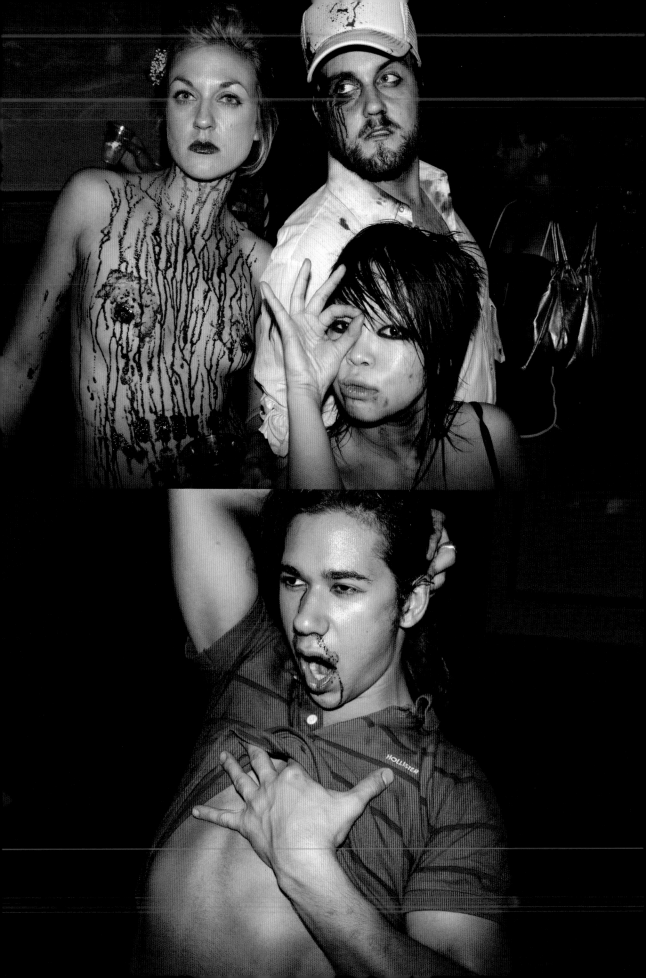

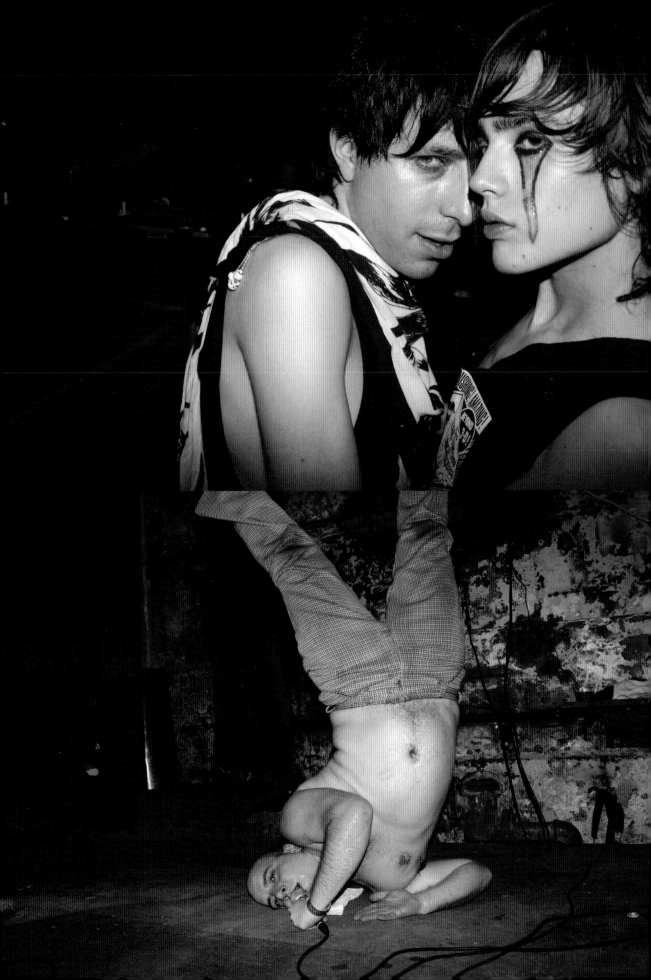

This was the era of the $99 JET BLUE cross country flight, when my site was popping enough for me to pull off the lifestyle of a budget-oriented, couch-surfing, bi-coastal rock star. I was in NYC so often that it must have seemed to my friends out there like I would just teleport back and forth inside the photo booths that were in all our favorite bars. I spent many early mornings, after the after party, waiting for DELANCEY CAR SERVICE (there was no Uber) in front of a bodega, munching a breakfast bagel and watching the sun rise. It was around this time that I accidently started the trend of wearing glasses with no lenses, because I got Lasik but felt so weird and anxious without my glasses that I popped the lenses out and kept rocking them.

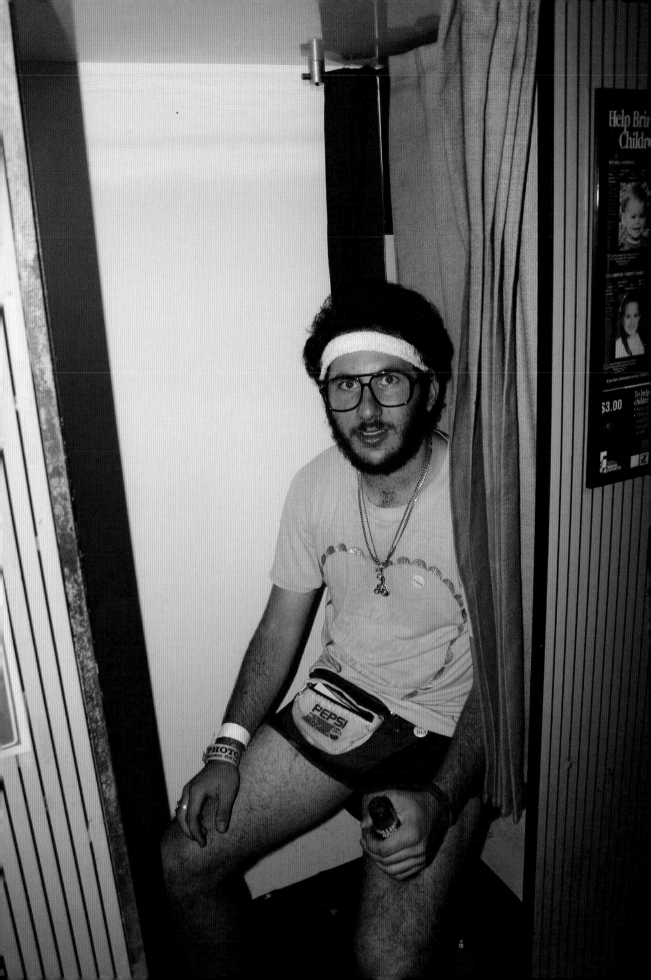

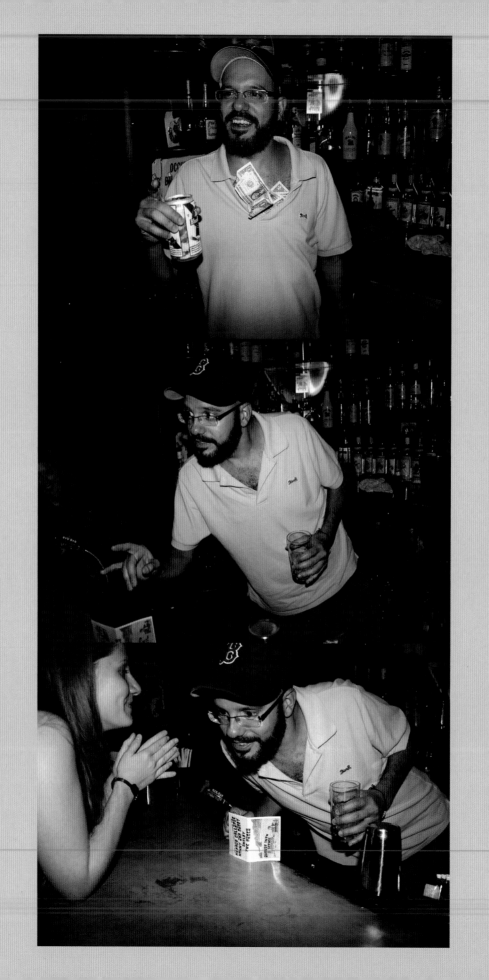

Back in the day, the LOWER EAST SIDE was a place where you never knew what underground comedy icon might be serving you drinks in exchange for tips shoved down his cleavage. DAVID CROSS. NYC, 2005

AMERICAN APPAREL neon leg warmers, VITAMIN WATER, and GRANDMA'S Mardi Gras beads: nightly essentials in LA. LA, 2005

Headphones and digital cameras have changed a lot over the years, but the nipple still demands to be free.

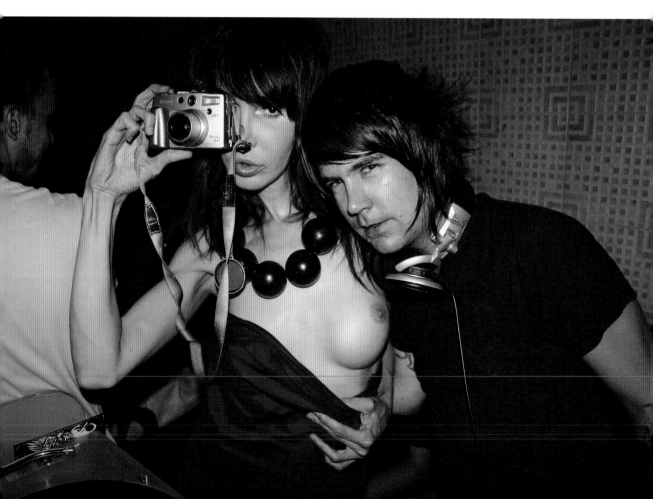

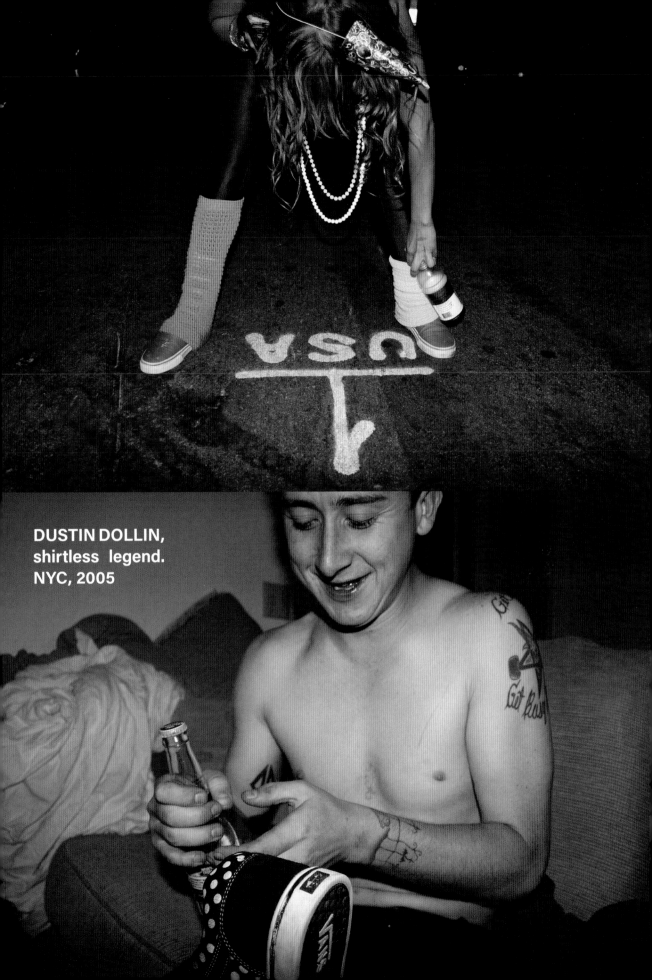

DUSTIN DOLLIN,
shirtless legend.
NYC, 2005

The early years of THECOBRASNAKE.COM were wild. I couldn't afford hotels, so I slept on couches and stayed out all night when I didn't have a place to crash. But it was all worth it to get to capture the energy of cultural icons like the guy from LMFAO... Oh wait, sorry—that's just the FAT JEW. Maybe it wasn't worth it? ;)

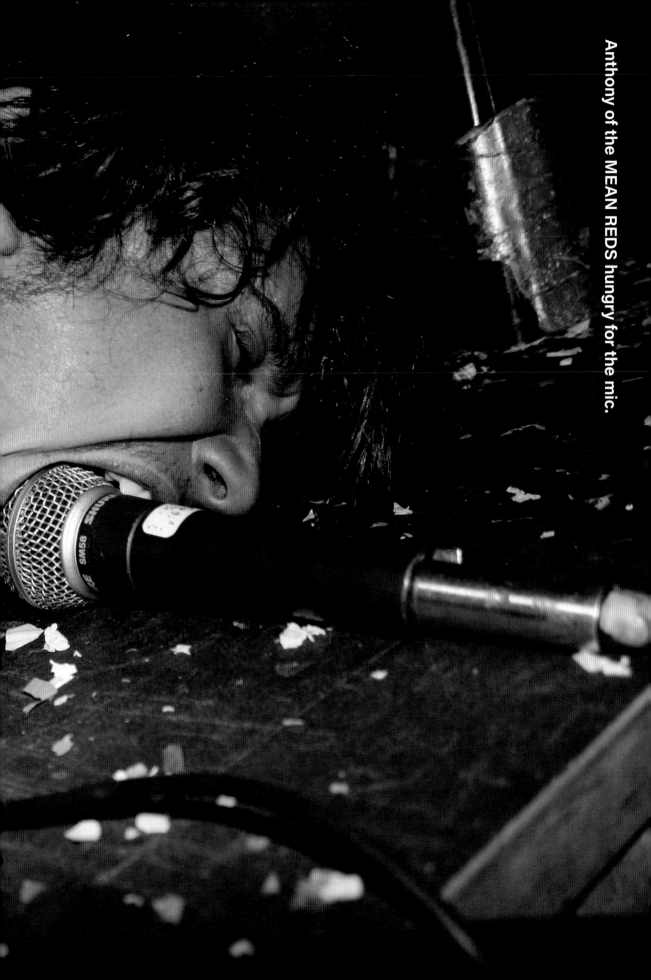

Anthony of the MEAN REDS hungry for the mic.

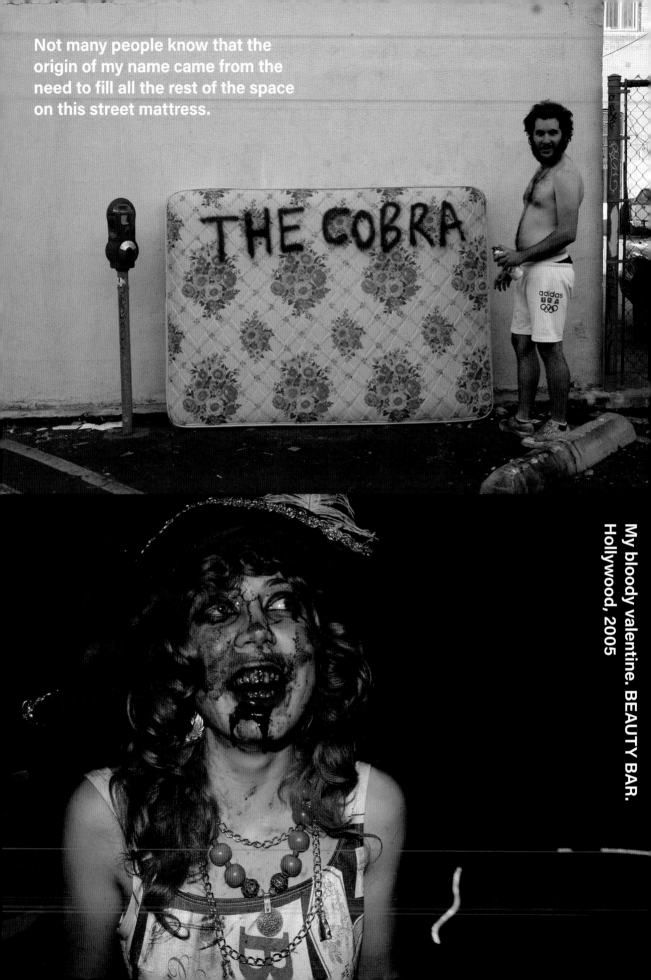

Not many people know that the origin of my name came from the need to fill all the rest of the space on this street mattress.

THE COBRA

My bloody valentine. BEAUTY BAR.
Hollywood, 2005

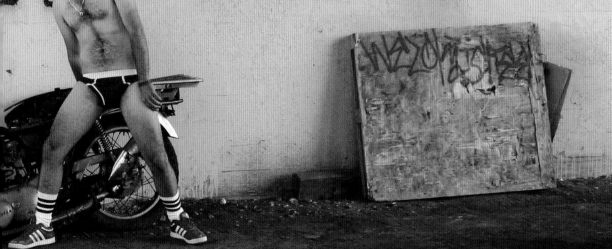

My first love was street art, and I came up as an apprentice to SHEPARD FAIREY.

By late 2005, the
scene was being created at
amazing nights in small bars and
intimate venues. Places with no cover,
dark corners, and great music, where you
could dance to your new favorite song and
then find yourself waiting behind the band
in the bathroom line. BEAUTY BAR, STAR
SHOES, and CINESPACE in LA — MAX FISH,
LIT, and DARK ROOM in NYC.

BEAUTY BAR. LA, 2005

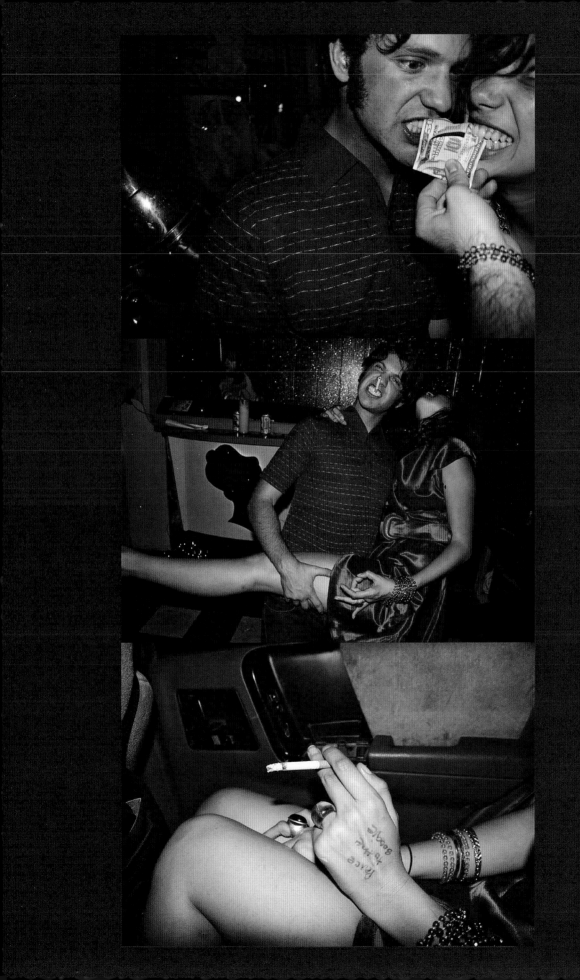

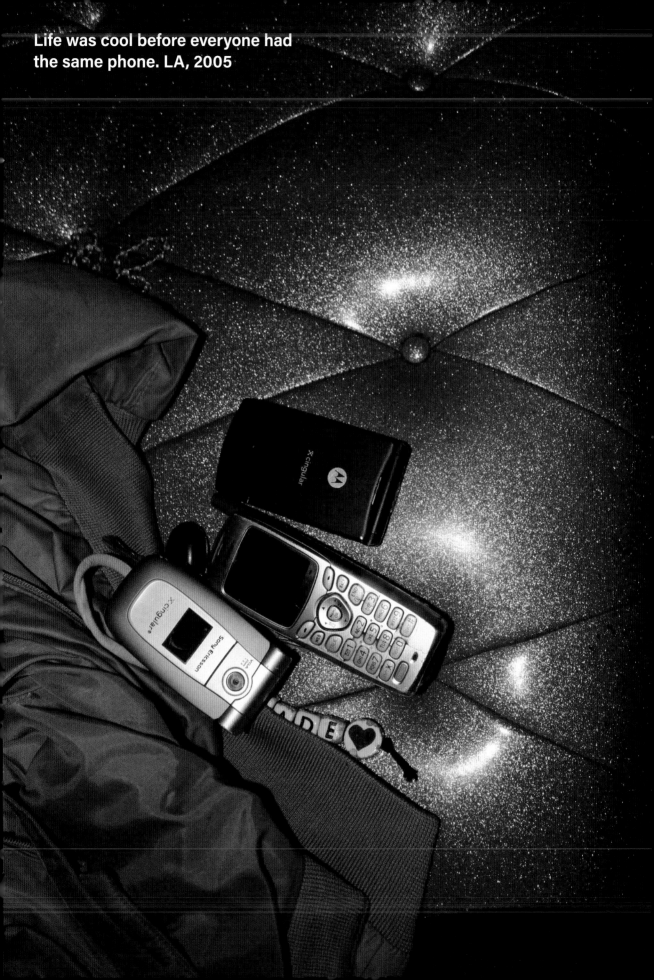

Life was cool before everyone had the same phone. LA, 2005

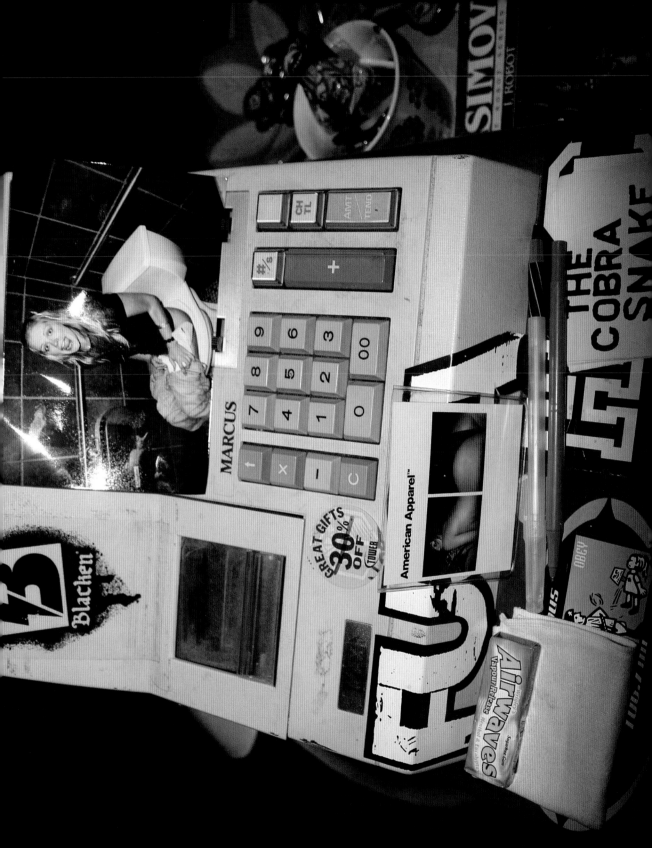

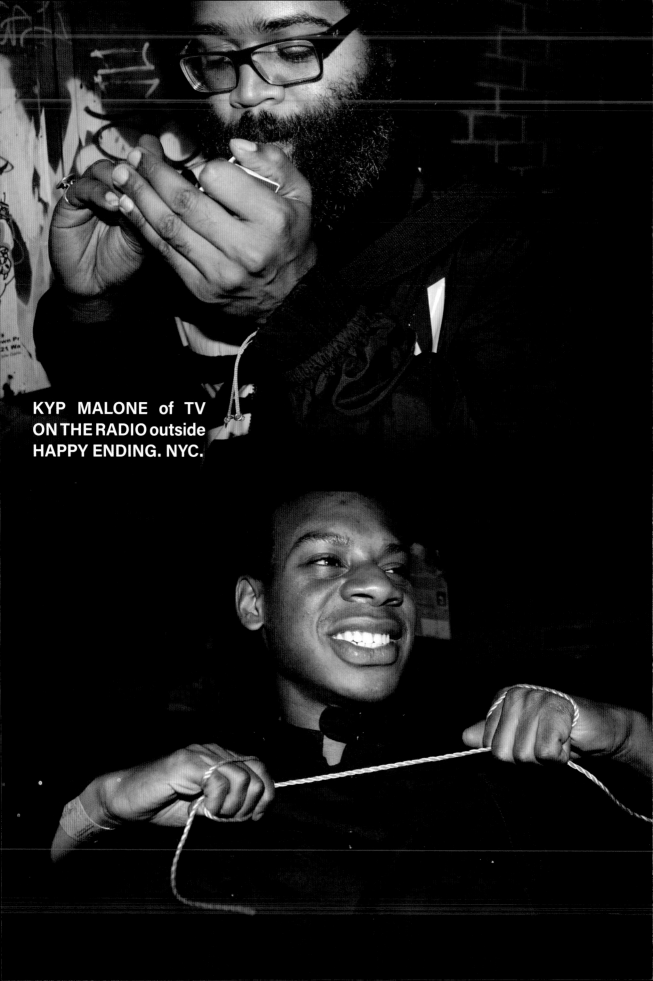

KYP MALONE of TV
ON THE RADIO outside
HAPPY ENDING. NYC.

TELFAR CLEMONS
before
he
was
a
legendary
designer,
working
the
door
at
the
best
parties
in
New York. He always let me in, which shows very
poor judgement. NYC, 2005

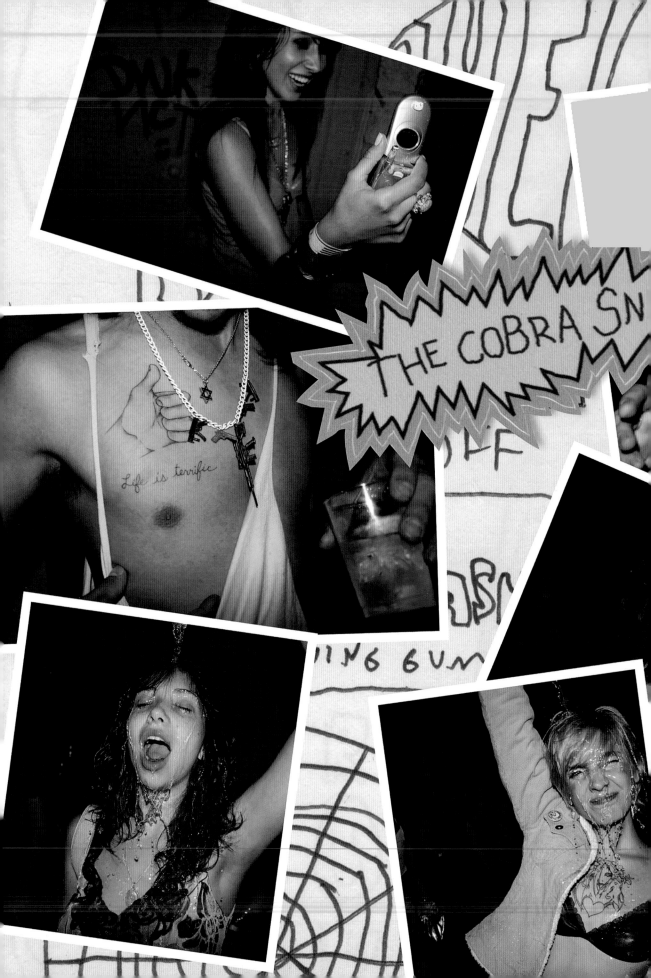

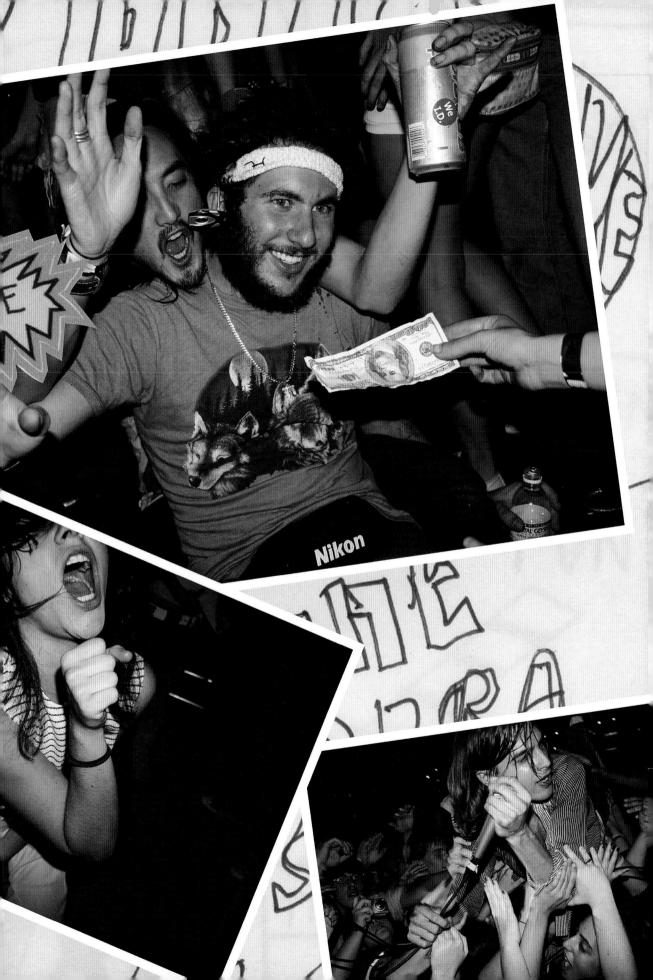

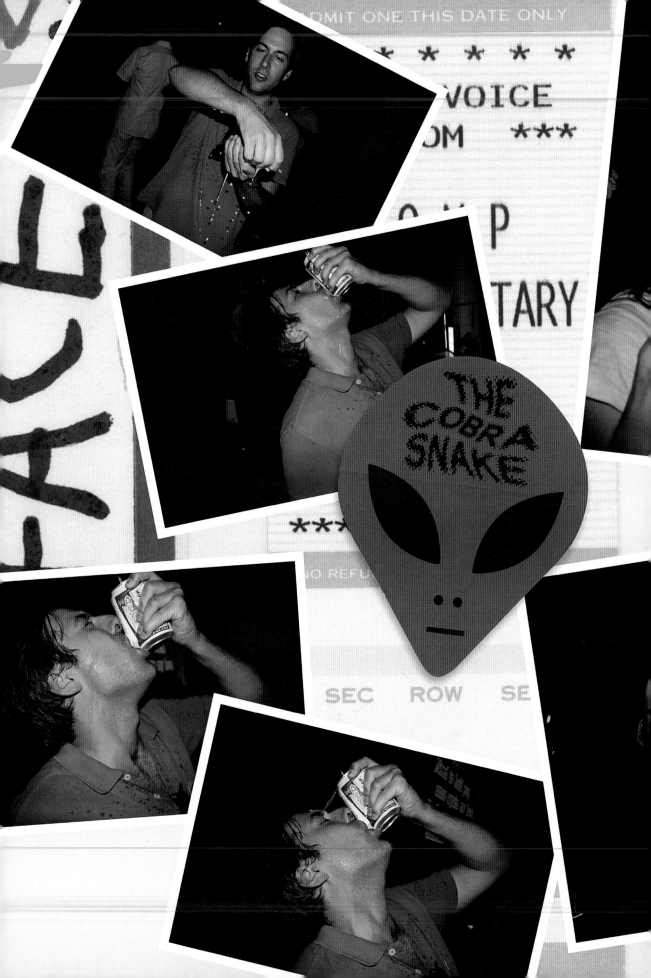

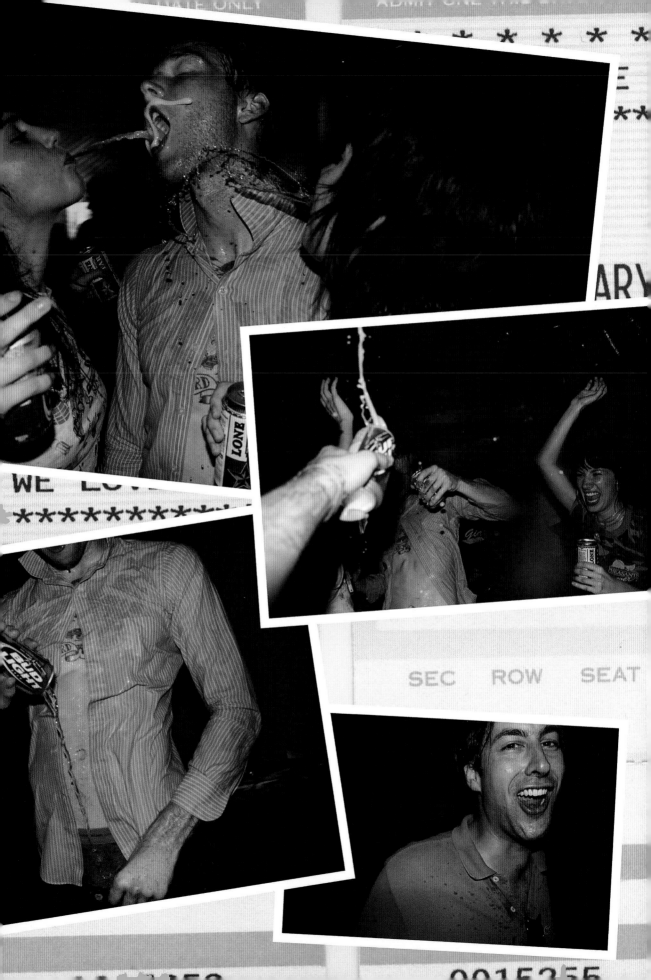

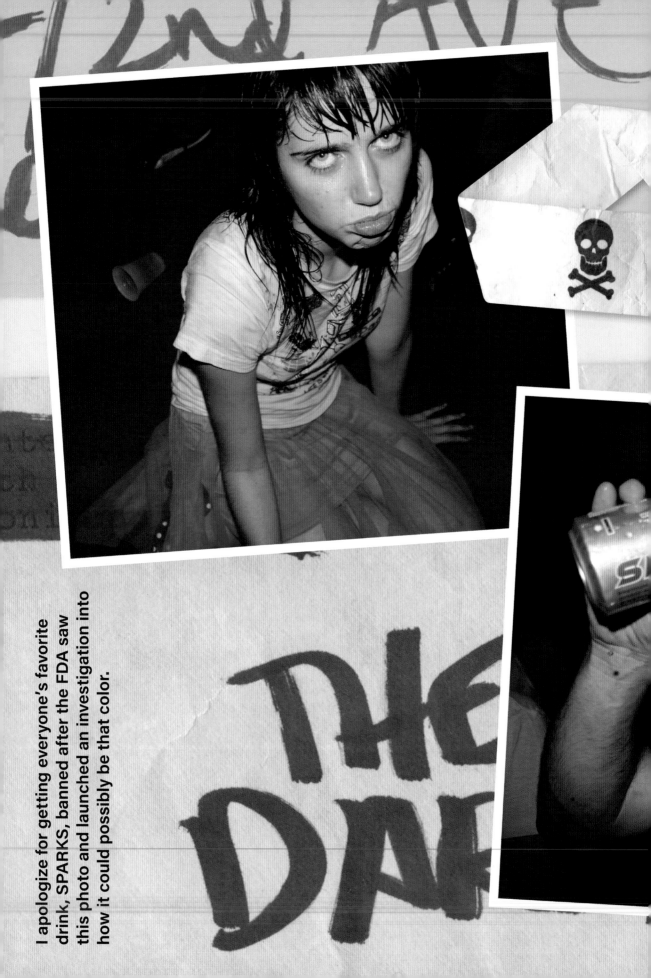

I apologize for getting everyone's favorite drink, SPARKS, banned after the FDA saw this photo and launched an investigation into how it could possibly be that color.

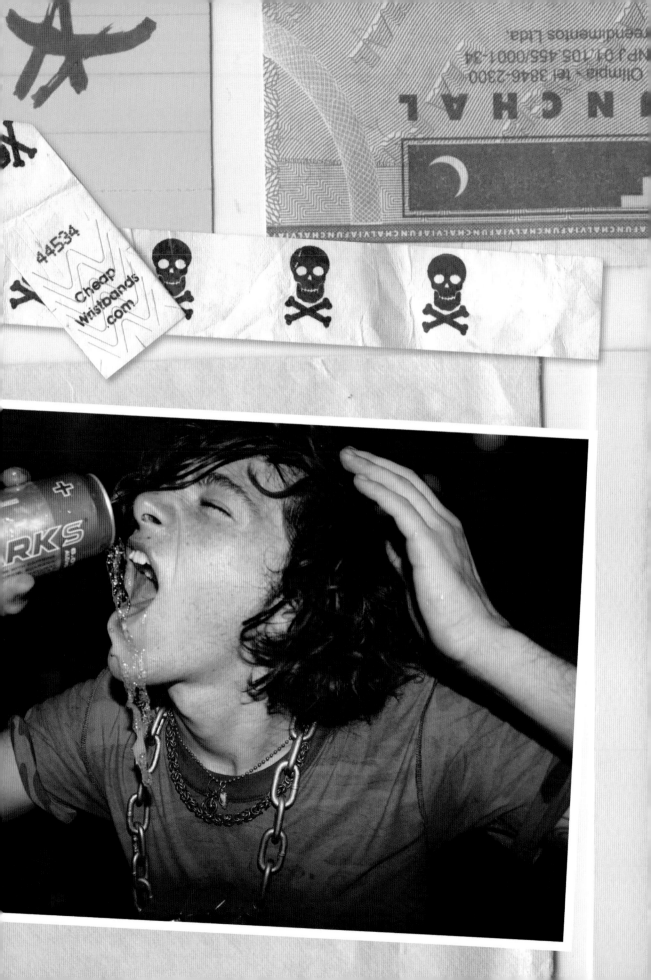

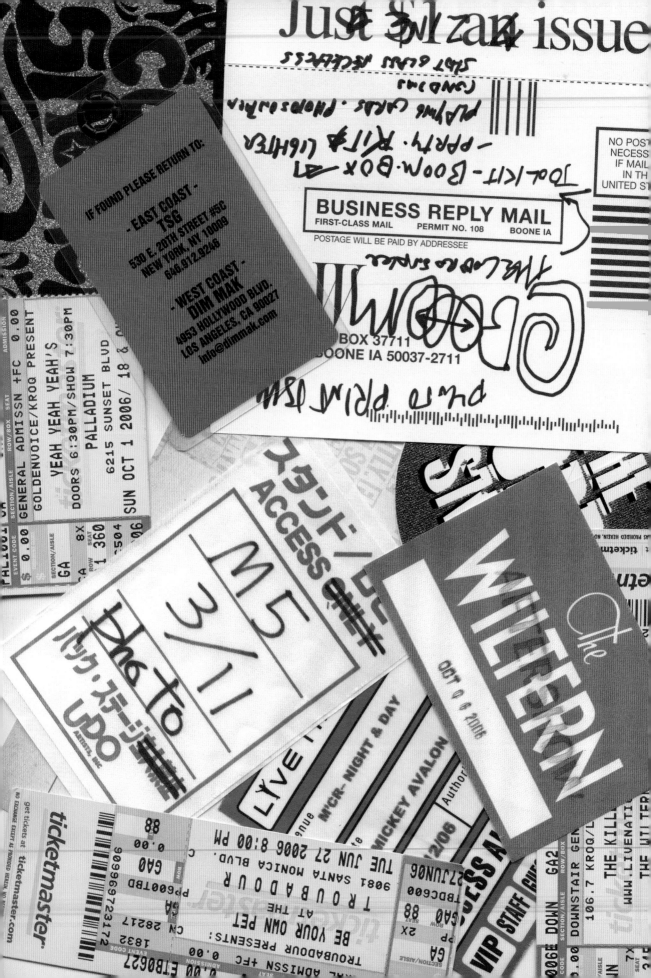

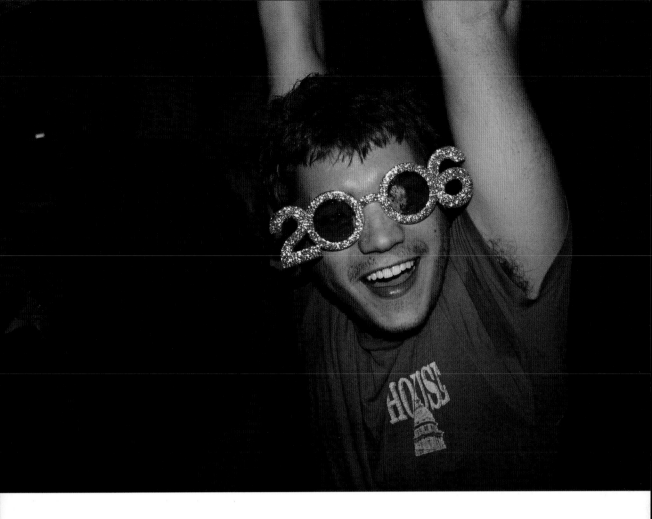

EMILE HIRSCH, New Year's Eve, 2006.
For the COBRASNAKE, every day was New Year's, and
the craziest parties would happen on a random Tuesday.

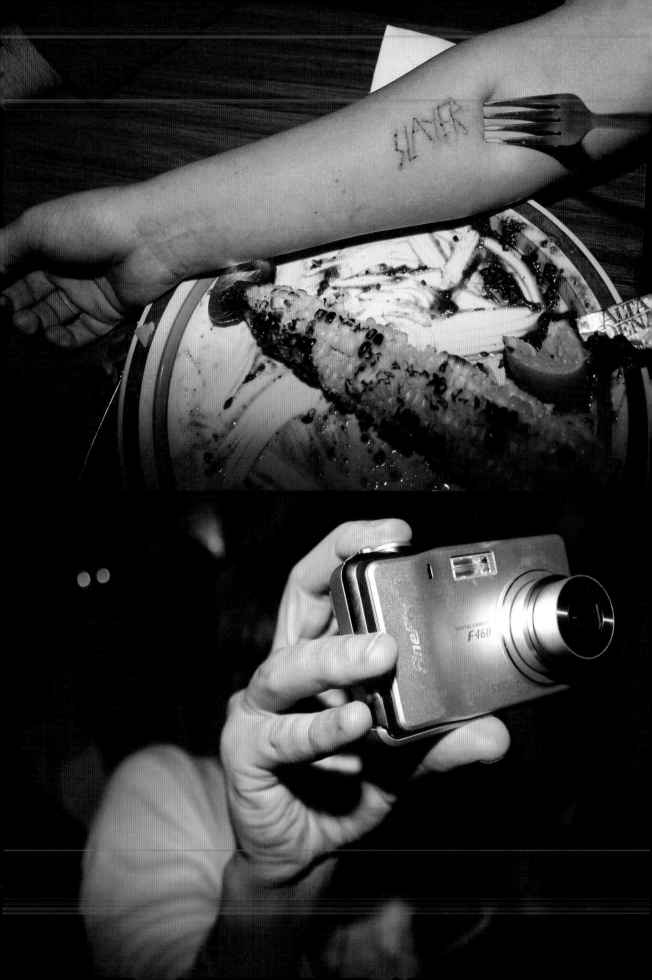

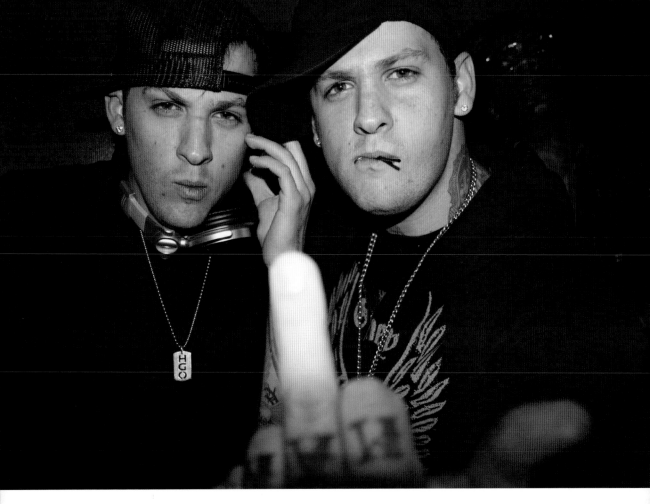

Late night street corn, DIY body modification, 5-megapixel digital cameras, and being aggressively mean-mugged by GOOD CHARLOTTE. Everything you need to become the most influential photo blog of all time.

My friends BLACK BLACK BLACK getting bloody before a show at THE ECHO. LA, 2006.

What makes nightlife photography so extraordinary is that the moments are so fleeting. You don't need a cheap special effect, the ephemeralness is special enough... Actually nevermind, you need lots of fake blood.

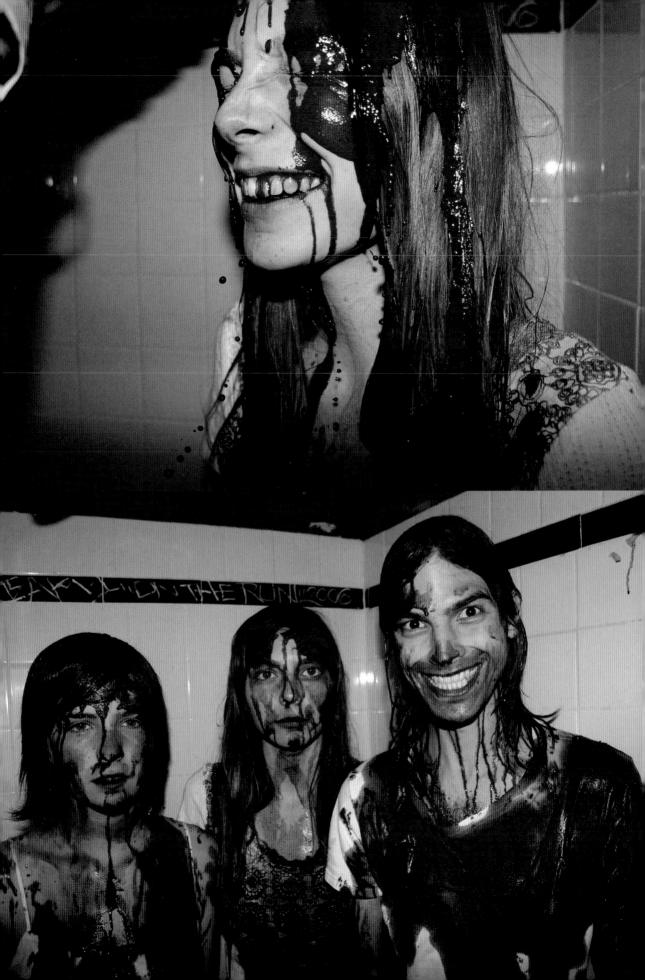

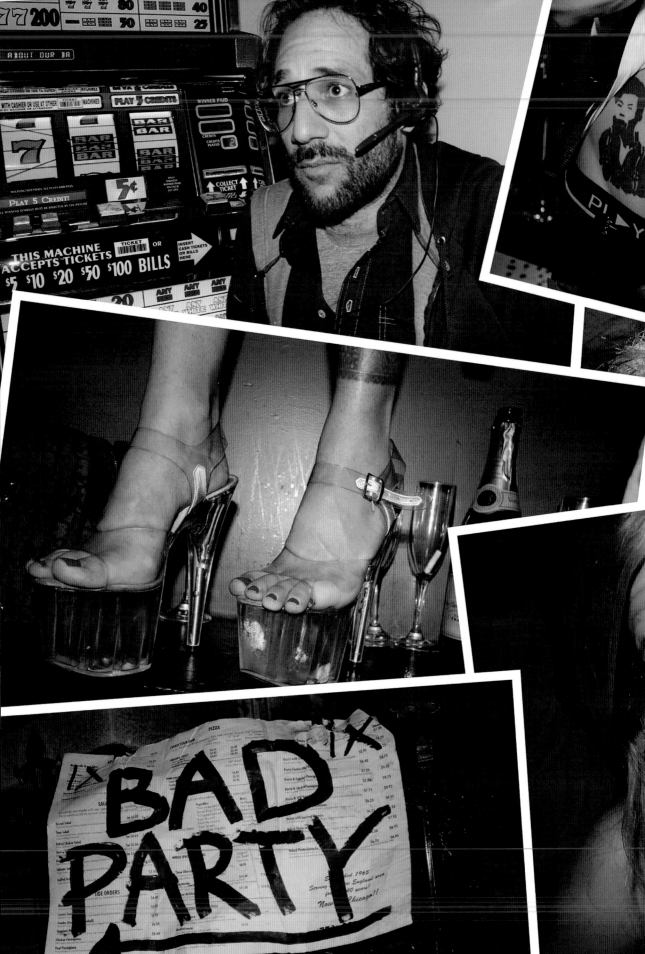

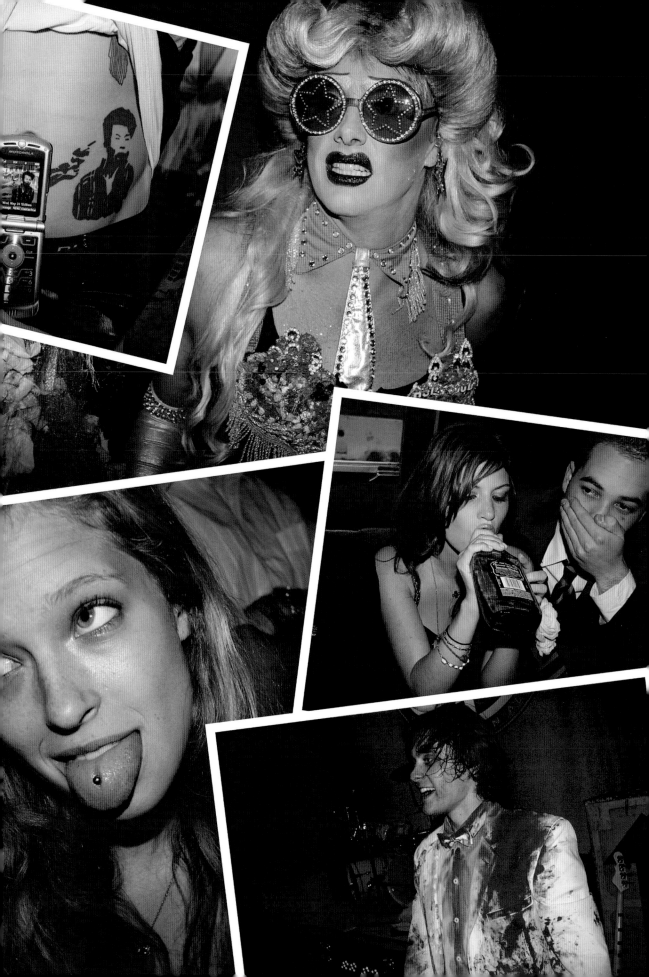

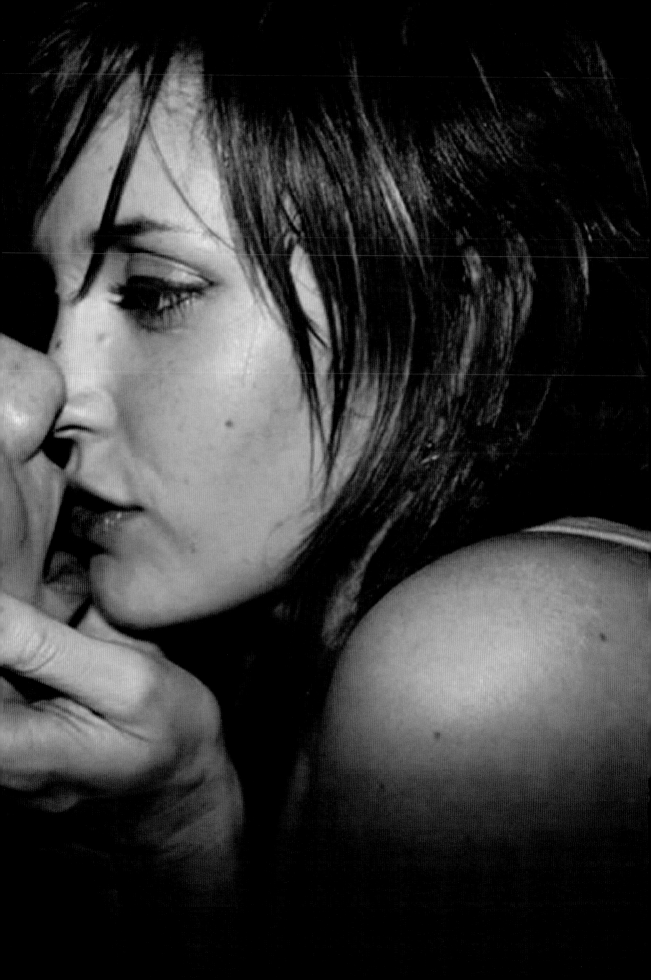

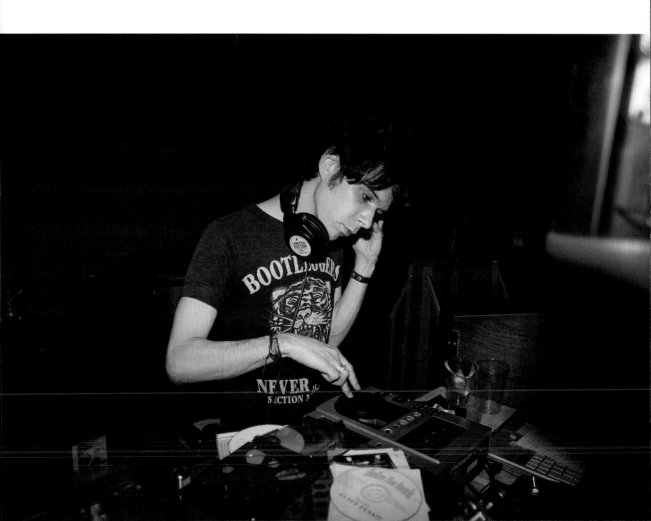

MIKKI BLANCO at a CHICAGO house party—
impeccable blouse game from the jump. CHICAGO, 2006

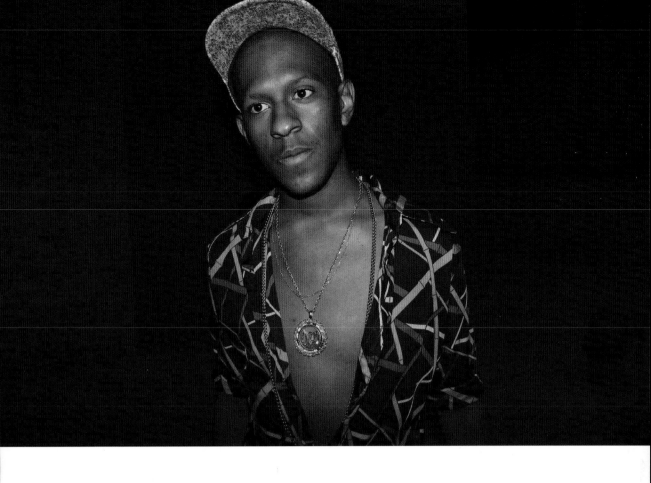

All the bands were becoming DJs back in those days.
NICK ZINNER DJ set. LA, 2006

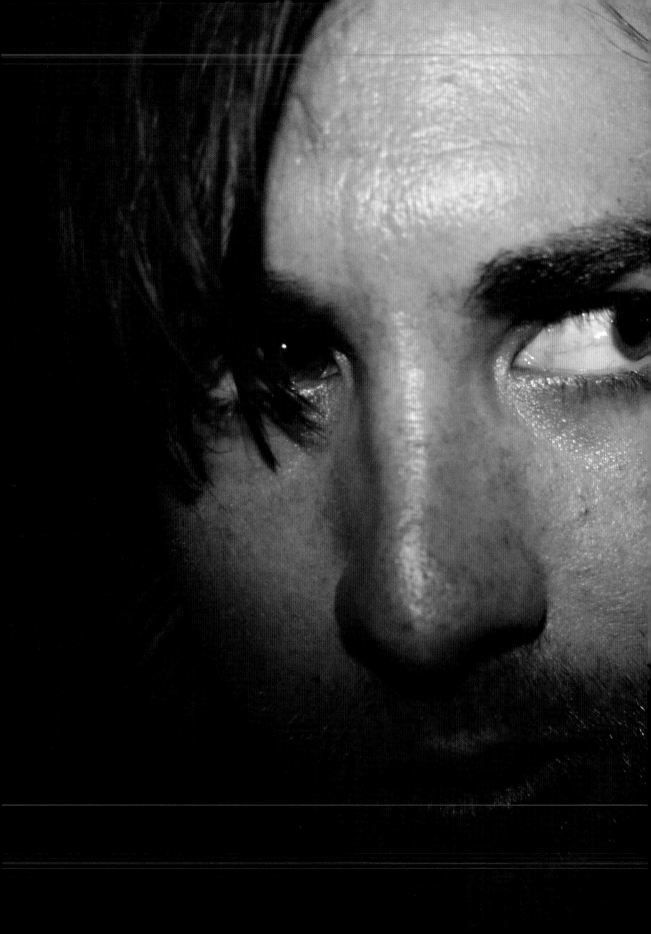

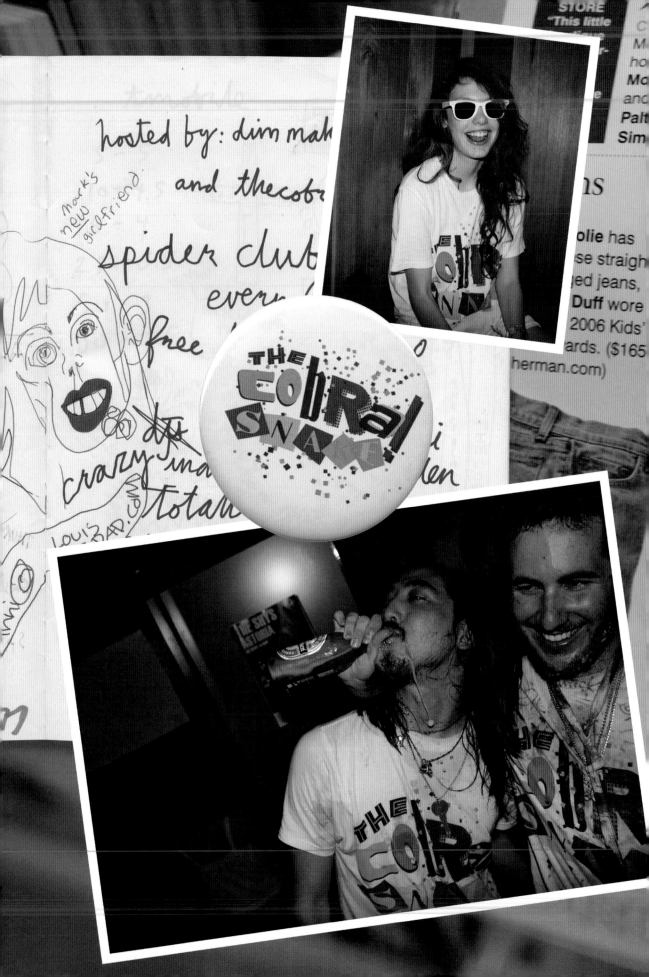

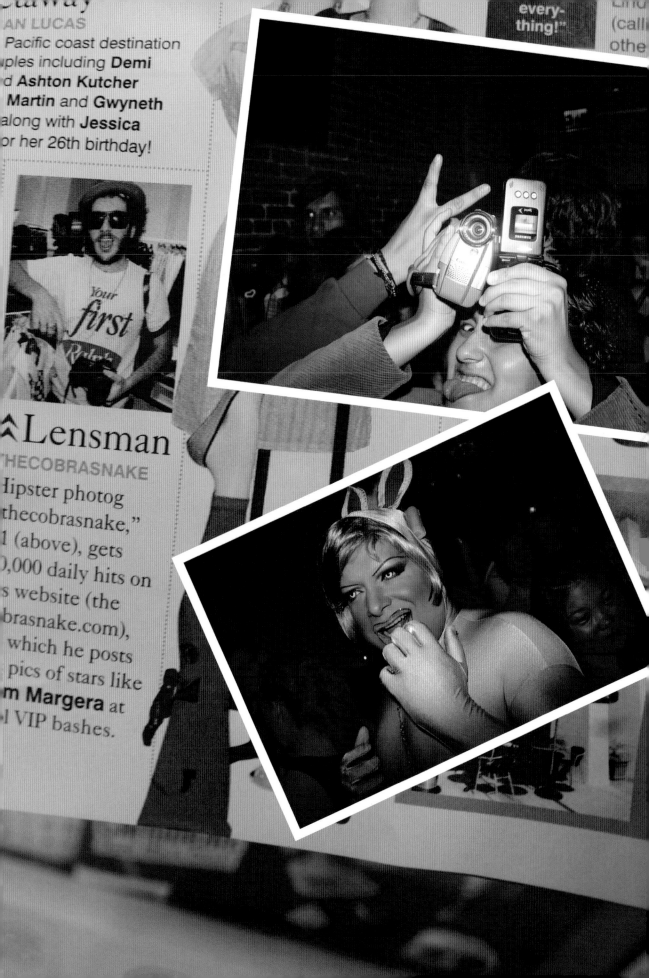

AN LUCAS

Pacific coast destination
uples including **Demi**
d **Ashton Kutcher**
Martin and **Gwyneth**
along with **Jessica**
or her 26th birthday!

⌃Lensman

THECOBRASNAKE

lipster photog
thecobrasnake,"
l (above), gets
0,000 daily hits on
s website (the
brasnake.com),
which he posts
pics of stars like
m Margera at
l VIP bashes.

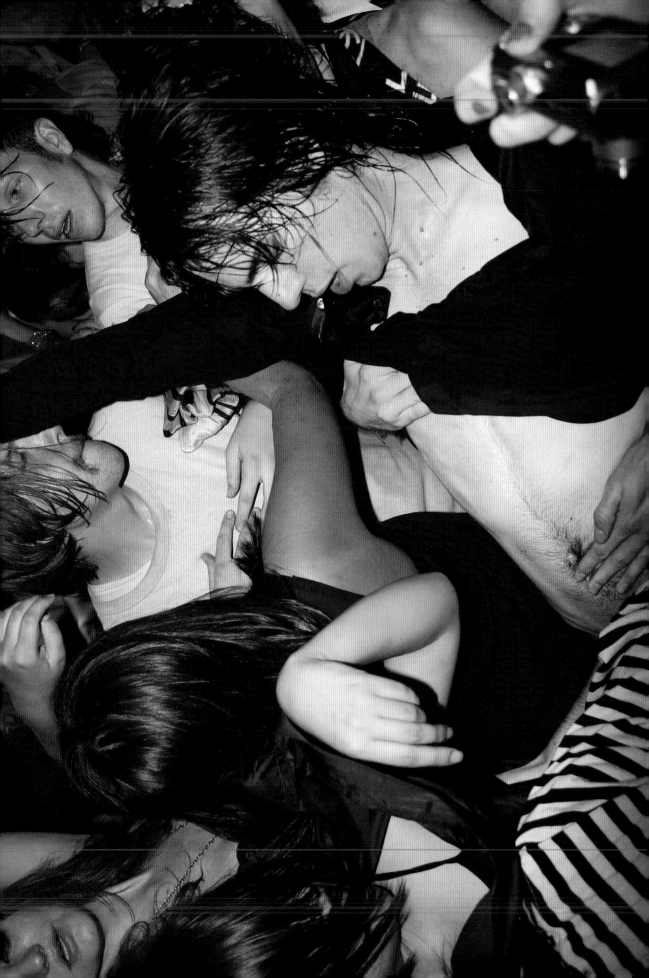

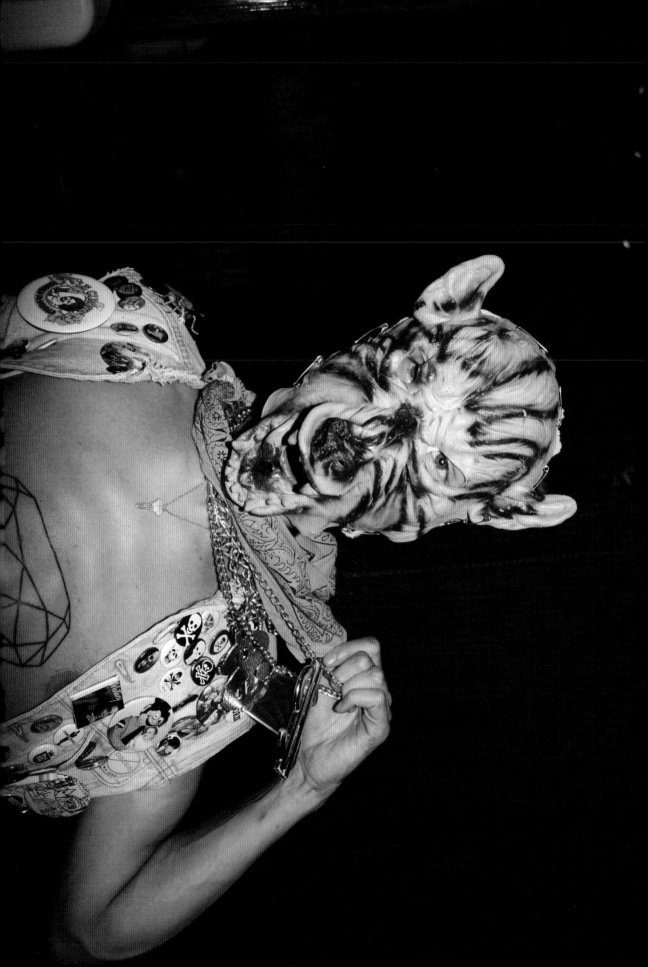

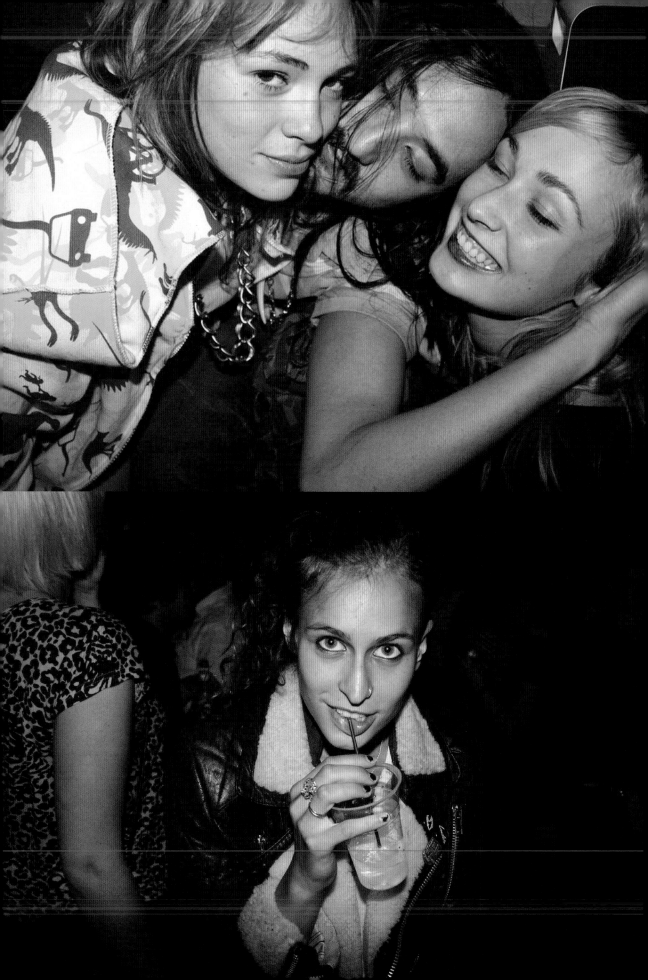

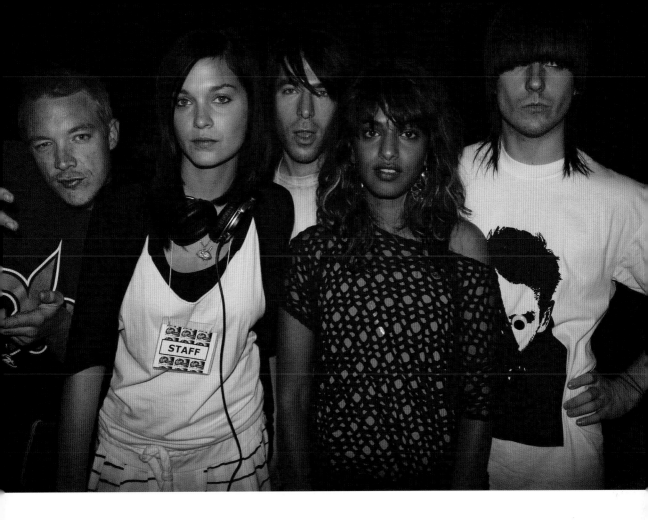

Snapshots from the rise of bloghouse. I was the blog, STEVE was the house.
UFFIE and DORA with STEVE, and DIPLO with MIA and MISSHAPES.
NYC, 2006

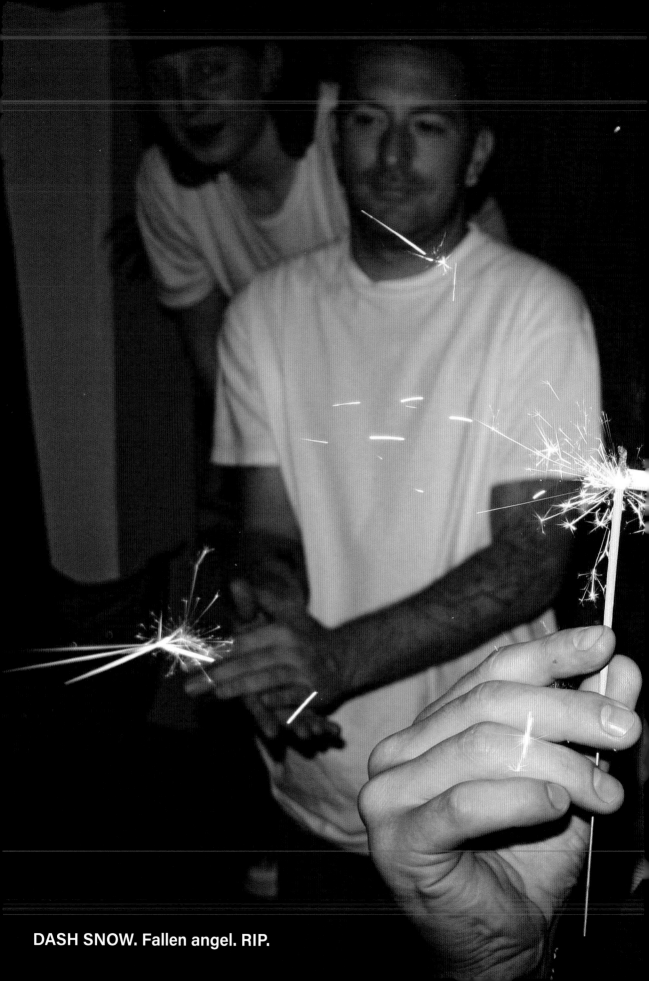

DASH SNOW. Fallen angel. RIP.

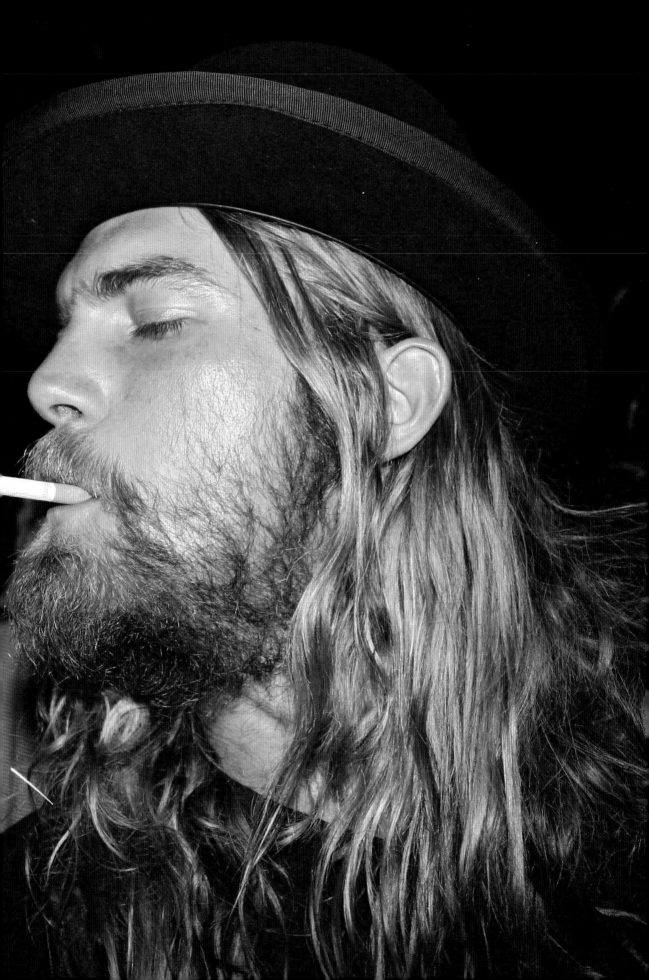

MARLON and REBECCA.

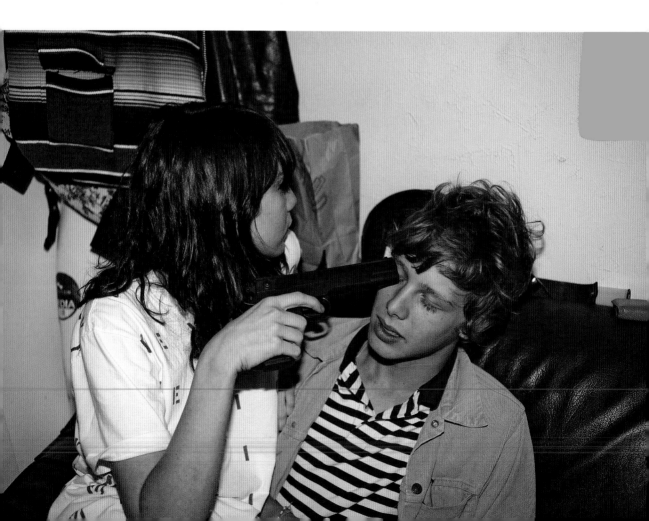

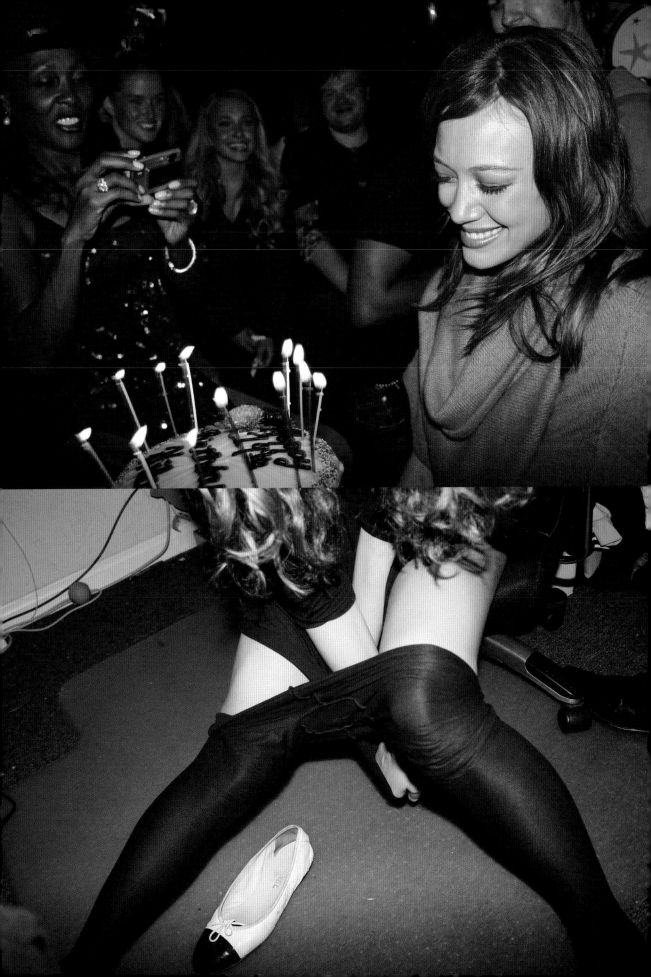

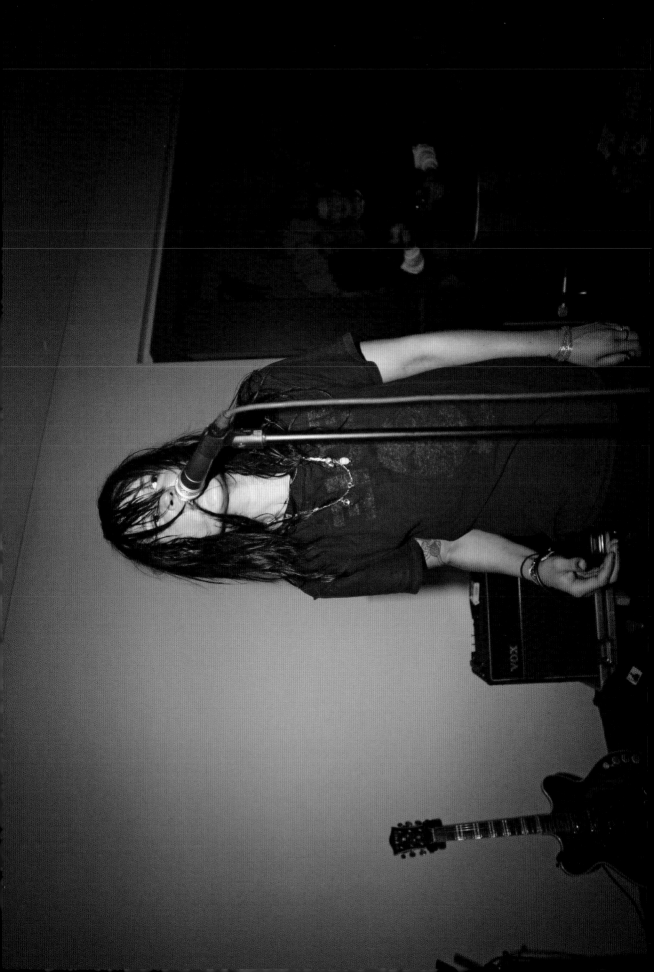

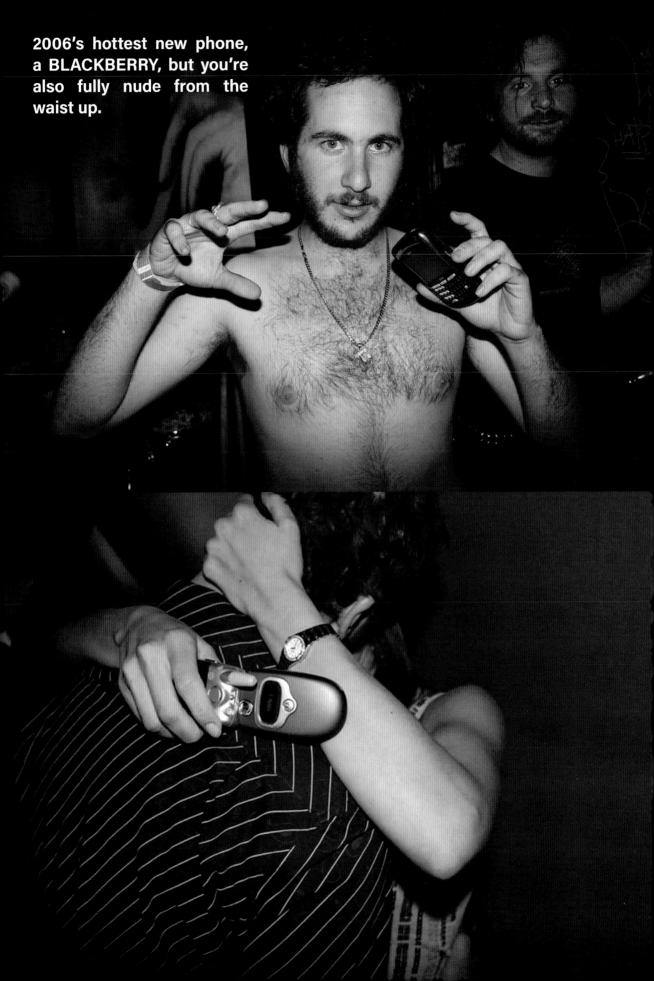

2006's hottest new phone, a **BLACKBERRY**, but you're also fully nude from the waist up.

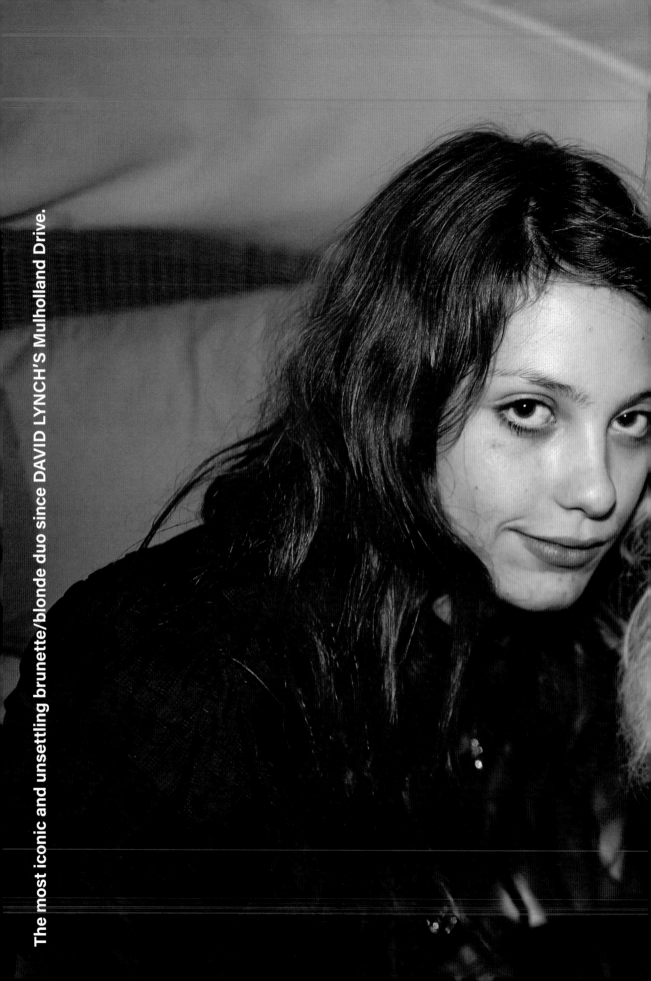

The most iconic and unsettling brunette/blonde duo since DAVID LYNCH'S Mulholland Drive.

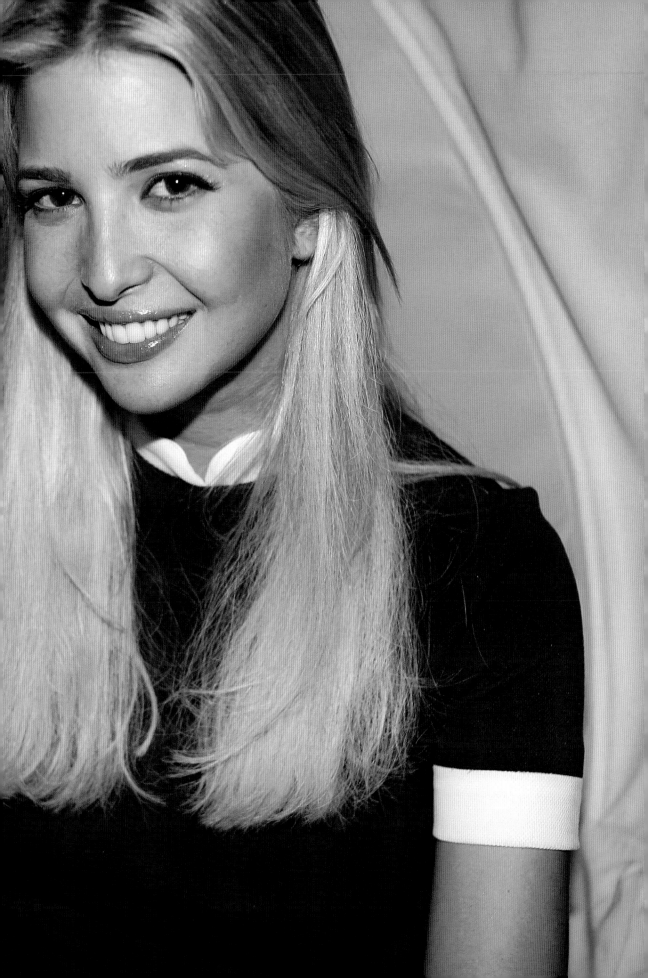

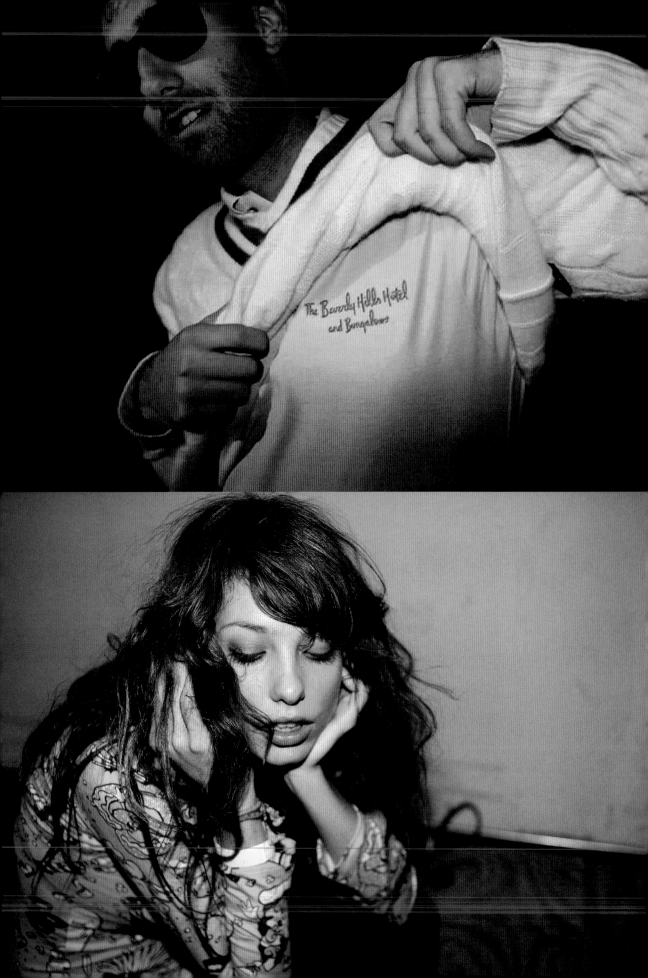

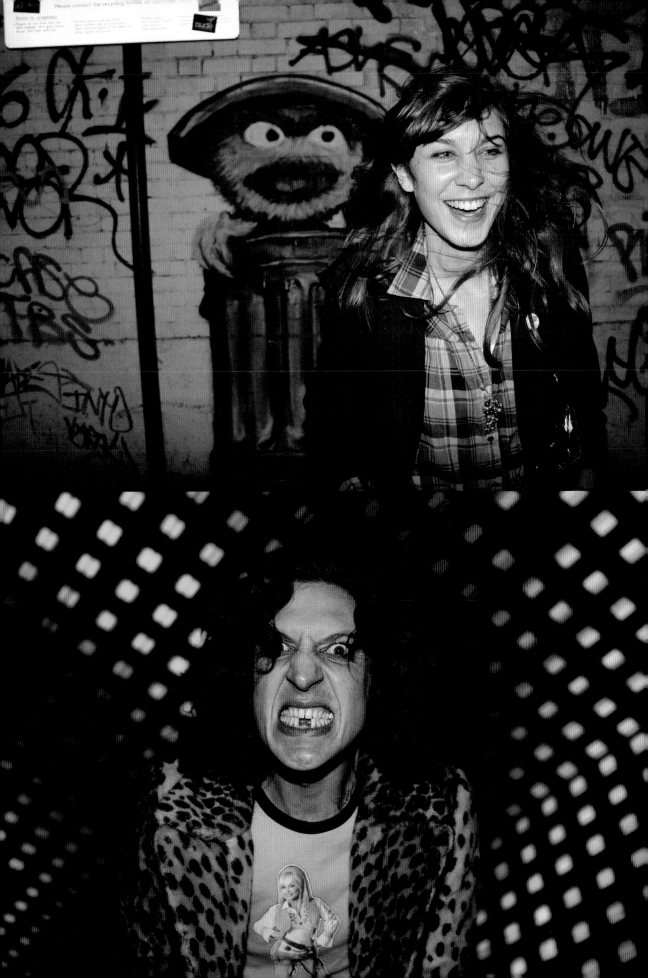

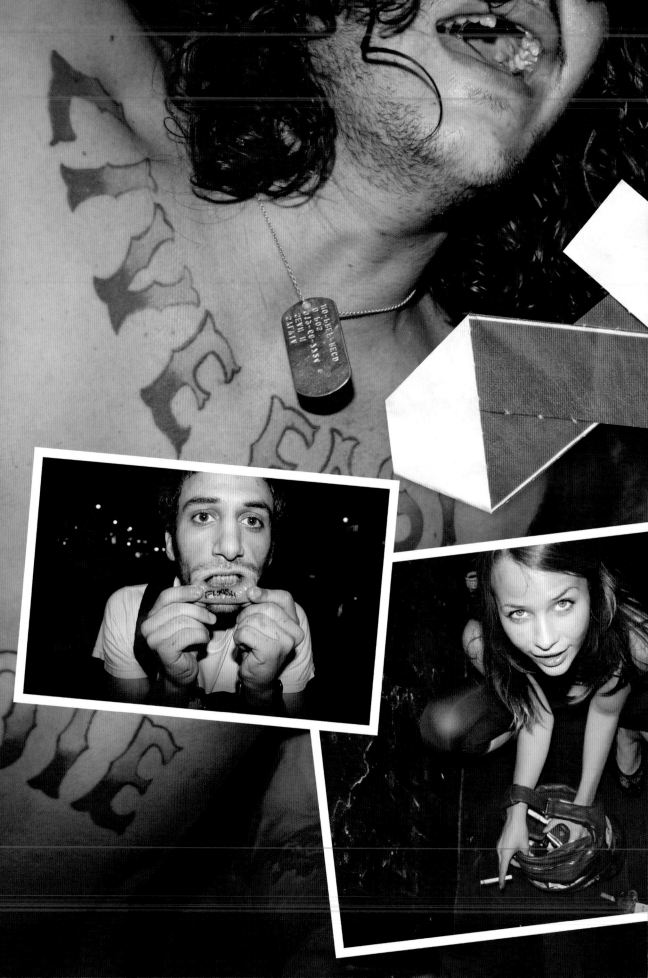

BLOC PARTY

il 6th 2hrs
moon 125=
soft drink
rgie
0 866 4110

26756

FLASH

138

ARCA!
THE L
SHOUT
MEA
IARN
HAN
OONEY

enture
enture team
email
email action
merch
vending machine

promotion
party photos

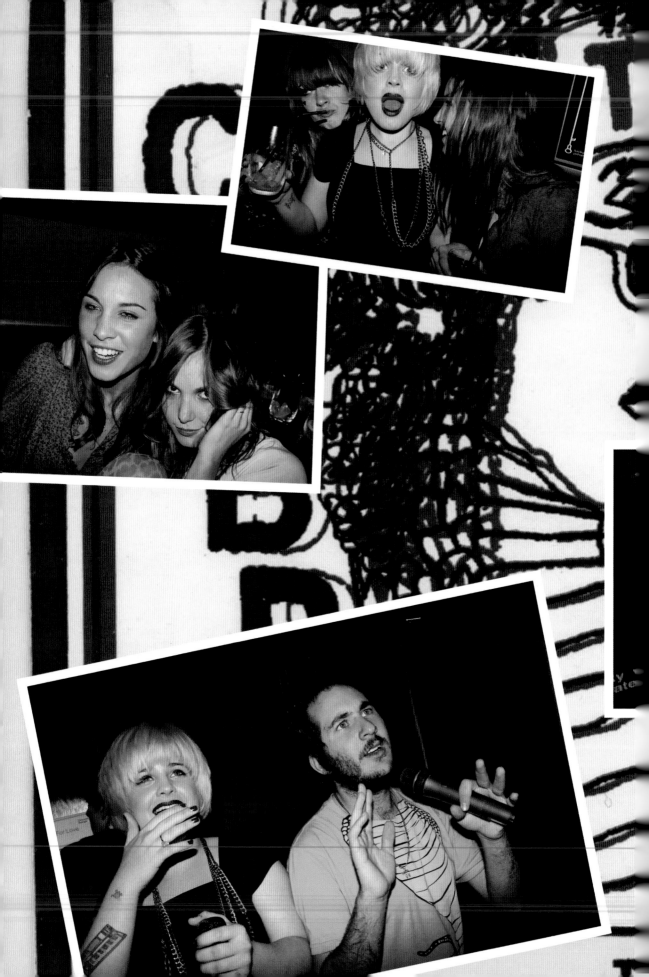

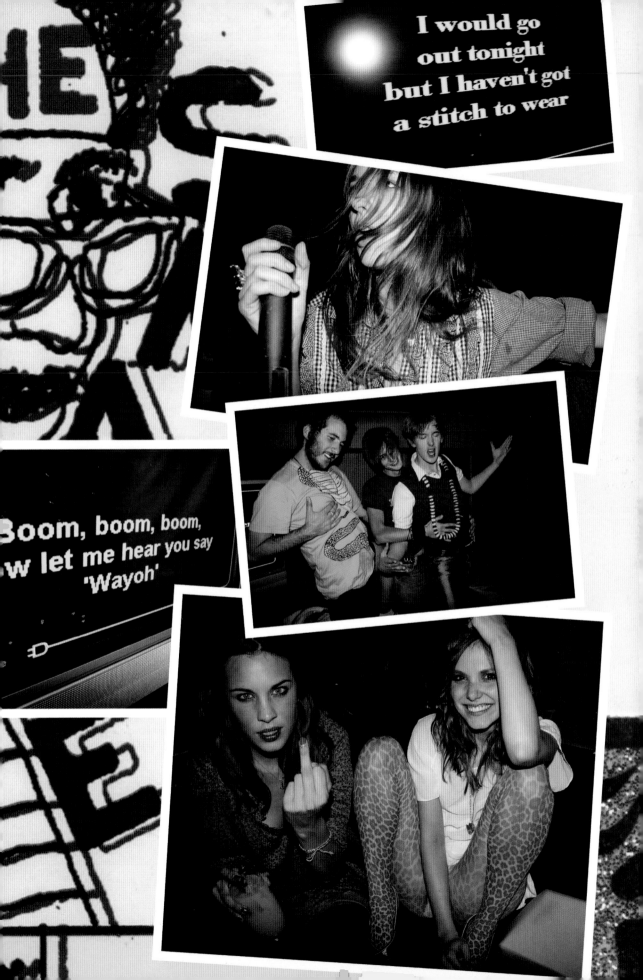

I would go
out tonight
but I haven't got
a stitch to wear

Boom, boom, boom,
w let me hear you say
'Wayoh'

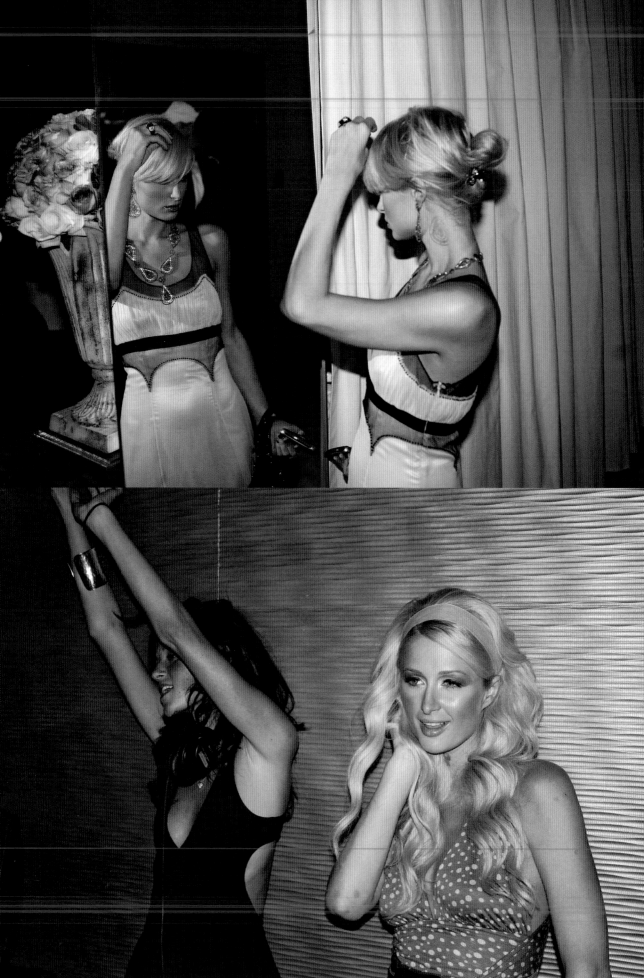

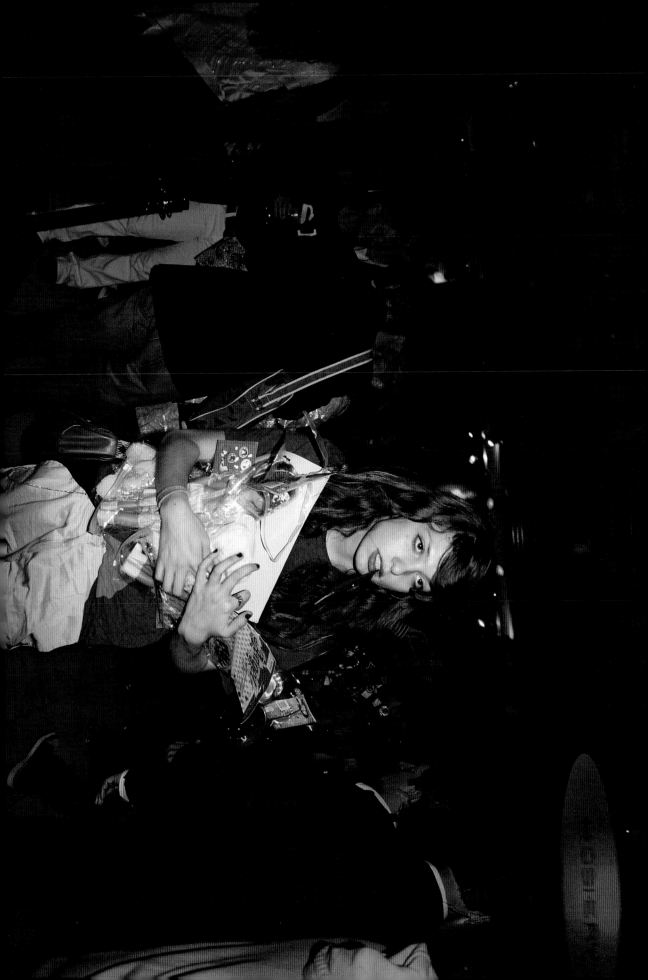

If she doesn't remember the stock image smiling phone answer guy on the T-MOBILE SIDEKICK, she's too young for you bro.

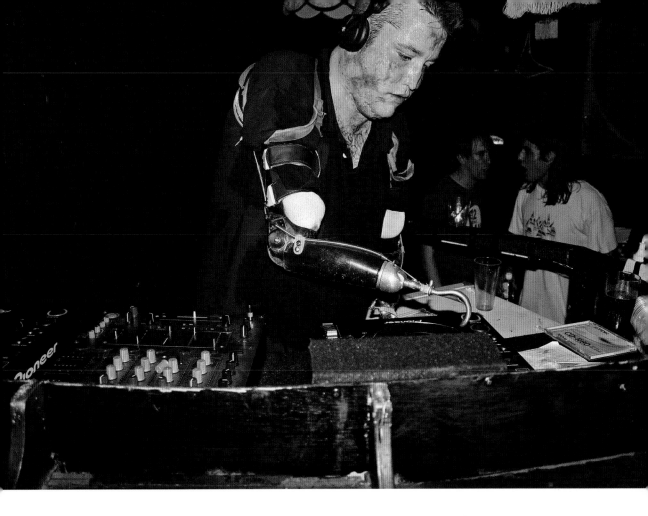

The legendary DJ HOOKIE, now an inspirational speaker, check him out!

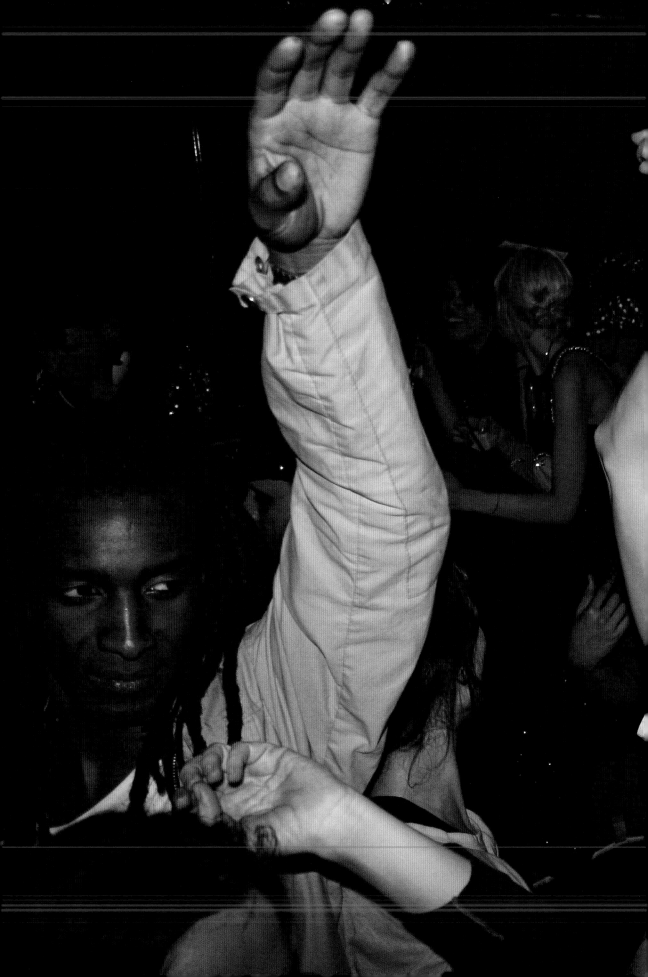

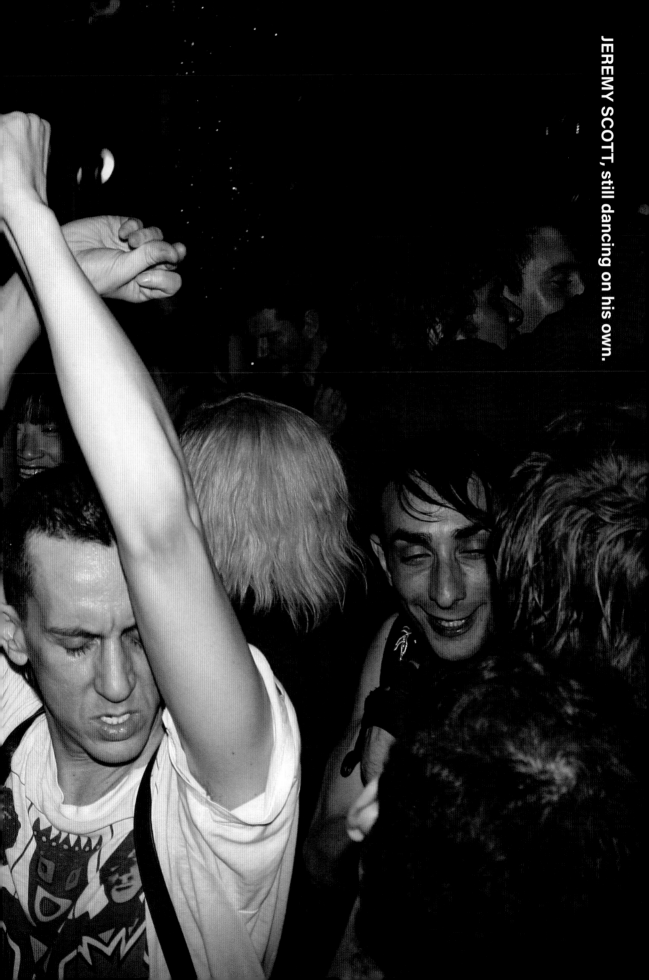

JEREMY SCOTT, still dancing on his own.

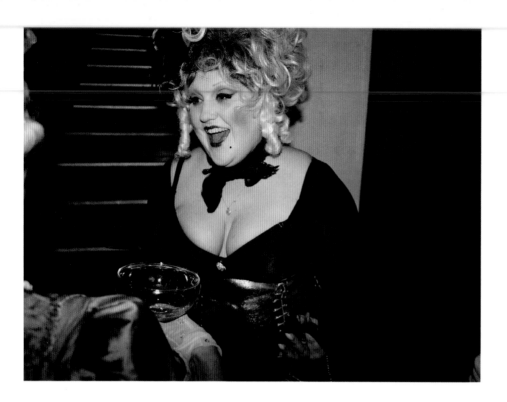

BETH DITTO, fashion icon then and now.
Brit boy DEV HYNES aka BLOOD ORANGE crushing a
classic plate of late-night fries... err, chips.

THIS MOVIE IS RATED "R" NOBODY UNDER 17 1
WITHOUT A ~~HARD~~ BE LET IN. OK.

+ SEXUAL SITUATIONS

THE

UP

ABOUT

AND

STORY

MARK

TH~~O~~

T~~I~~

WHERE THE FUCK IS
MY IPOD
BY MARK

AUGUST 7

BANG ~~ING~~

2007's hottest new phone, a MOTOROLA RAZR covered with a quarter pound of blingy stickers.

Super sweet moment with SO ME at CINESPACE during the peak of KANYE's infatuation with ED BANGER.

We really liked colorful all-over-print hoodies back then, what can I say?

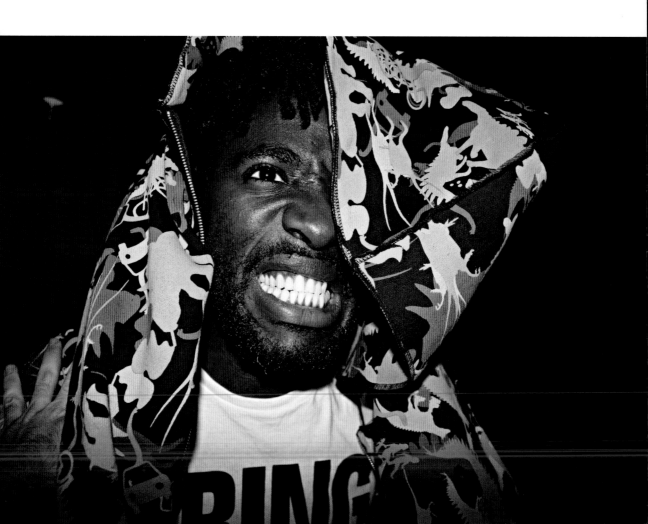

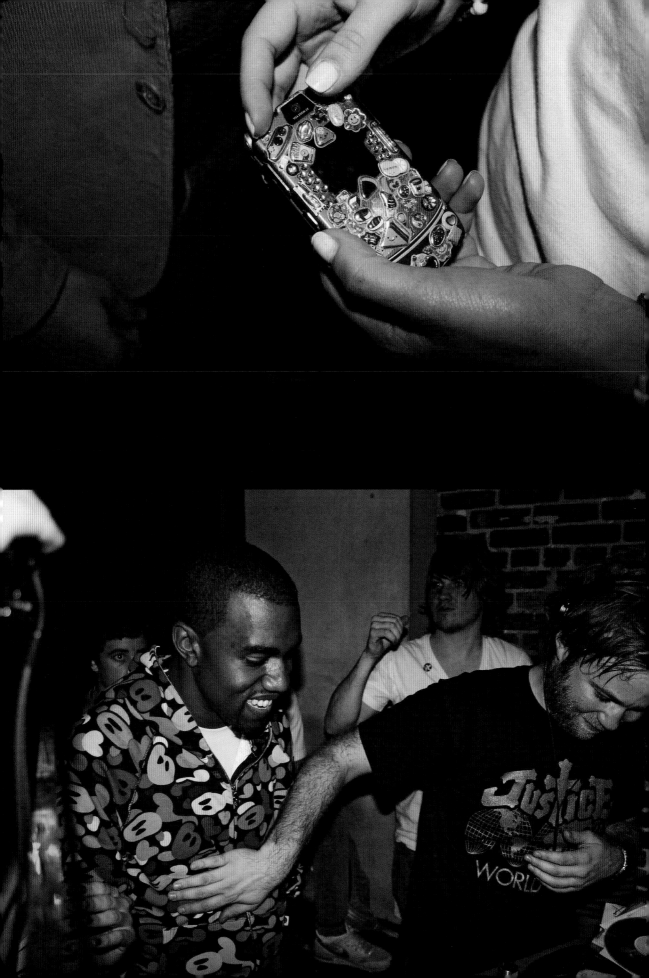

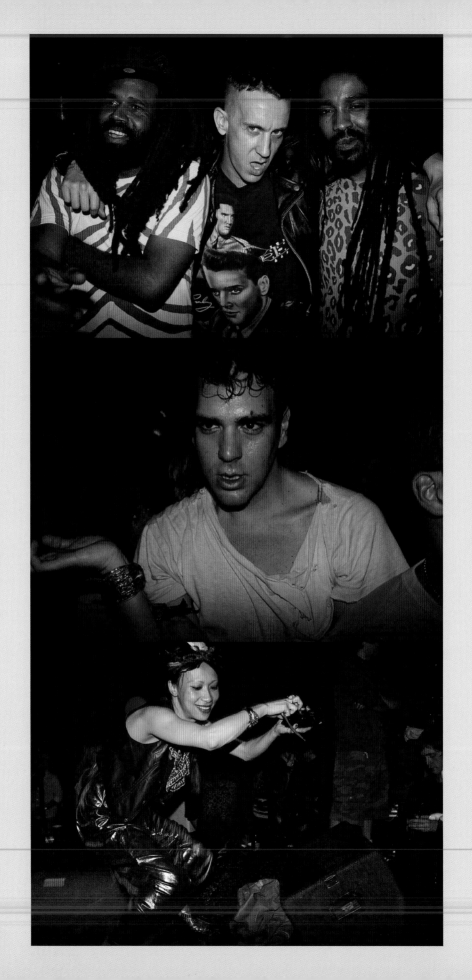

Slices of life at
an OPENING CEREMONY
party. NYC, 2007.

JEREMY SCOTT with ROCKERS NYC
and EZRA WOODS, NYC. The mix of
different scenes and vibes at this time was
really electric, it felt like all the old divisions
between high-school lunch tables were
breaking down and the punks were
hanging with the theater kids, the
goths were at the hip-hop parties.
Magical.

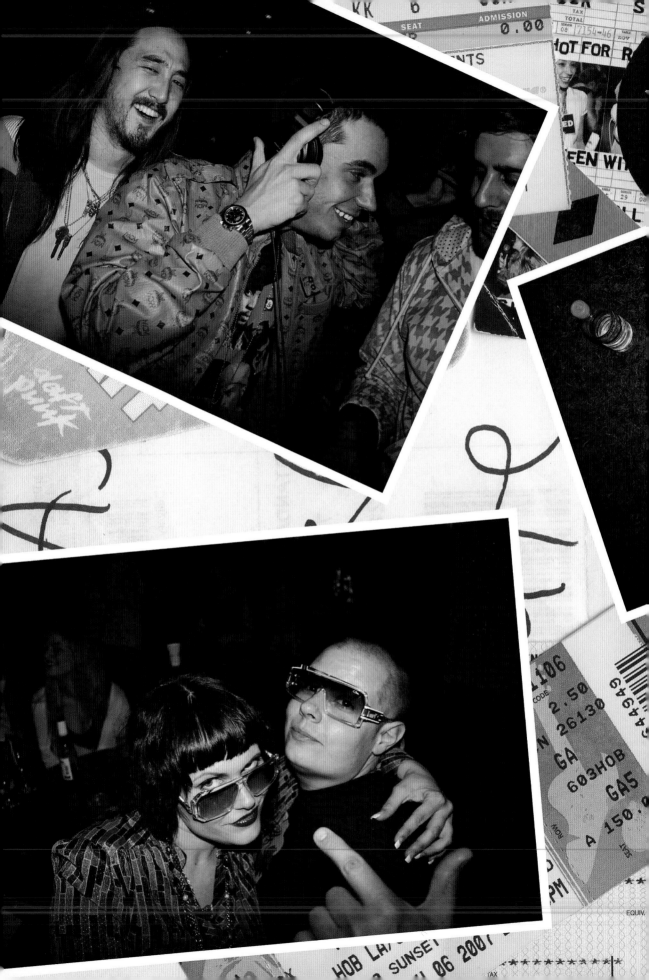

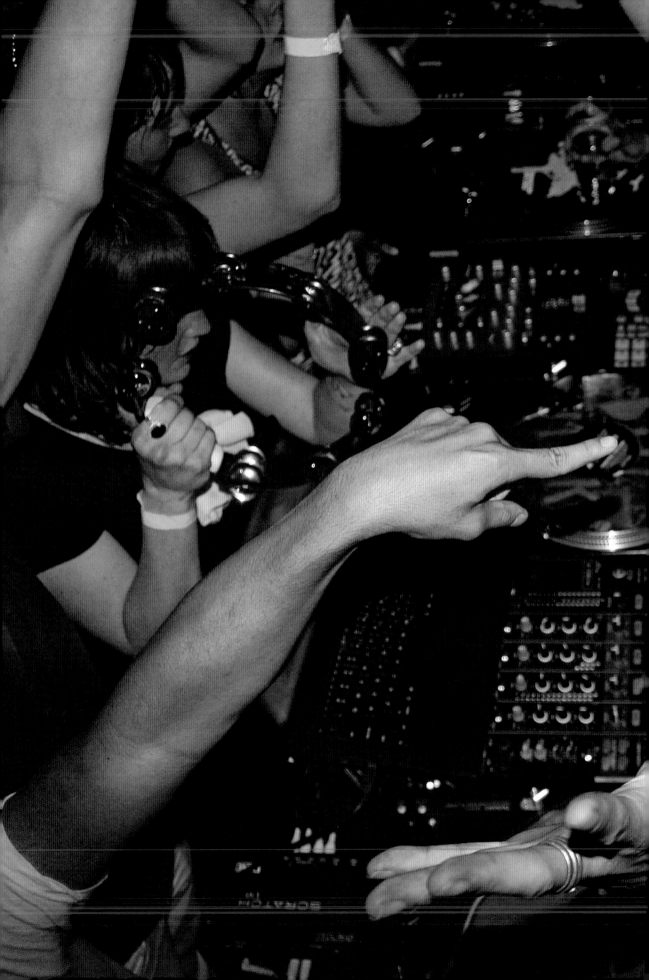

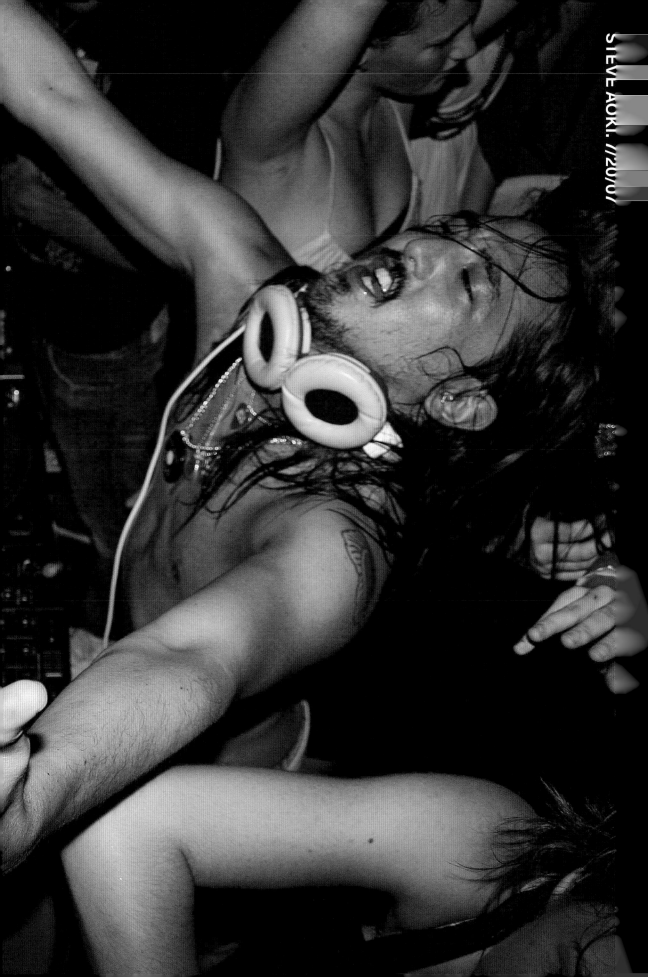
STEVE AOKI. 11/20/01

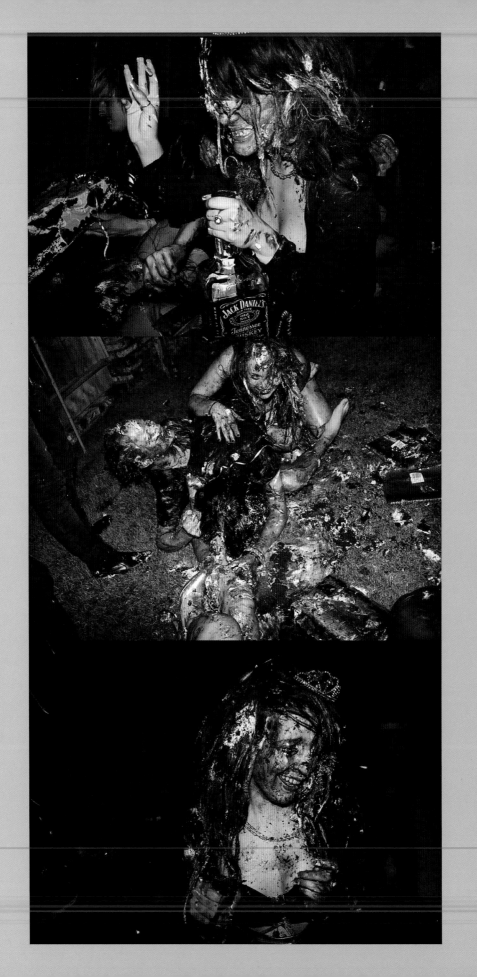

I think people loved my website not only for the celebrities and cool cultural figures, but also for the pics of random friends of mine who weren't famous, having a birthday party on a random night that turned into a giant cake fight.

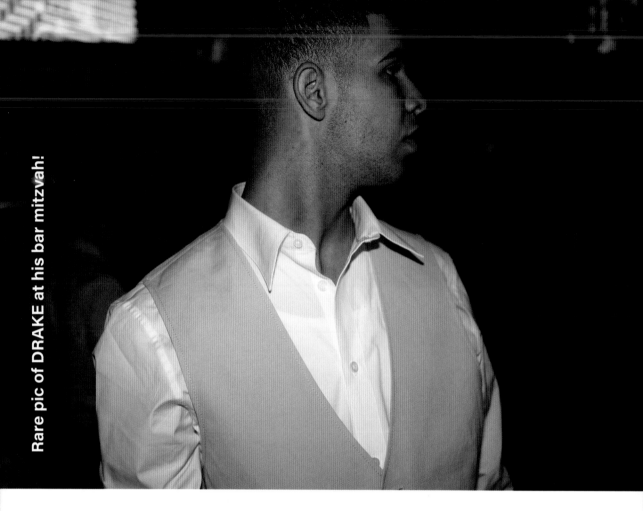

Rare pic of DRAKE at his bar mitzvah!

Rare pic of DIPLO before he was a fashion icon!
DIPLO if you're reading this I want my neon big text shirt back!

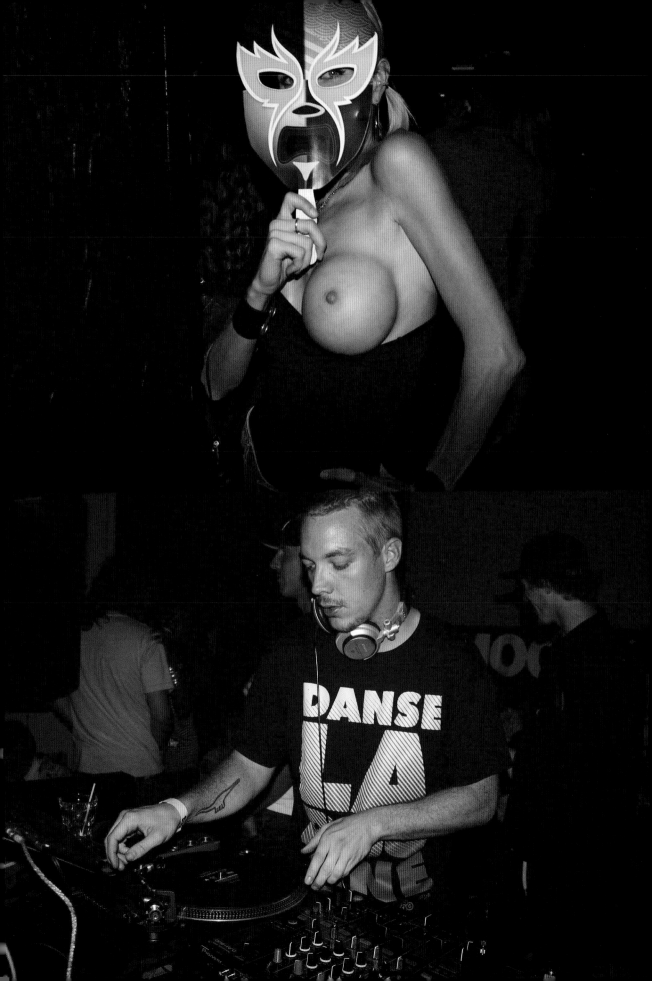

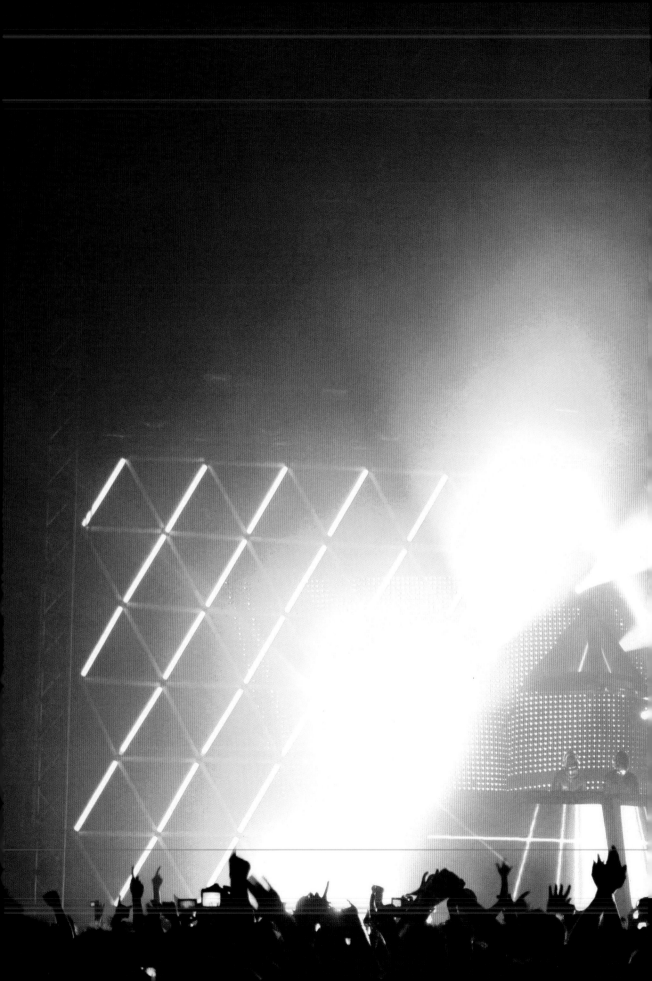

The DAFT PUNK pyramid, an iconic moment in millennial history. I tried to climb inside to get taken back to the DAFT PUNK robot planet, but they caught me when my "Who Let the Dogs Out?" ringtone went off.

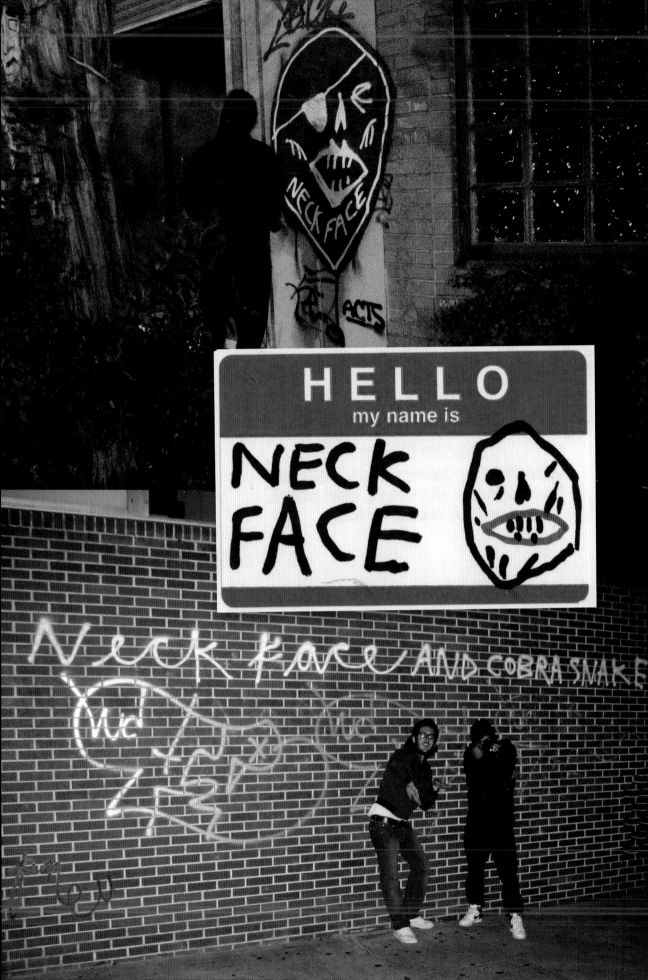

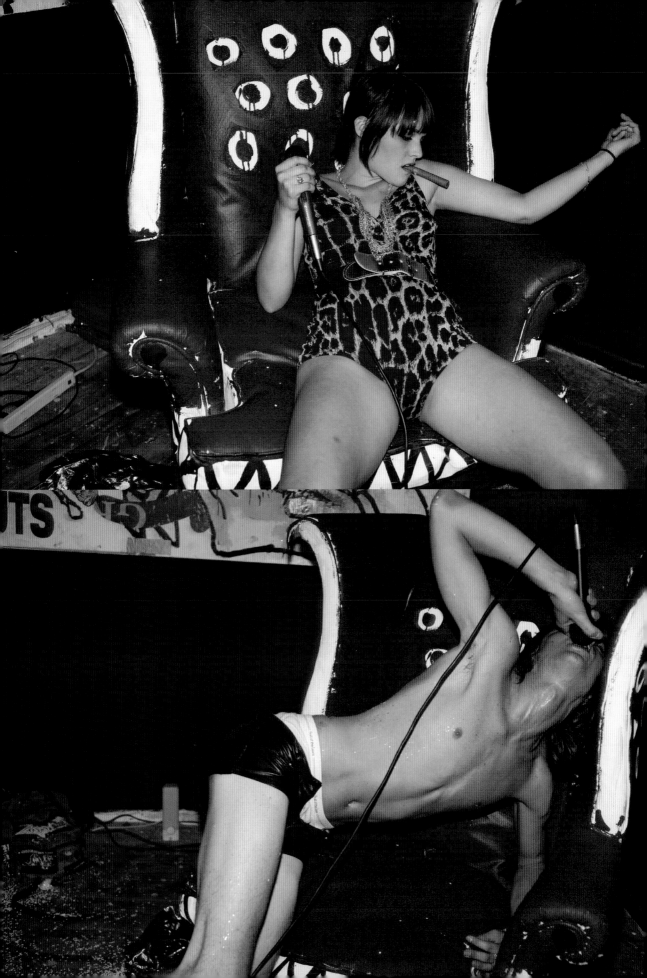

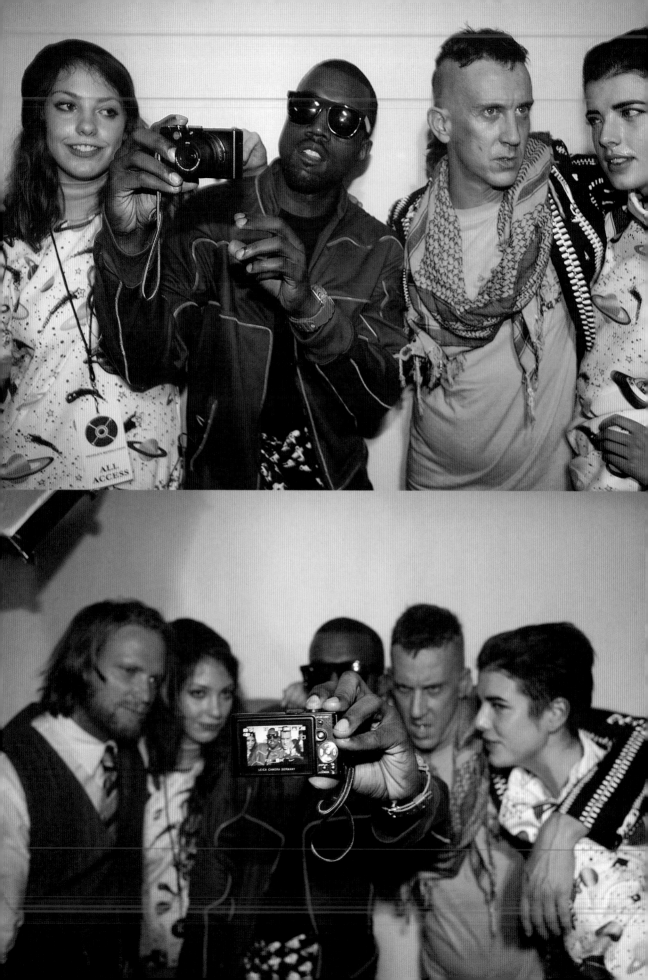

CORY, KANYE, JEREMY, AGNYSS, and GEORGE. The
COBRASNAKE Mount Rushmore, backstage at the
JEREMY SCOTT show. PARIS, 2007.

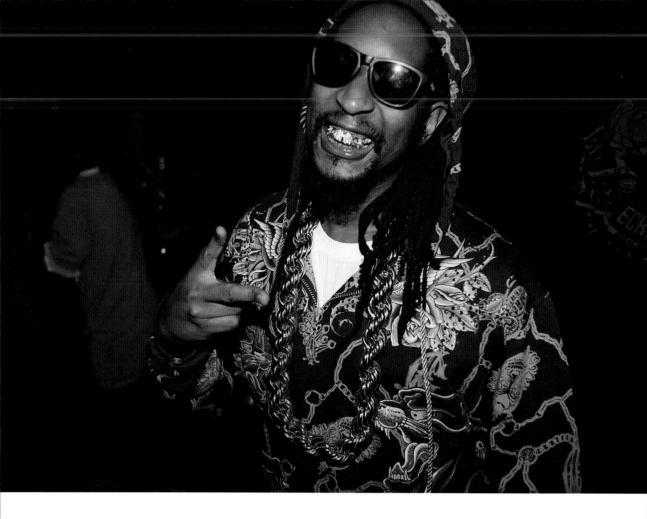

LIL JOHN. A purple ED HARDY hoody never looked better, and probably never should've been worn by anyone else at any other time. NYC, 2007

Cobra handstyles.

thecobrasnake
thecobrasnake
thecobrasnake
thecobrasnake
thecobrasnake
thecobrasnake
thecobrasnake
thecobrasnake
thecobrasnake
thecobrasnake
thecobrasnake
thecobrasnake
thecobrasnake
thecobrasnake

PEACHES teaches you how to rock a glorious leotard.

BROKEN Magic shoelace bites
eyes patches

GUEST CHECK

4 | A7 | Q | 713

TER
WEBSITE ON II

HAPPY BIRTHDAY
DRASNAKE

Around the world with
the ED BANGER crew.

lcd soundsystem

FAT MAN

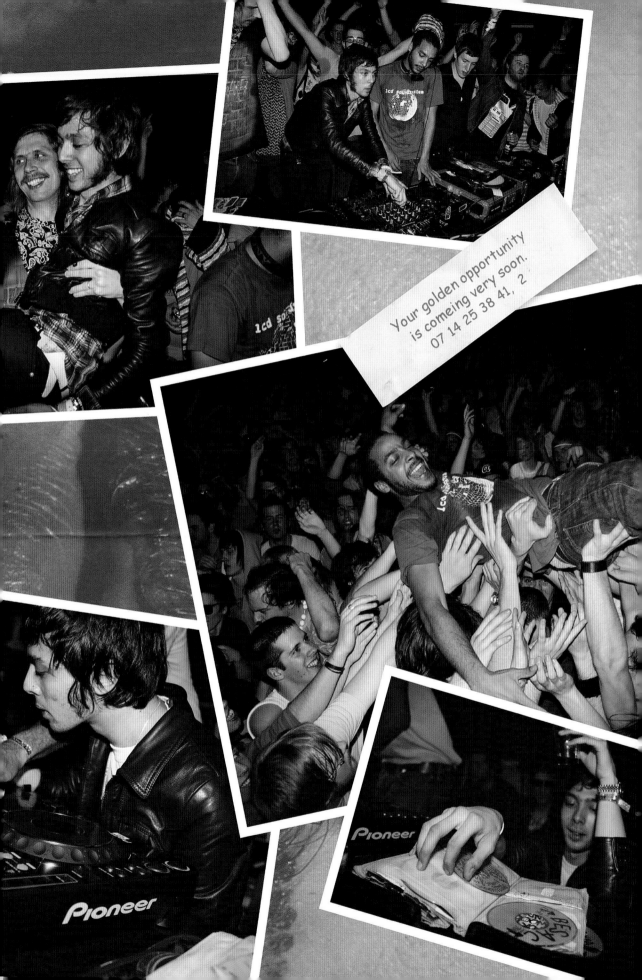

Your golden opportunity is comeing very soon.
07 14 25 38 41, 2

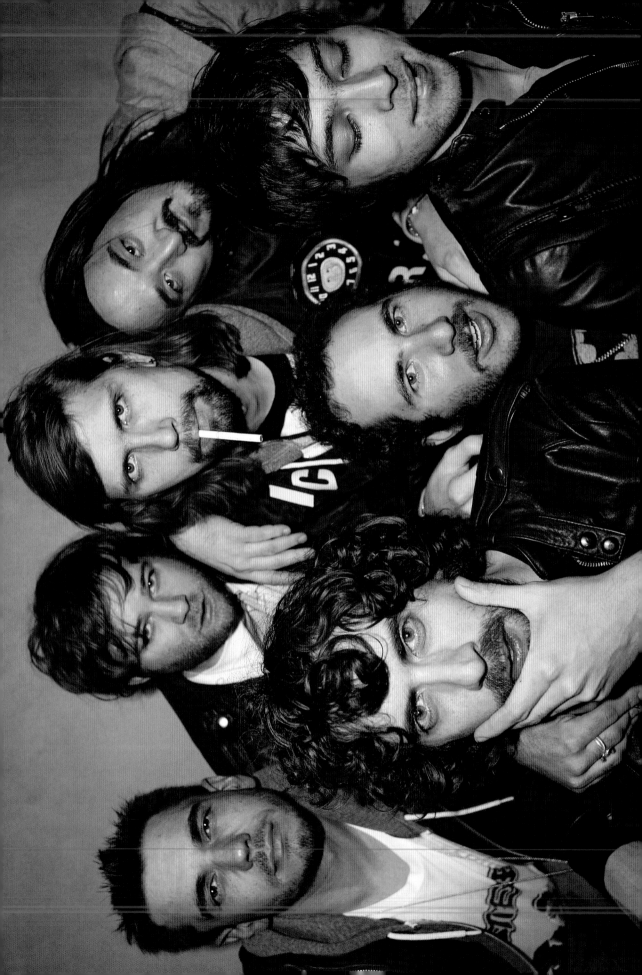

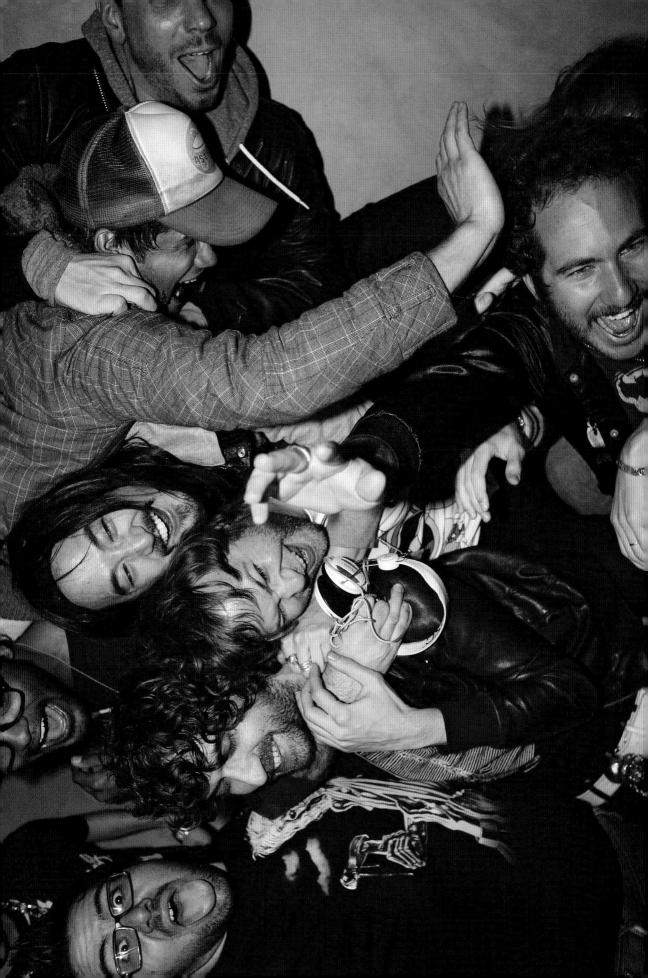

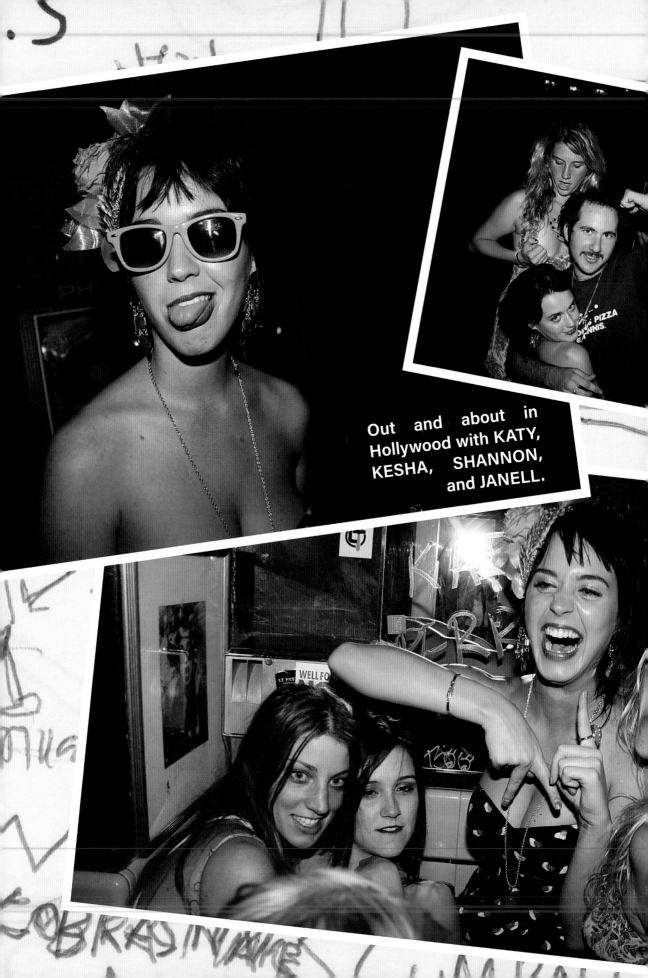

Out and about in Hollywood with KATY, KESHA, SHANNON, and JANELL.

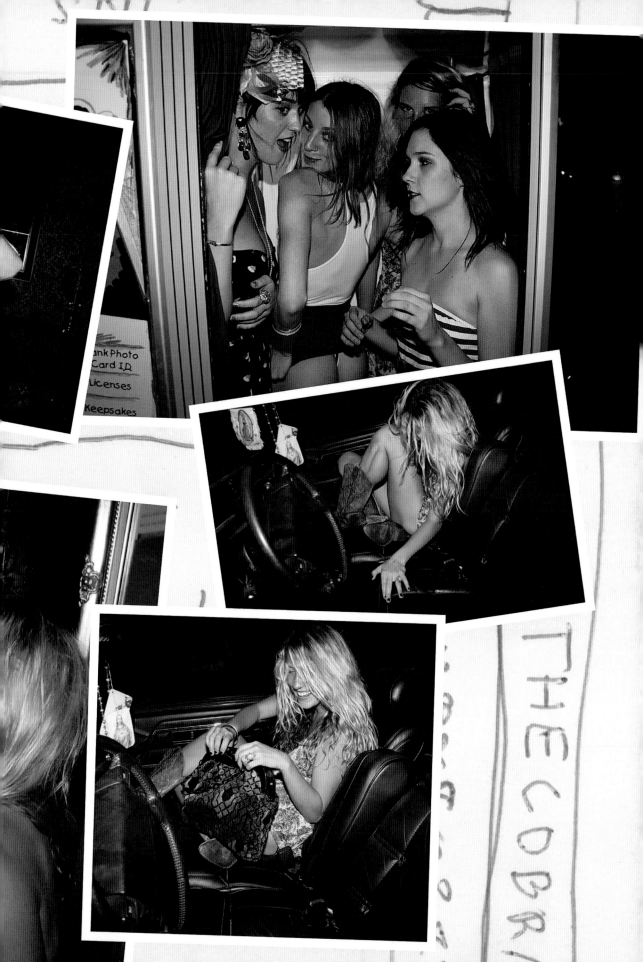

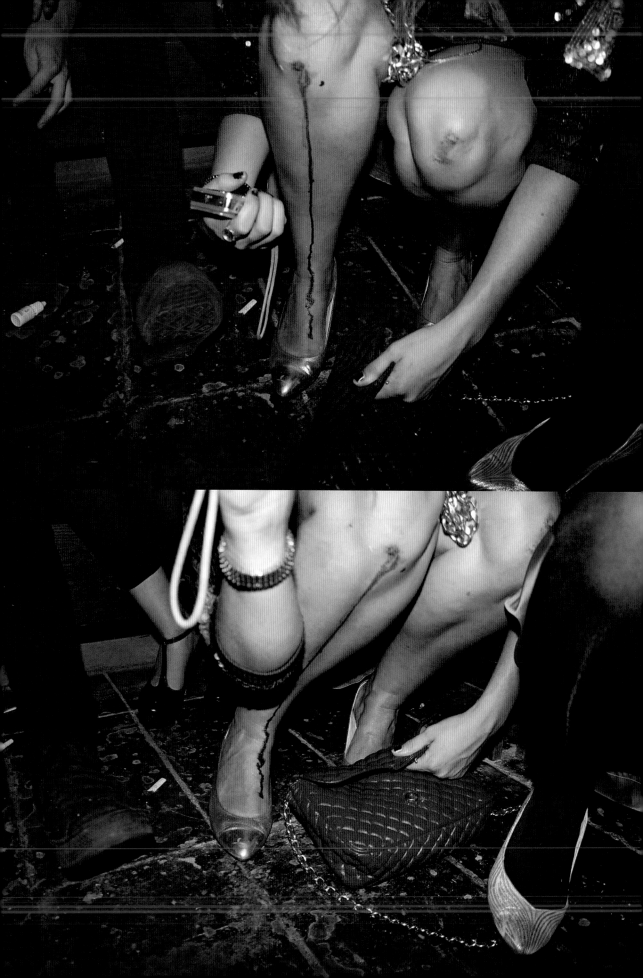

COBRA sez: always accessorize your vintage handbag to your open wound.

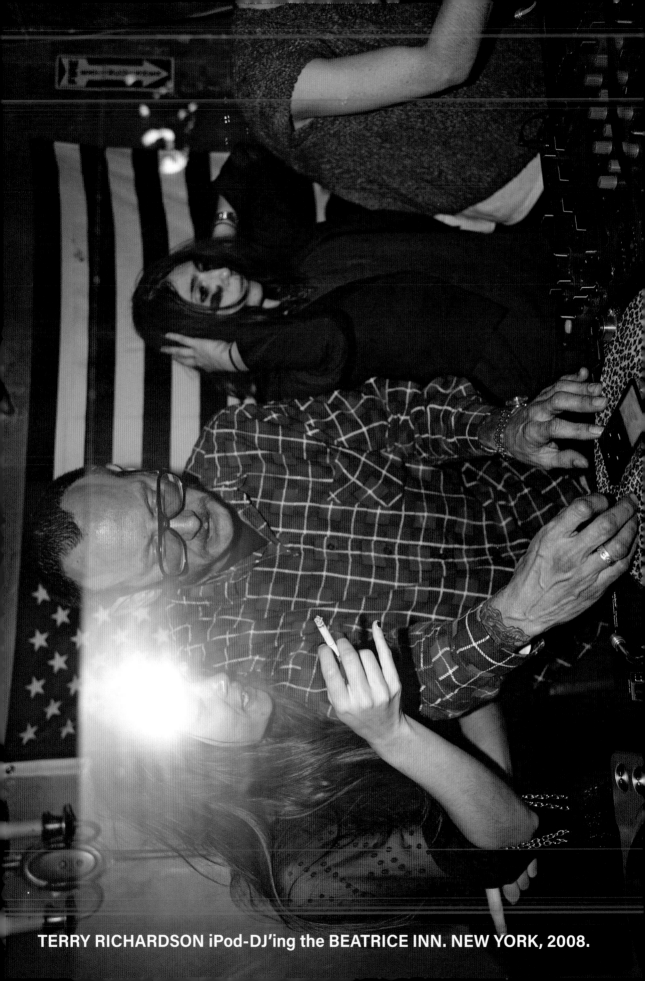

TERRY RICHARDSON iPod-DJ'ing the BEATRICE INN. NEW YORK, 2008.

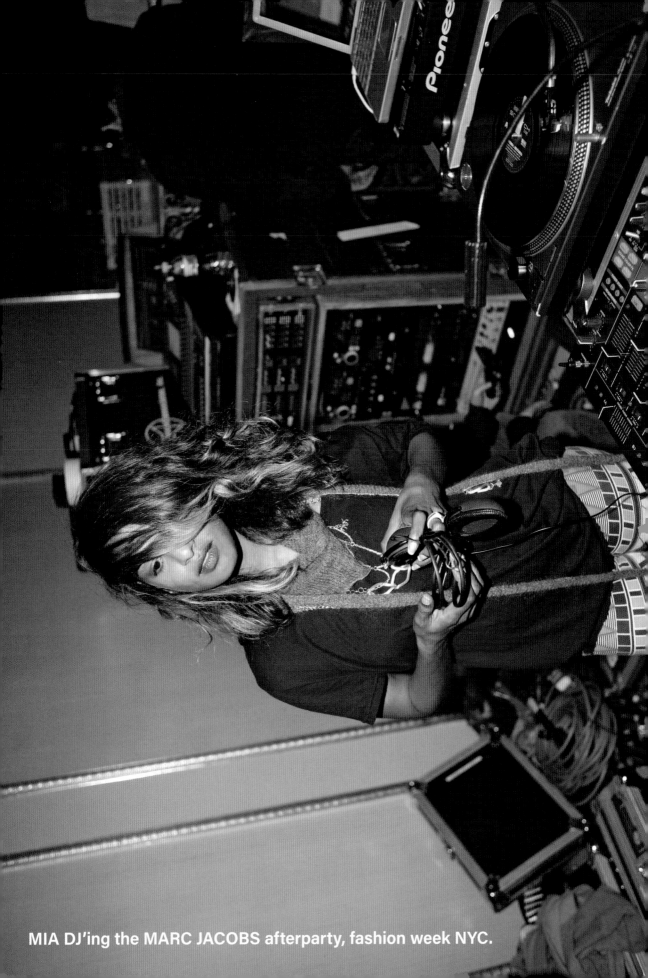

MIA DJ'ing the MARC JACOBS afterparty, fashion week NYC.

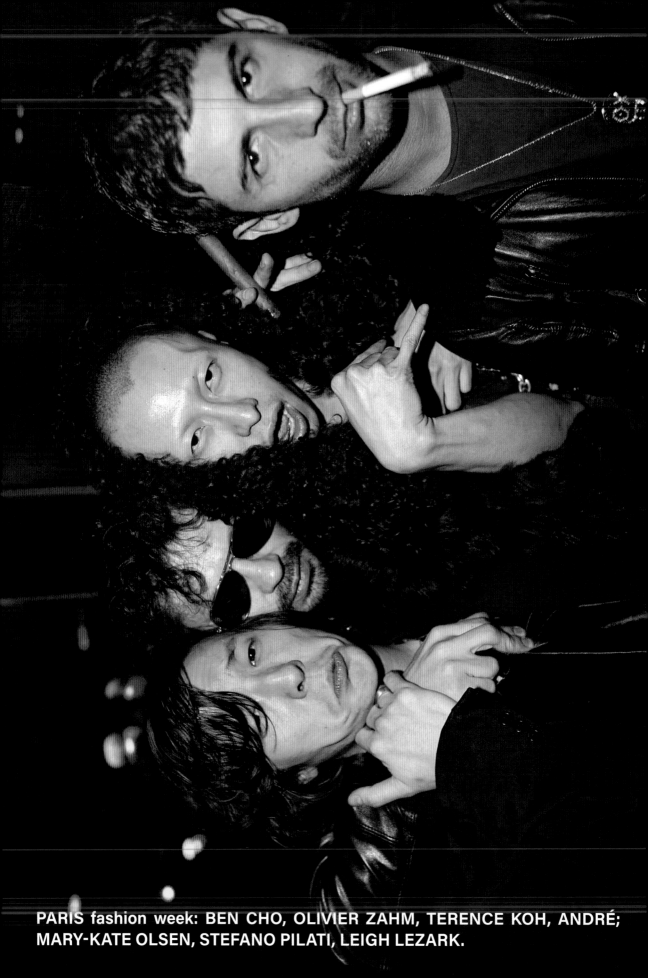

PARIS fashion week: BEN CHO, OLIVIER ZAHM, TERENCE KOH, ANDRÉ;
MARY-KATE OLSEN, STEFANO PILATI, LEIGH LEZARK.

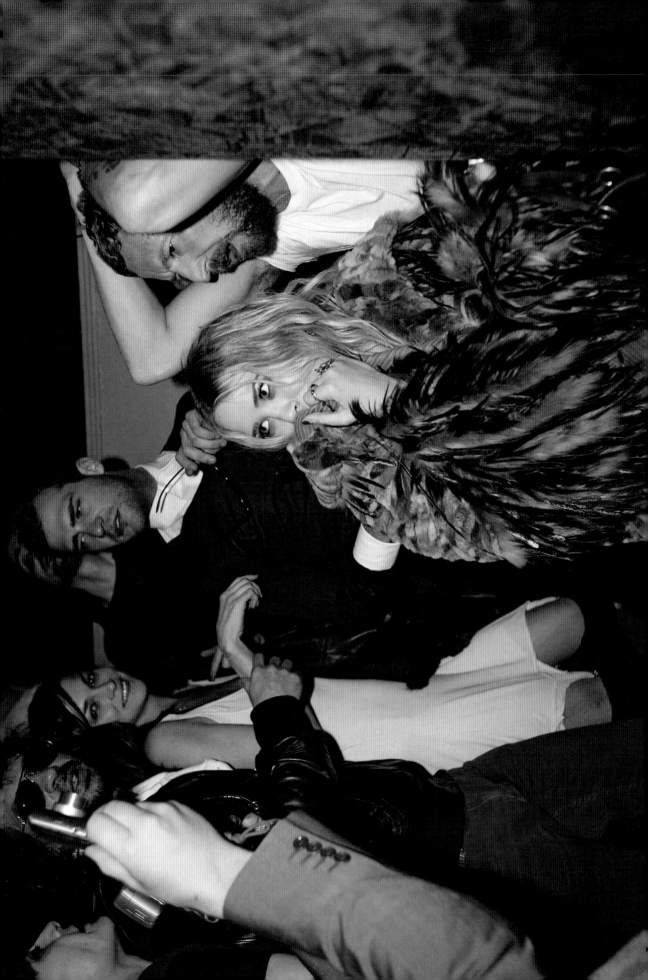

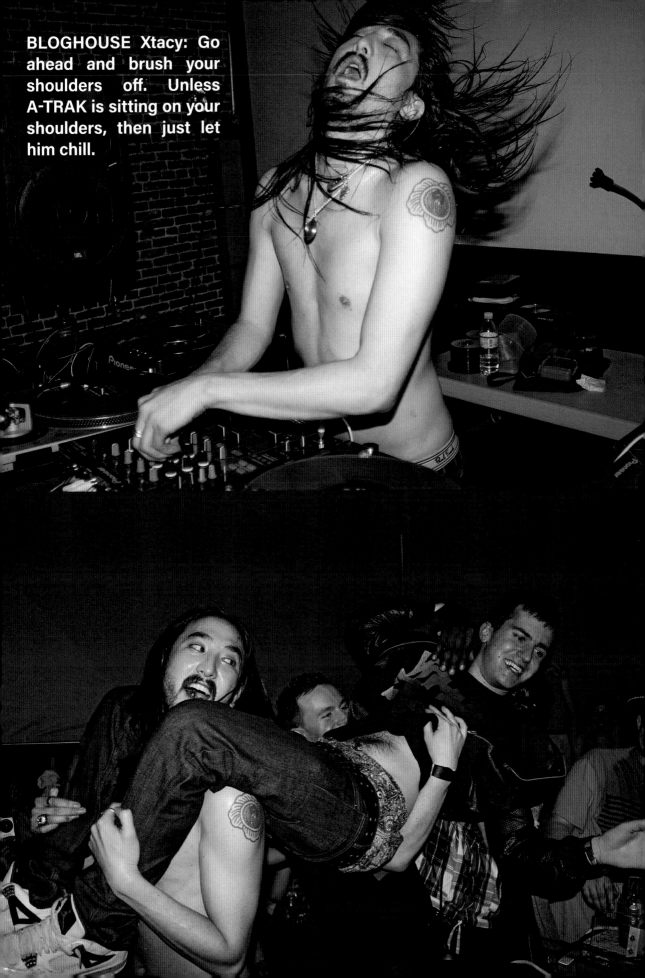

BLOGHOUSE Xtacy: Go ahead and brush your shoulders off. Unless A-TRAK is sitting on your shoulders, then just let him chill.

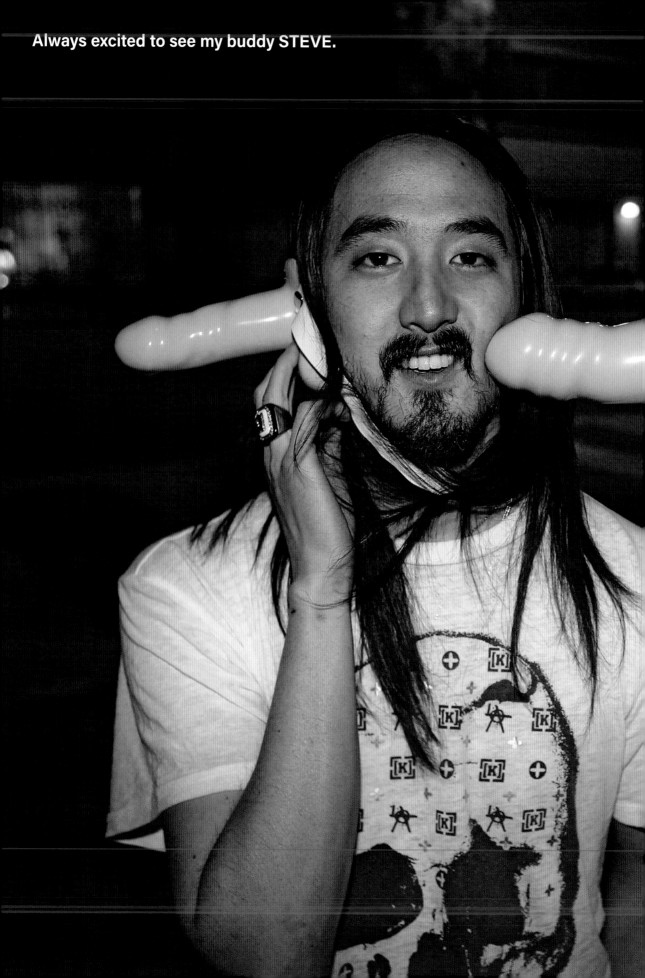

Always excited to see my buddy STEVE.

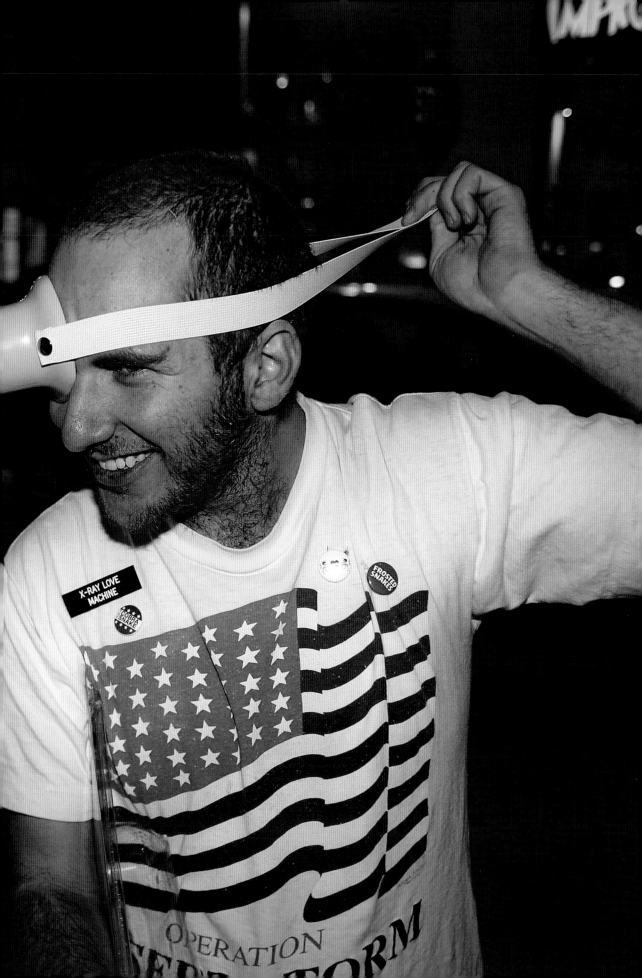

LADY GAGA out and about in an AMERICAN APPAREL tank top. The spirit of 2007 was strong in the air that night. Hollywood, 2007.

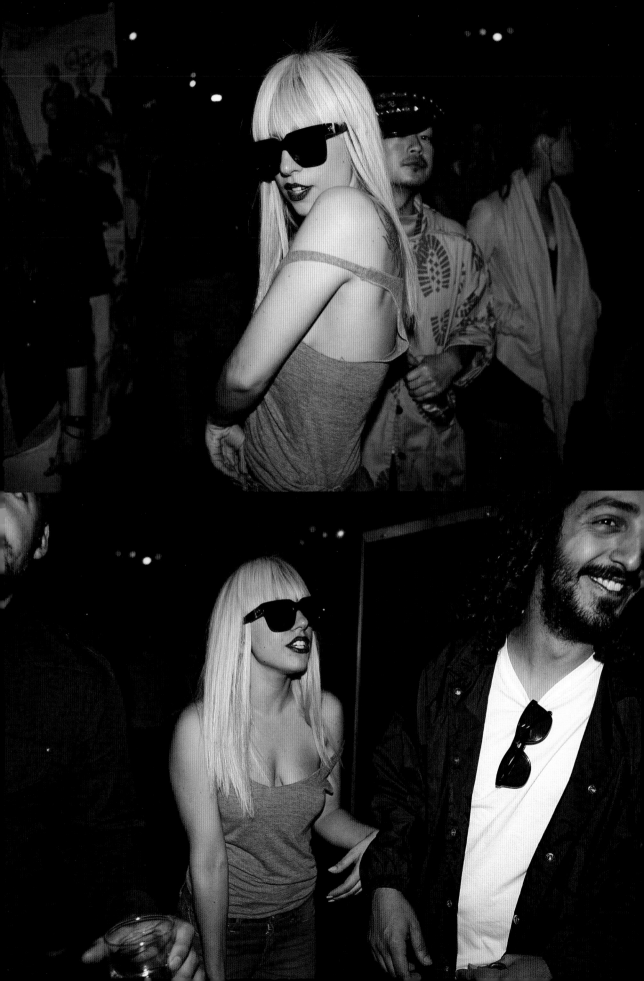

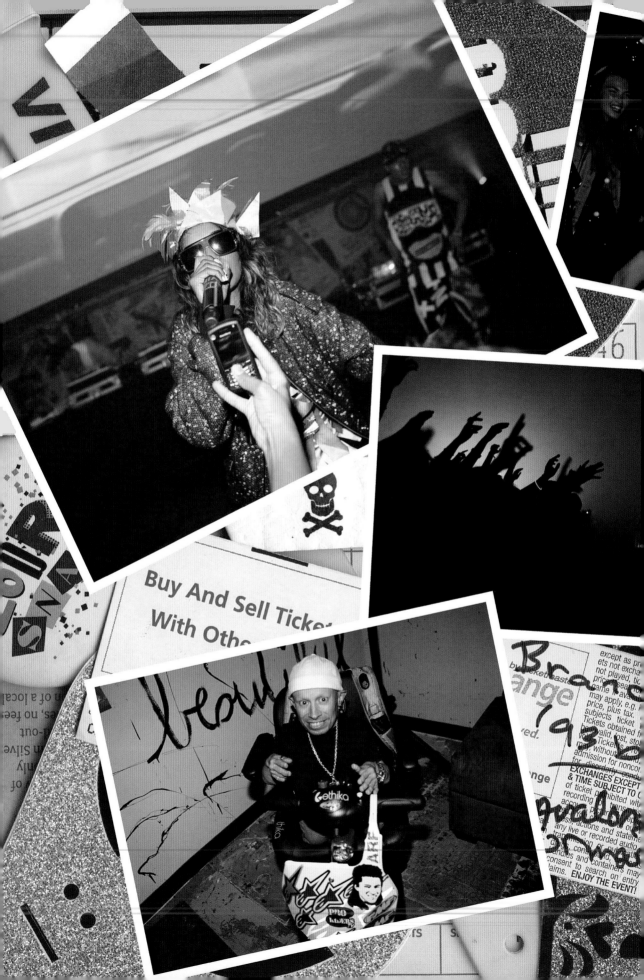

Buy And Sell Ticke...
With Oth...

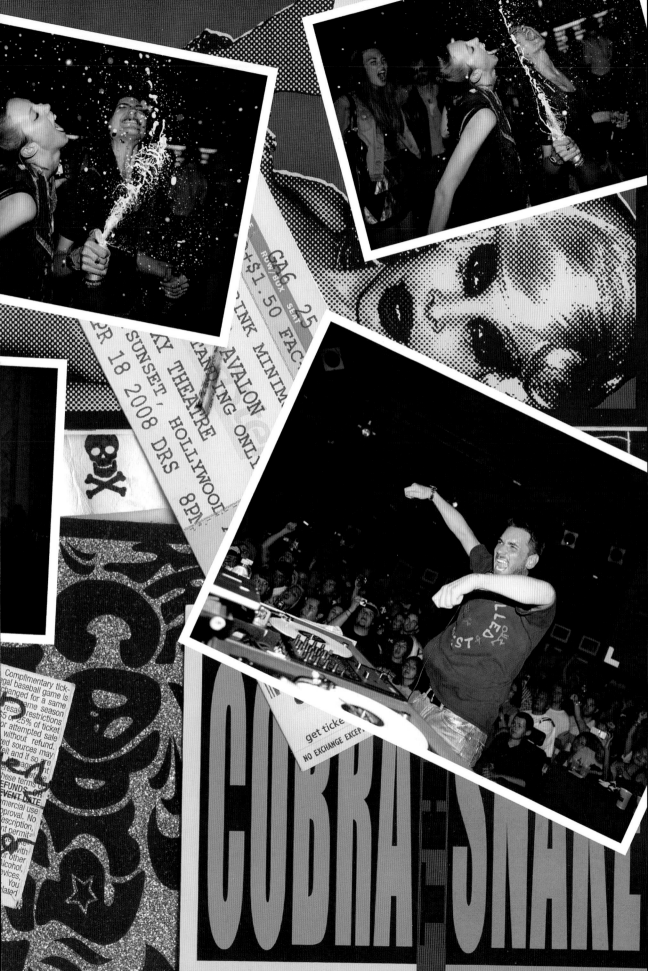

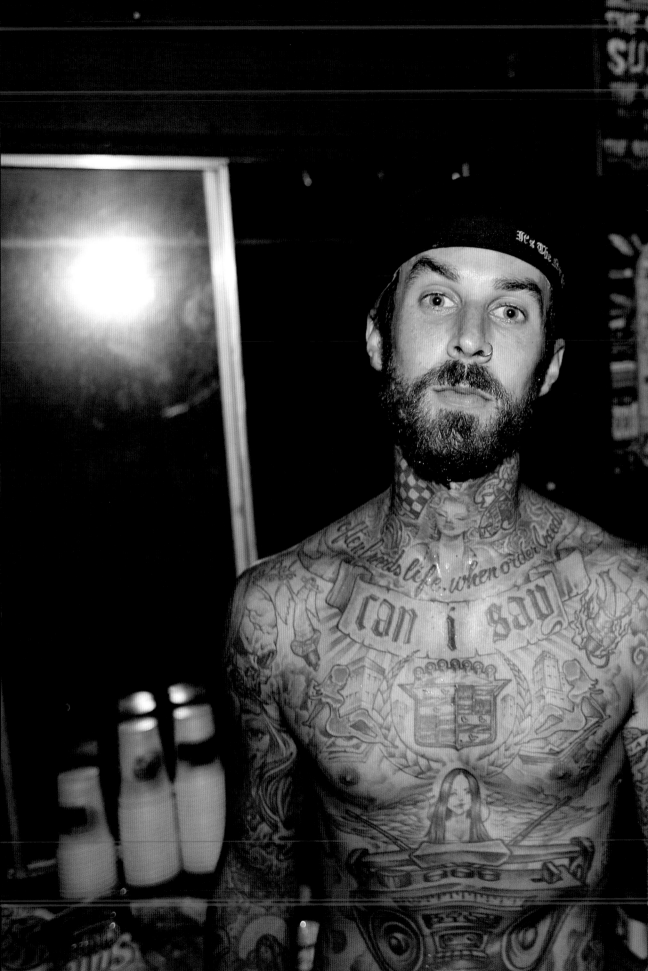

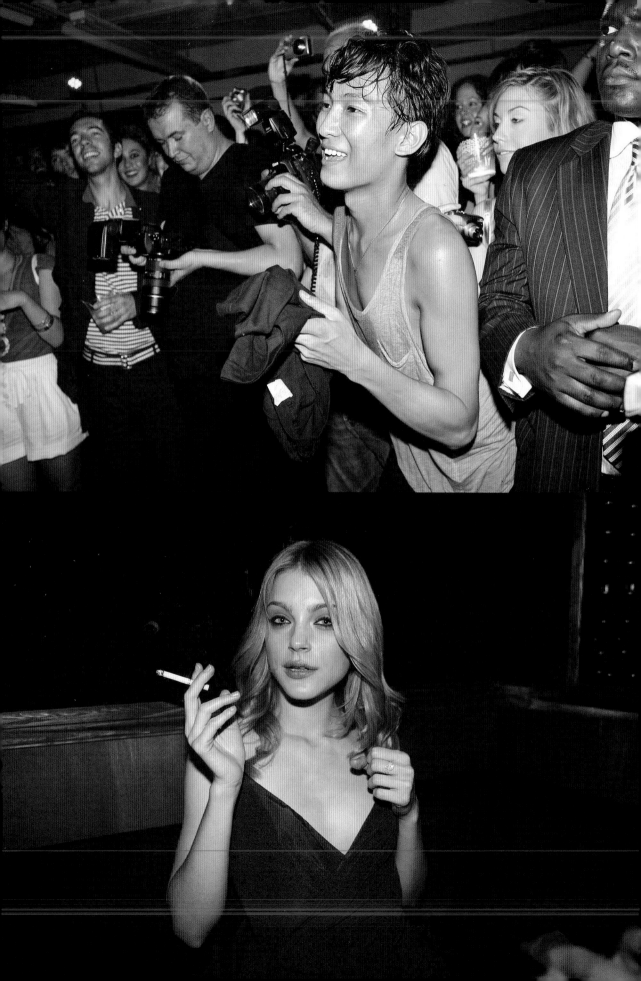

Fashion shows and VIP rooms. My aesthetic.

PETRA COLLINS holding down the curb.

Z BERG, always a handful (or two).

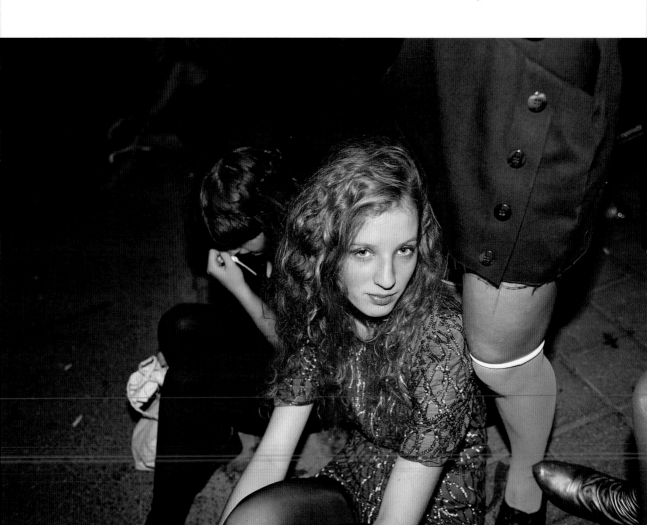

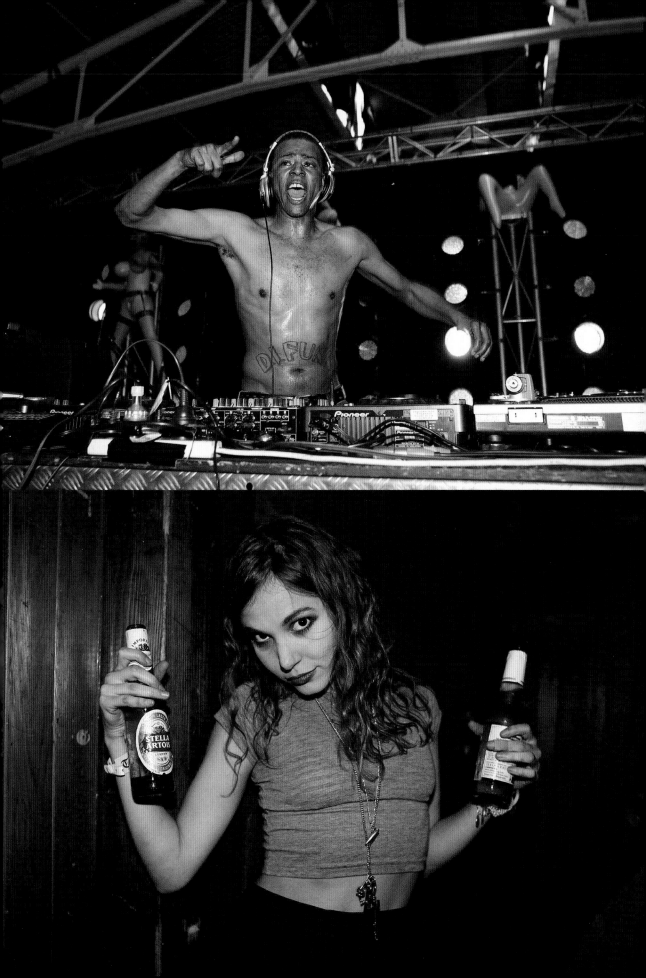

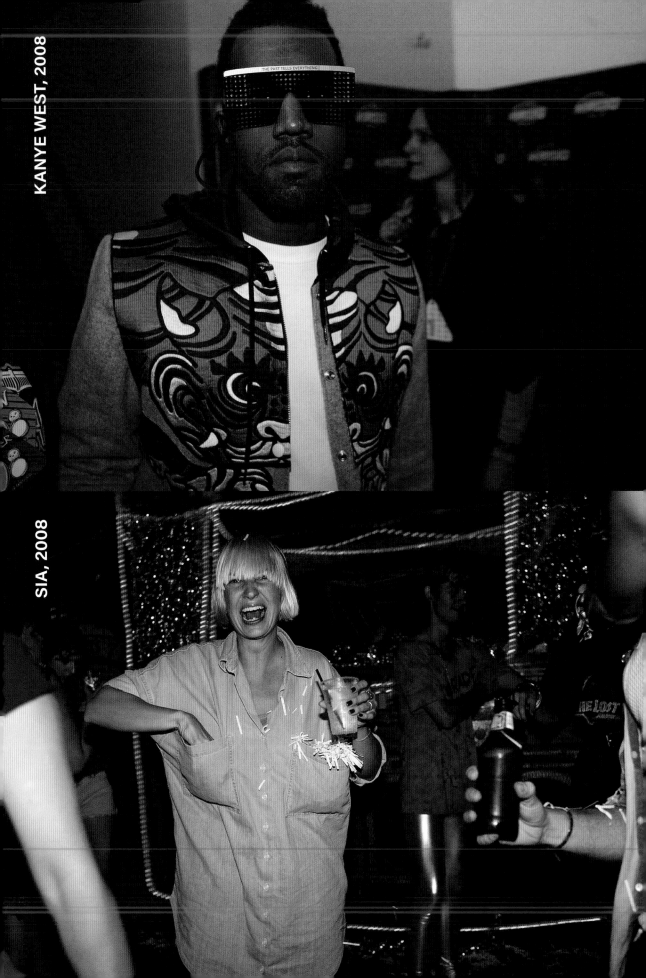

KANYE WEST, 2008

SIA, 2008

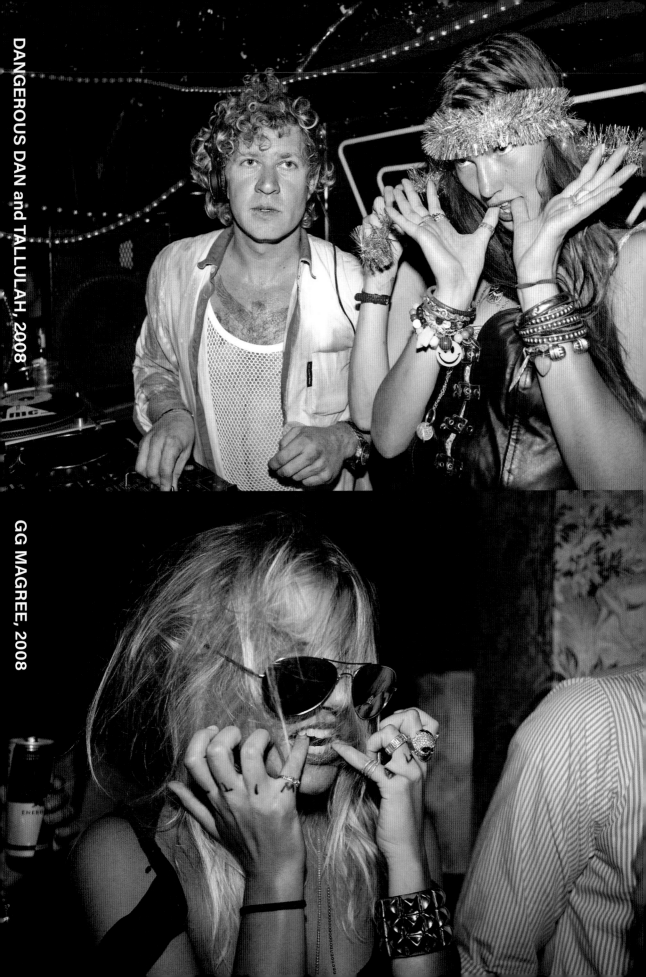

DANGEROUS DAN and TALLULAH, 2008

GG MAGREE, 2008

2009's hottest new phone is a MOTOROLA that you touch exclusively with velvet gloves.

COBRA Mobile.

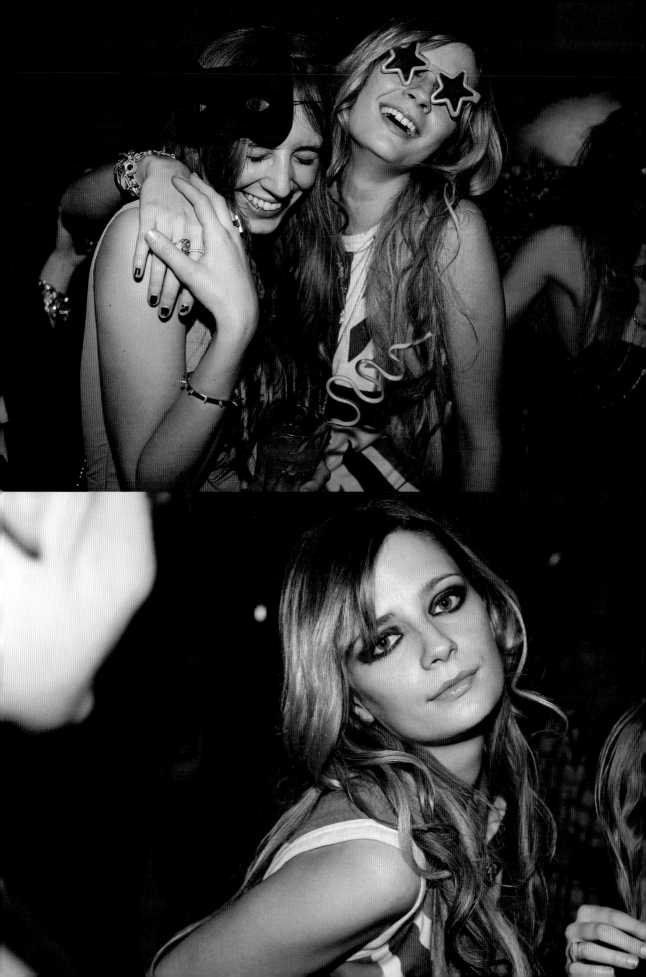

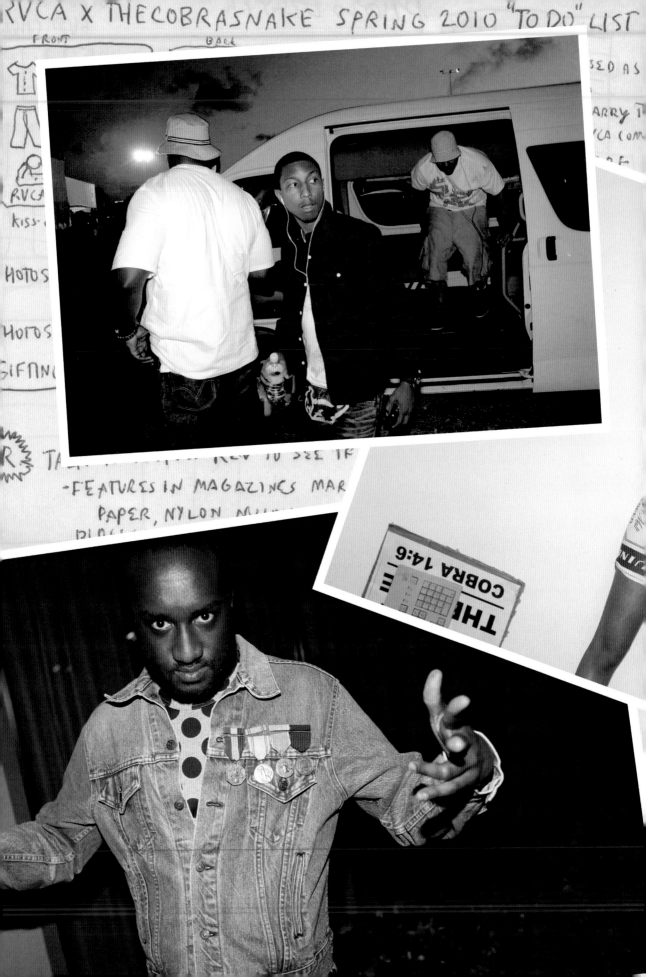

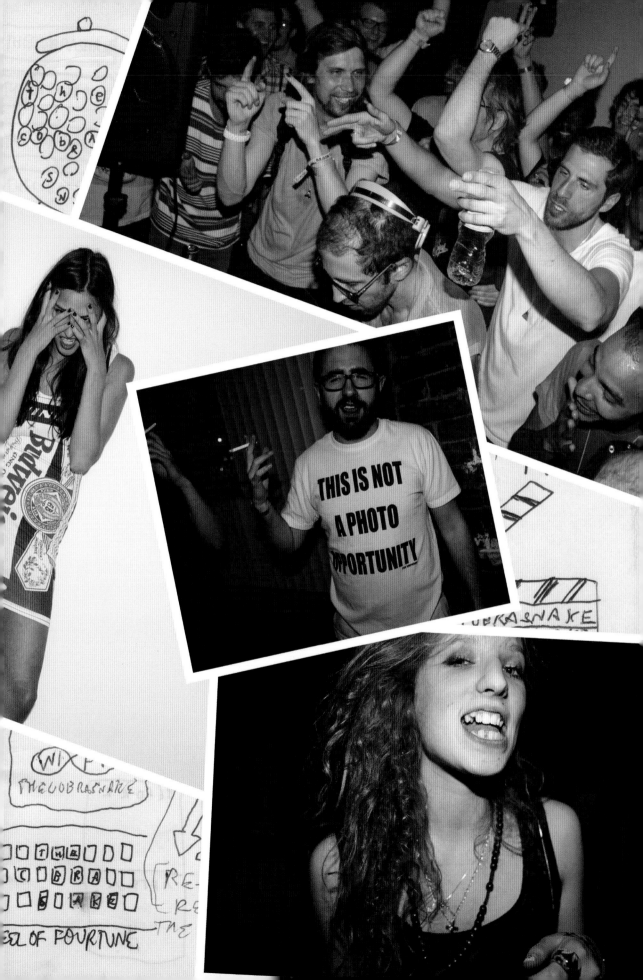

One of my shirts from my RVCA collaboration came out looking a bit

sparse,

so I bootlegged my own shirt by silk-screening every other one of my logos onto it.

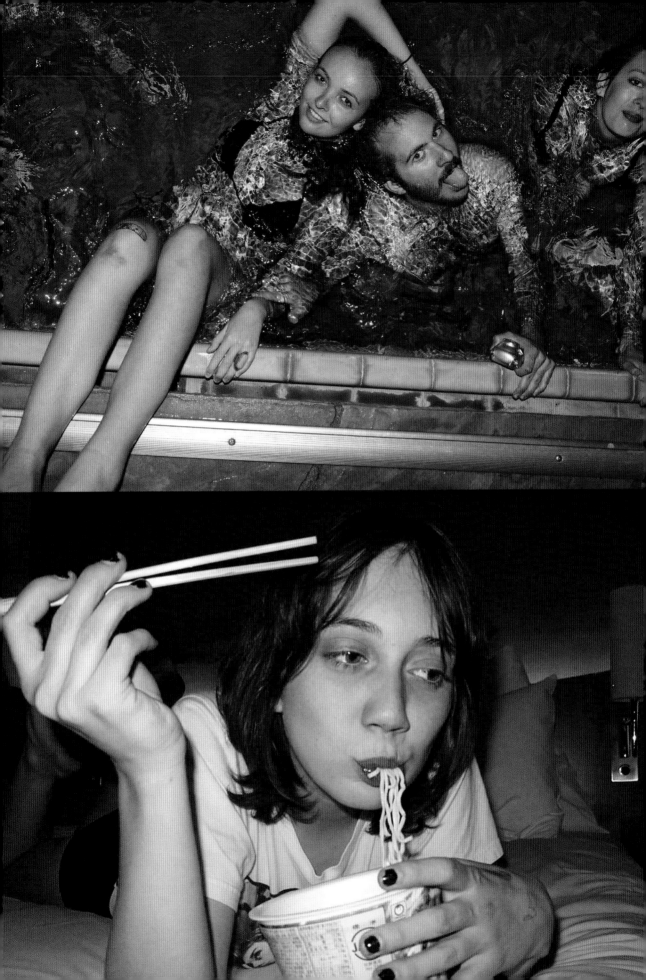

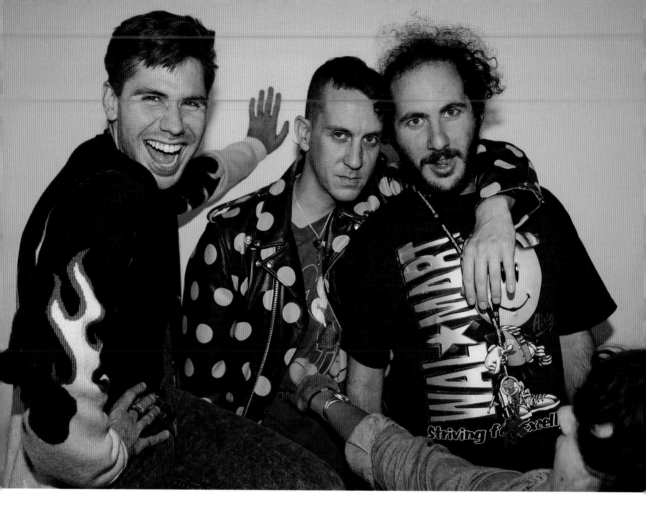

JONNY MAKEUP and JEREMY SCOTT, the only two dudes
who can make my style look toned-down and low-key.

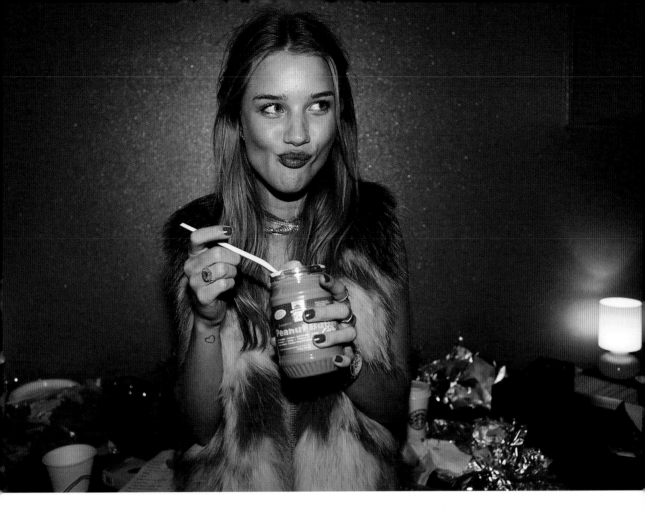

ROSIE HUNTINGTON-WHITELEY,
peanut butter princess. PARIS.

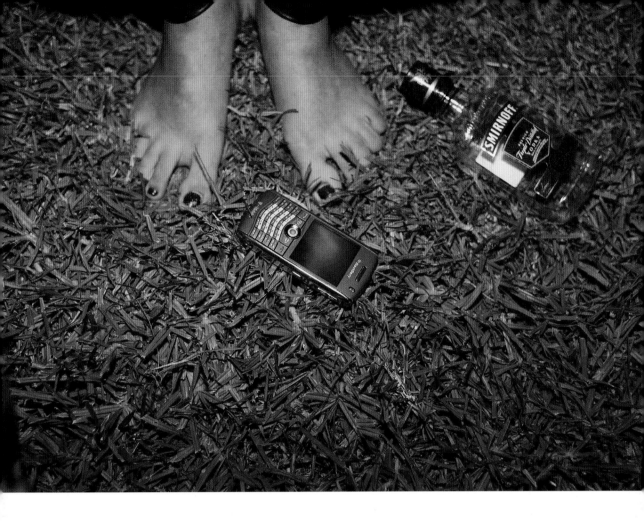

2009's hottest new phone is dropping your BLACKBERRY in
the grass and then shouting into it.

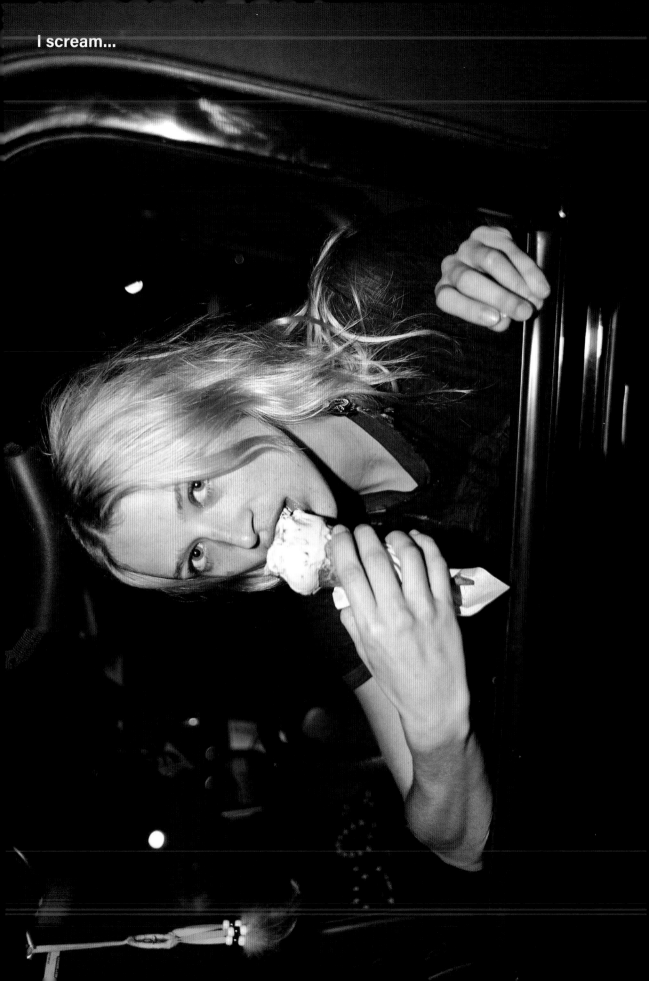

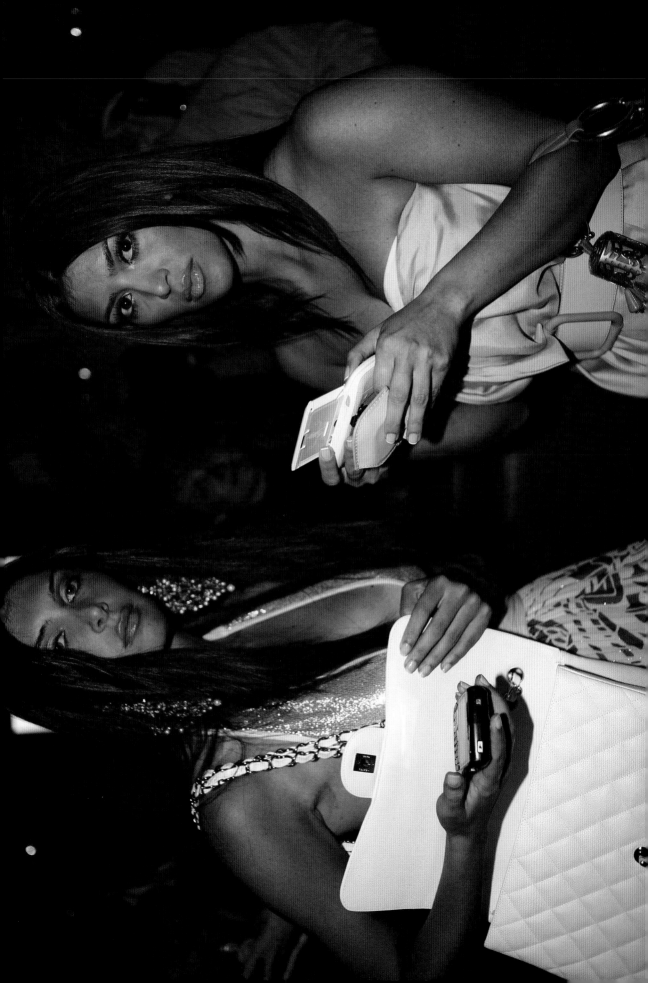

My three most iconic accessories:
KNITTING FACTORY wristband, DIESEL briefs, and hair.

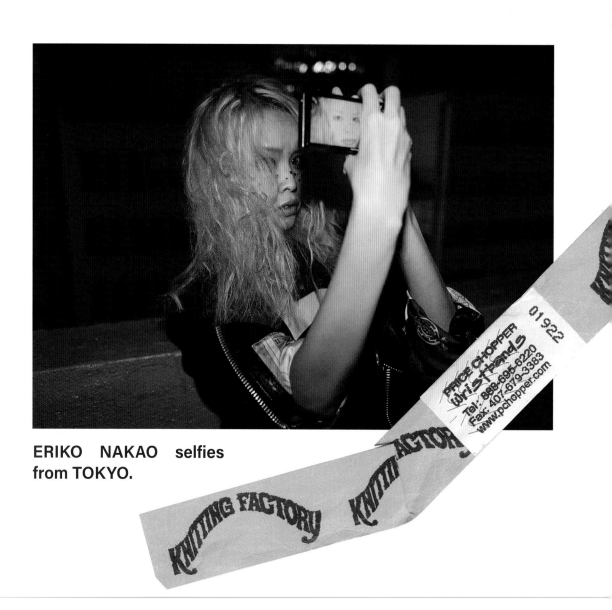

ERIKO NAKAO selfies
from TOKYO.

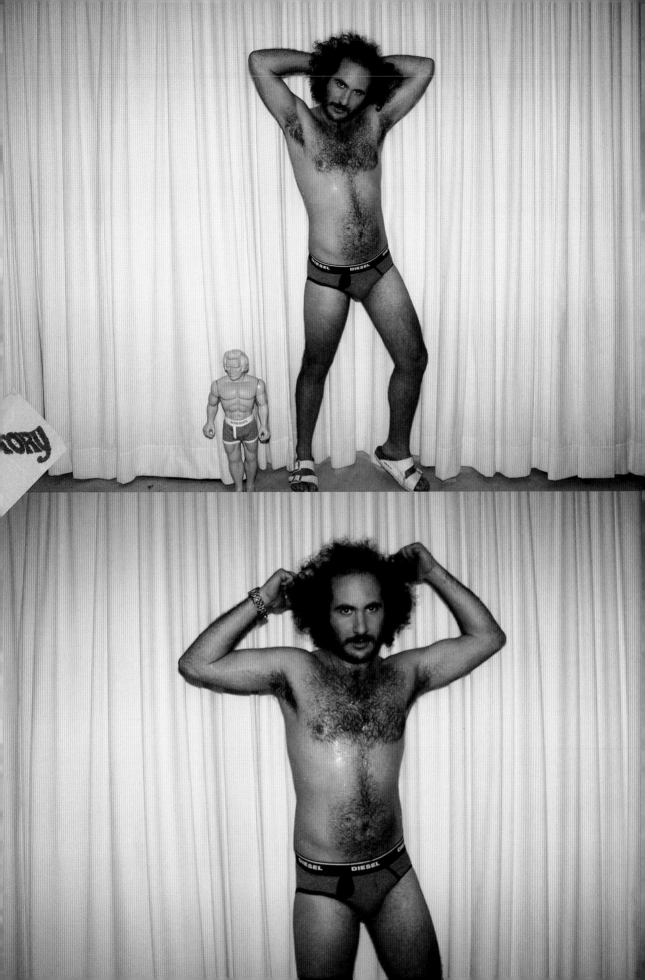

Don't have a cow, SELBY. TOKYO, 2009.

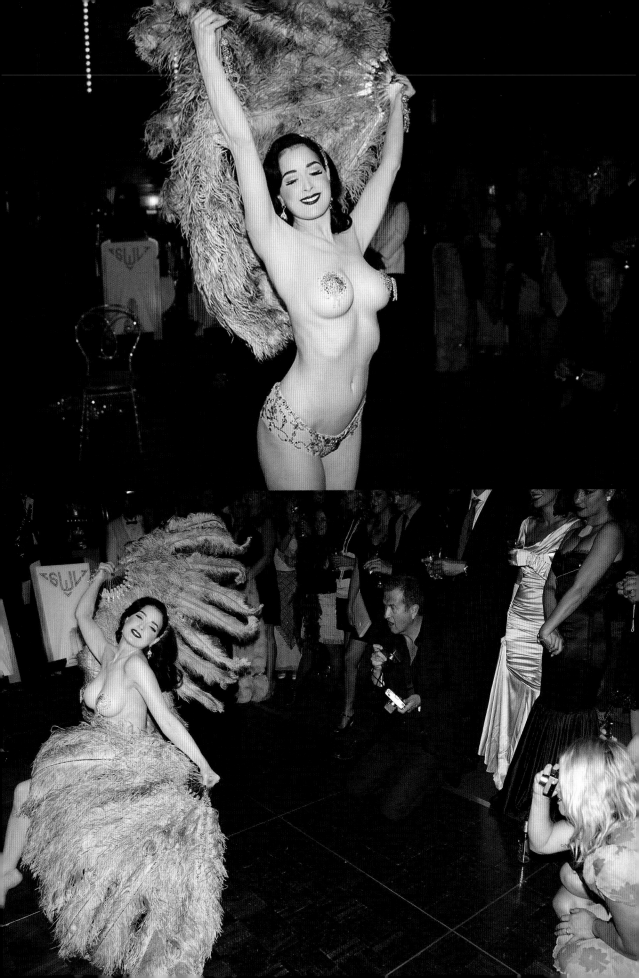

Showing my stripes at a music festival in SYDNEY in winter, 2009, chasing an endless summer. My uniform for world travel was really dialed-in at this point. BIRKENSTOCKS, shorts hitting above the knee, colorful shirt (ideally designed by me), and a tote bag for carrying essentials and hauling off any free stuff I might be offered or graciously allowed to steal. I had also become an expert at getting random strangers to take my photo in front of trash cans or shipping containers anywhere I might be in the world. This got increasingly easy over the years as I became more and more well known, but the feeling of getting off a plane on the other side of the world and having people know me and be excited to meet me was a shock every time. My little website, and my vision of a thousand awesome nights out, had spread across the globe.

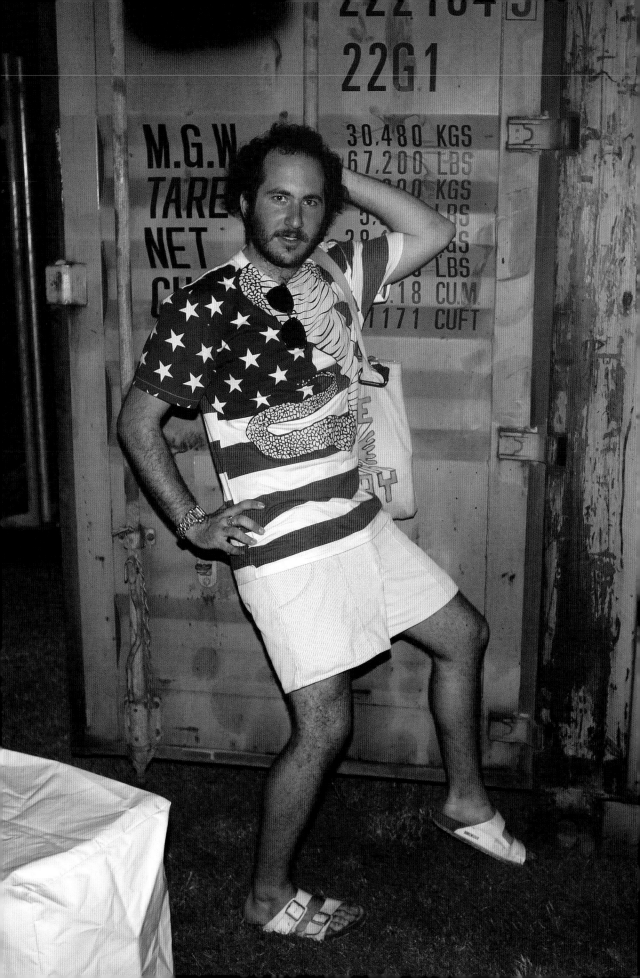

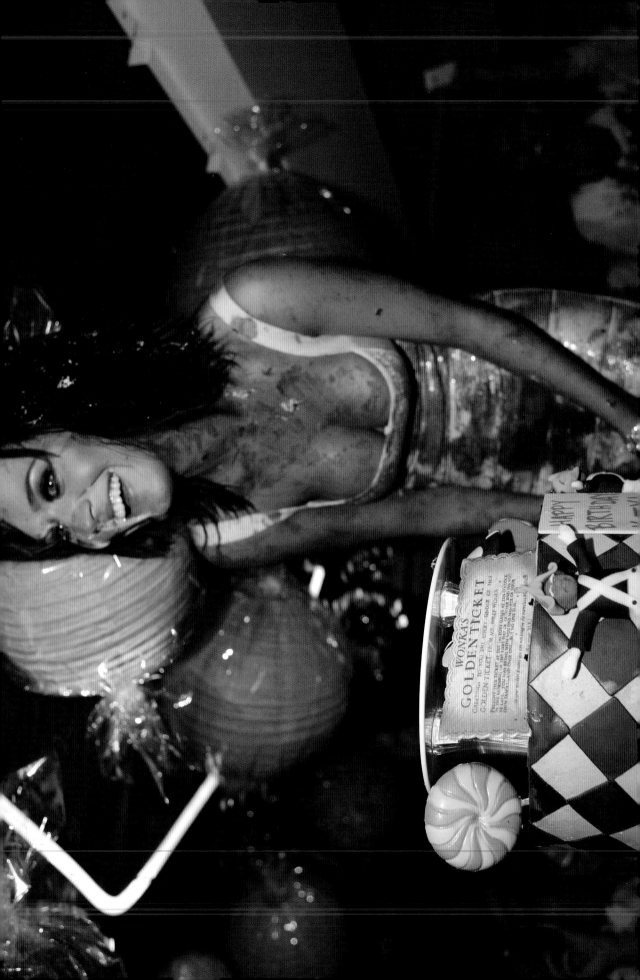

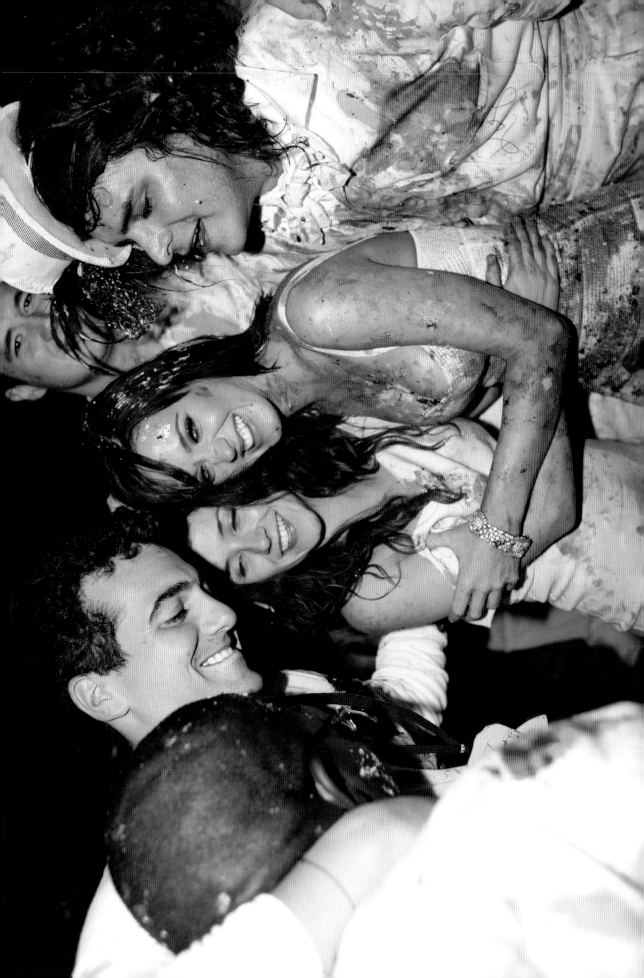

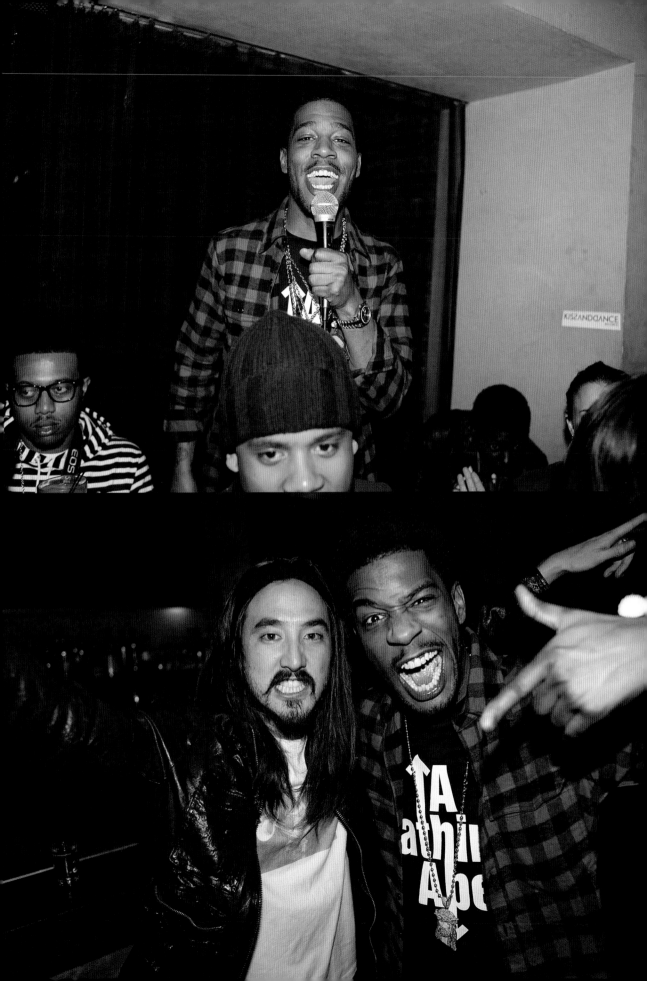

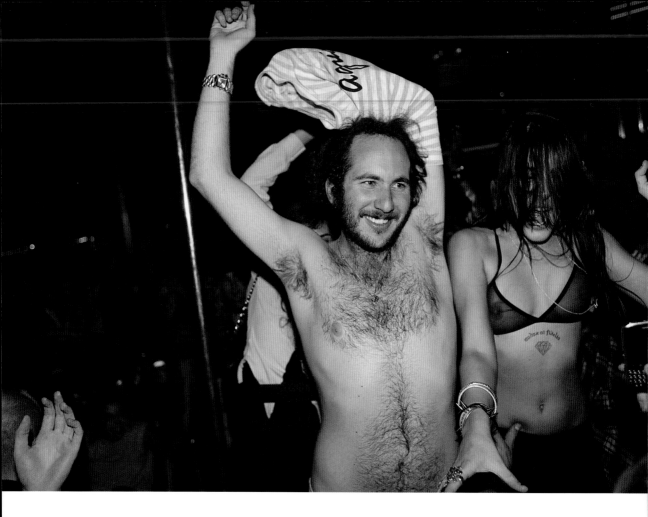

AOKI making it hot in here, me taking off all my clothes.
CINESPACE. LA, 2010.

ANDRÉ and MARK RONSON,
handsome boy power summit.

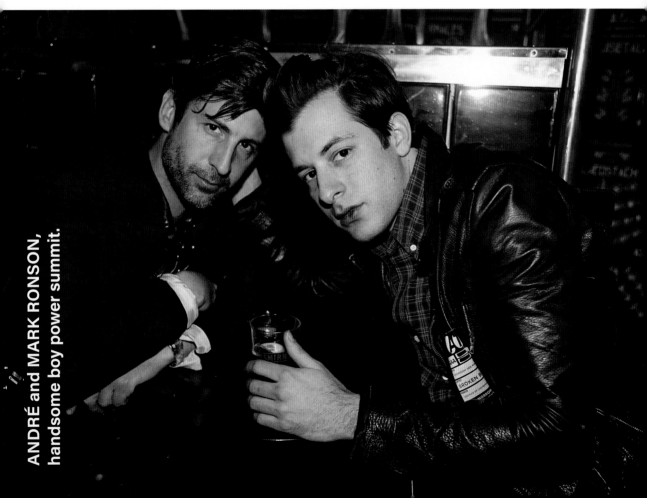

ANDRÉ and MARK RONSON, handsome boy power summit.

V.I.P. V.I.P. V.I.P. V.I.P. V.I.P. V.I.P.

Ralphs
Grocery List

here is a short list
of stuff you should
have for best viewing
pleasure on the ~~obrasnate~~
1. candy
2. bus pass
3. po box
4. ~~~~ home depot
5. pancho
6. mustaches are good
7. japan
8. scocks ready to
be knocked
off...

first IN CALIFORNIA

From TORONTO to
TOKYO the party
never stops.

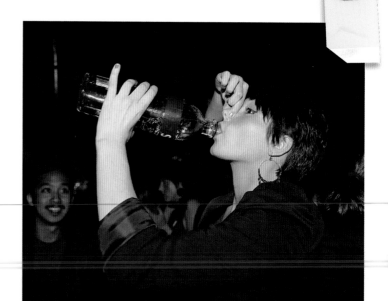

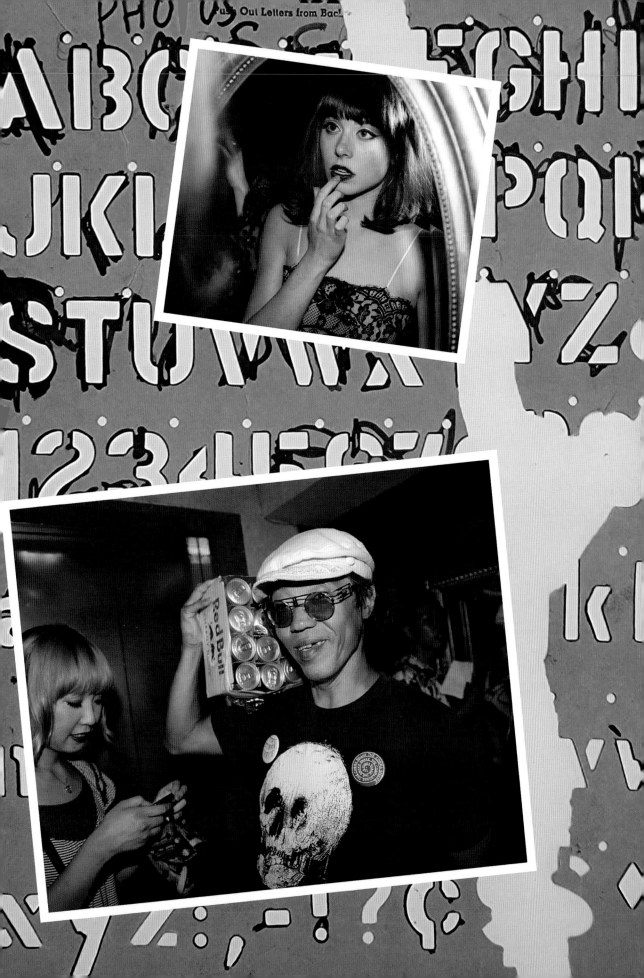

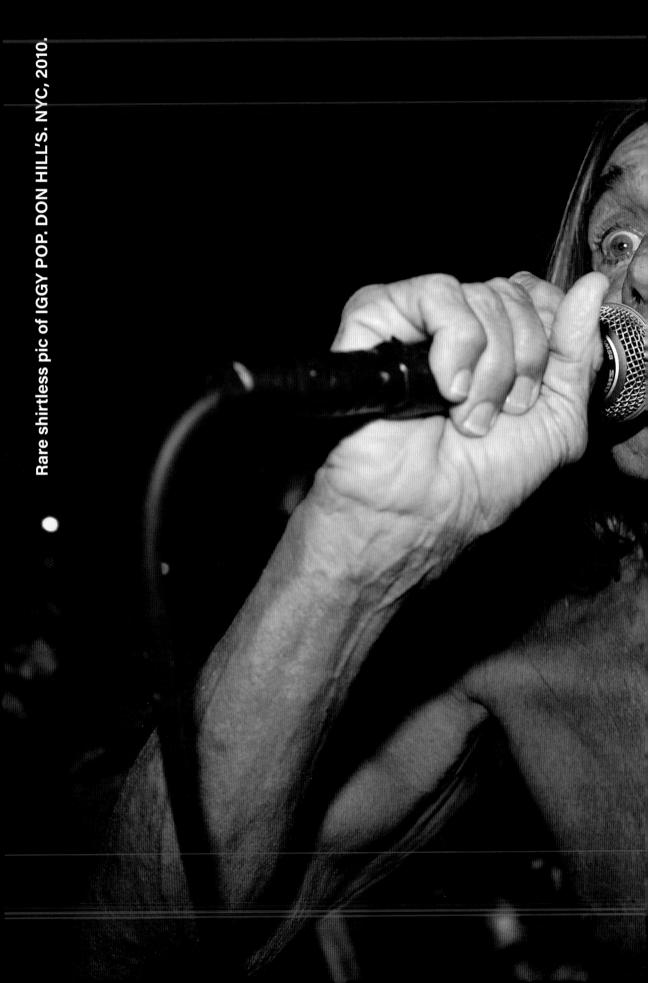

Rare shirtless pic of IGGY POP. DON HILL'S. NYC, 2010.

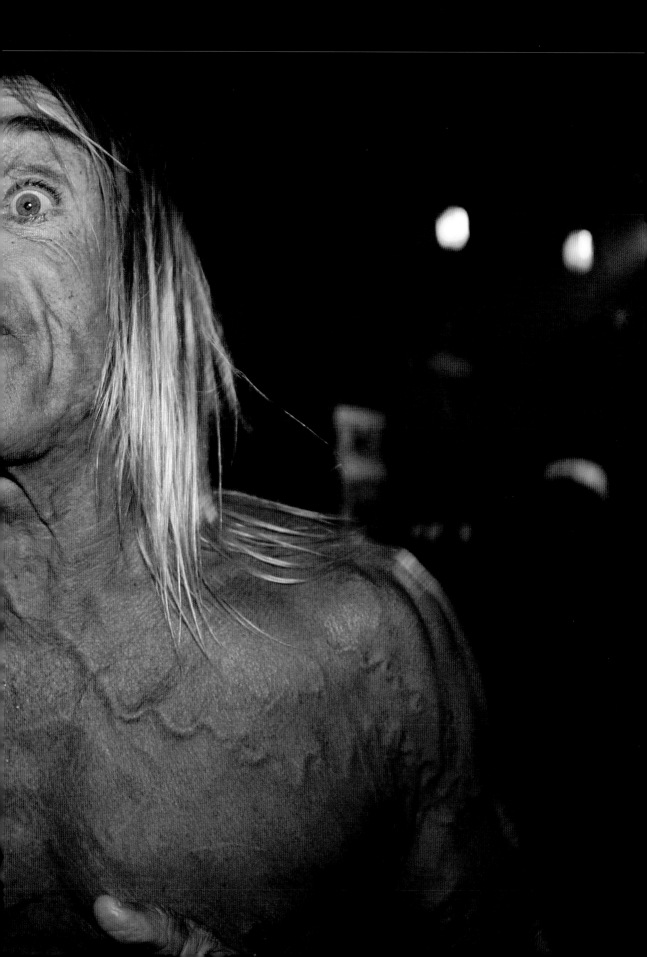

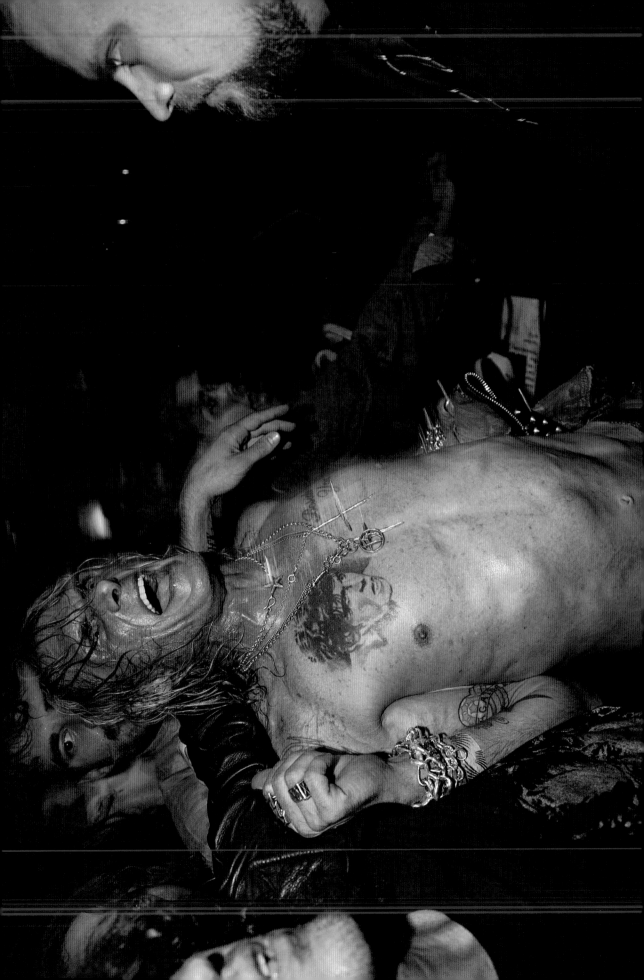

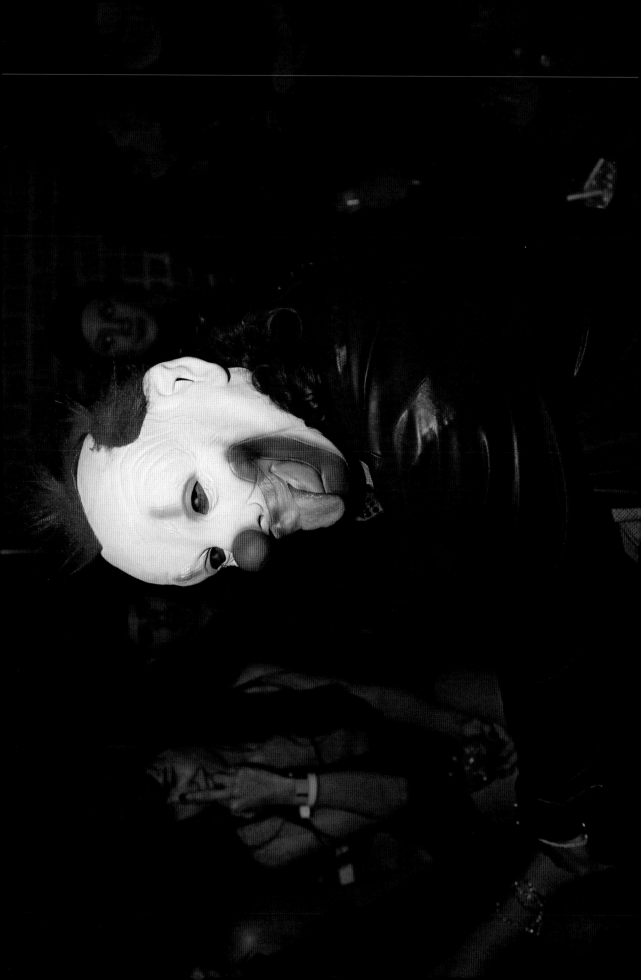

Photographic evidence that at one time I owned more than one hat.

One of the reasons I got into nightlife photography was the legendary archive of PATRICK McMULLEN from STUDIO 54.

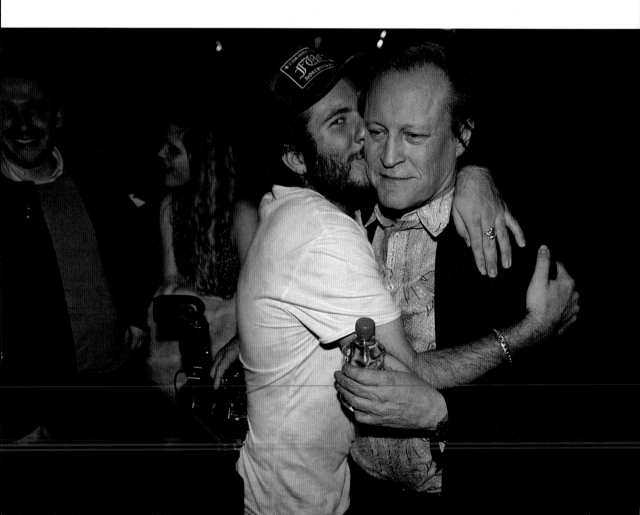

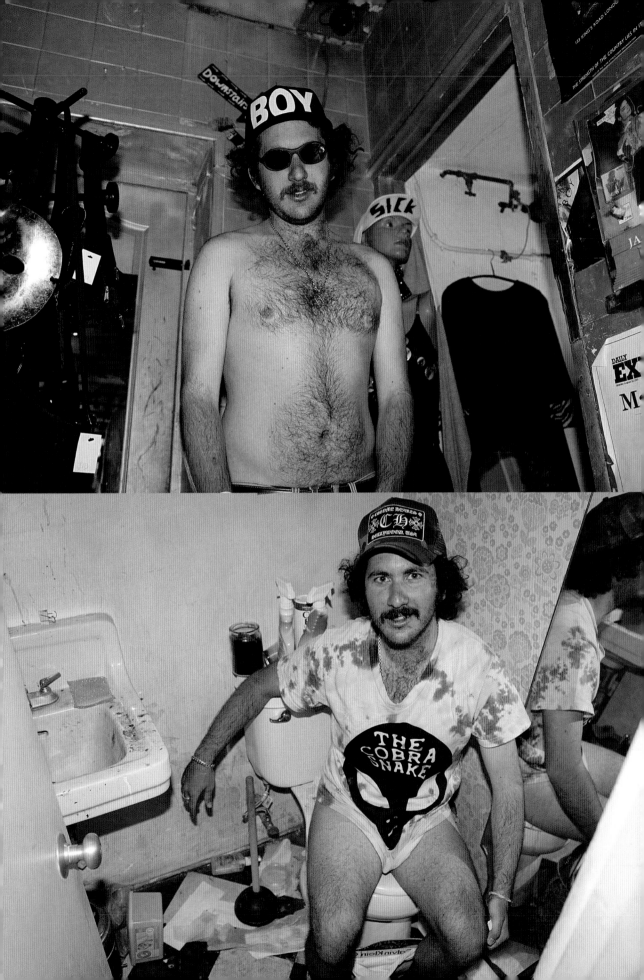

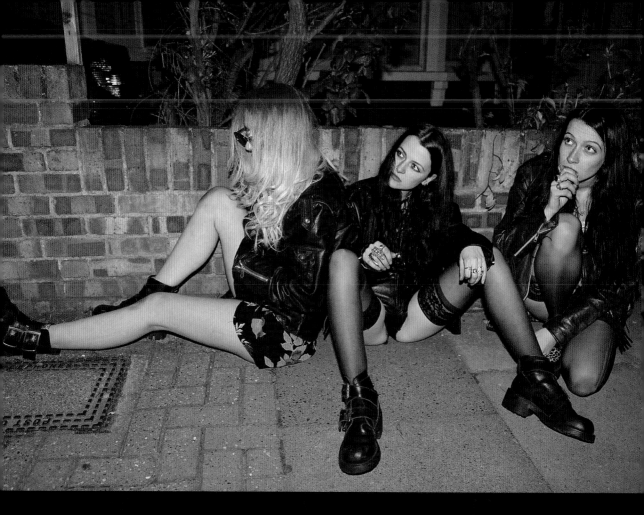

I didn't invent taking pictures of girls sitting on the floor, I just perfected it.

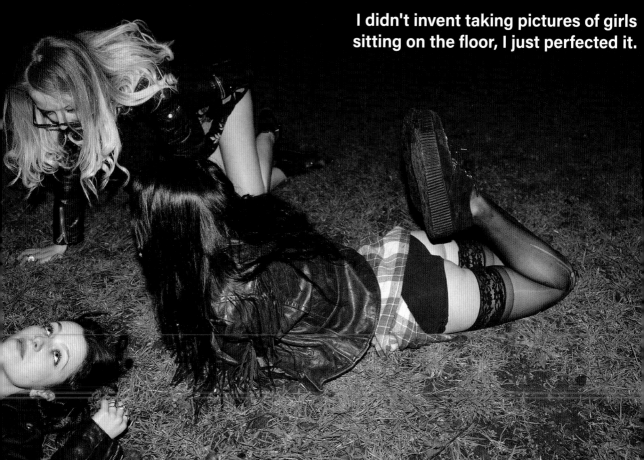

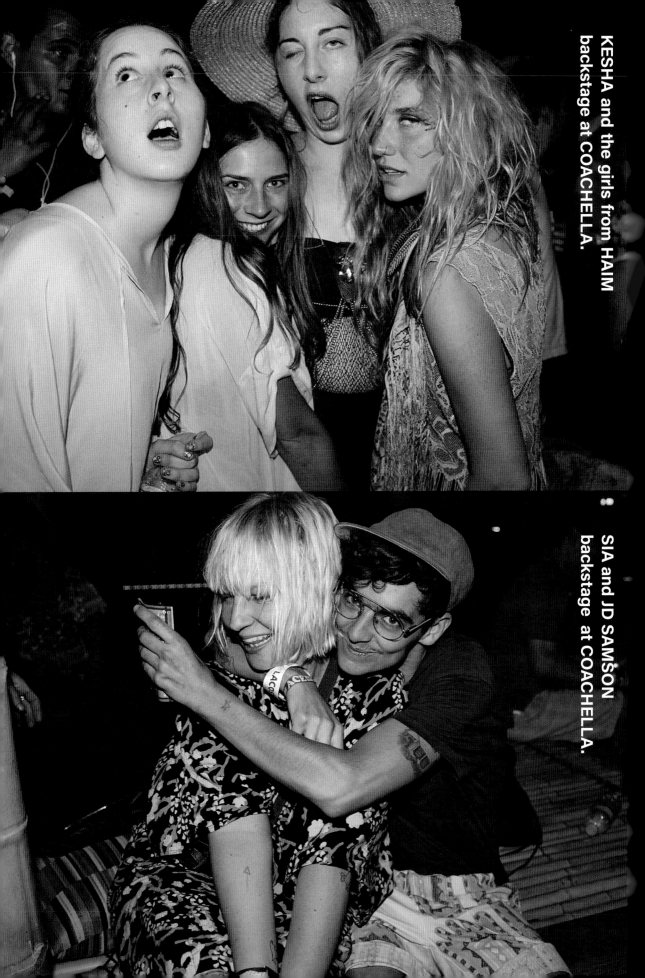

KESHA and the girls from HAIM backstage at COACHELLA.

SIA and JD SAMSON backstage at COACHELLA.

232

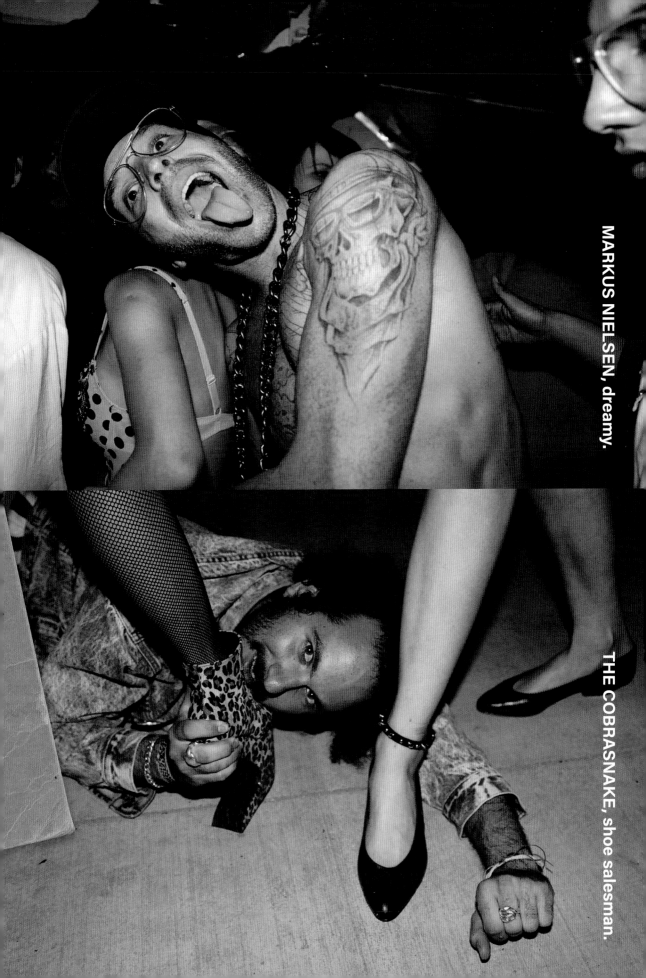

MARKUS NIELSEN, dreamy.

THE COBRASNAKE, shoe salesman.

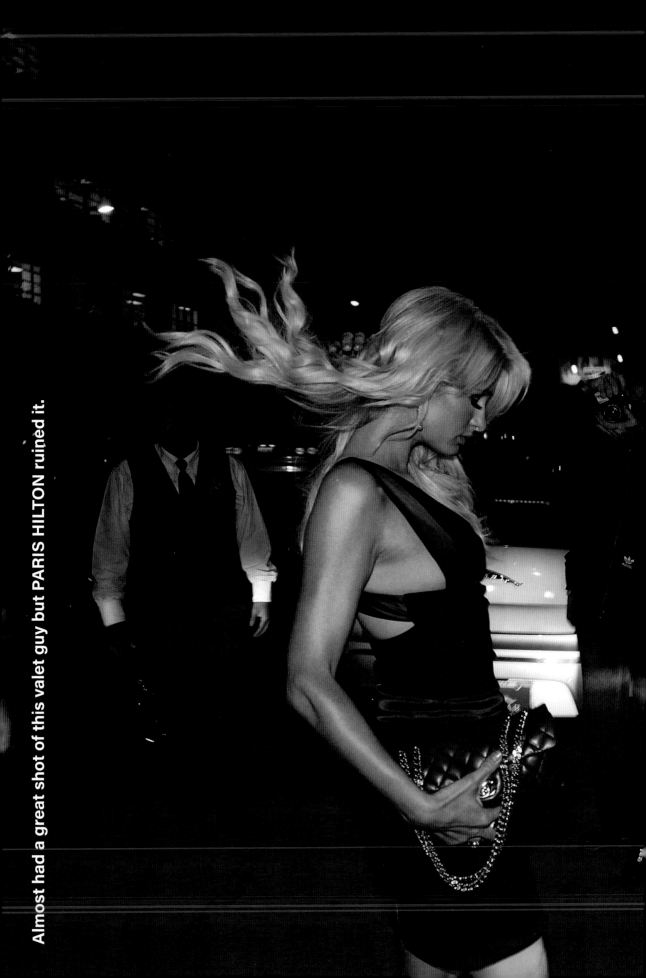

Almost had a great shot of this valet guy but PARIS HILTON ruined it.

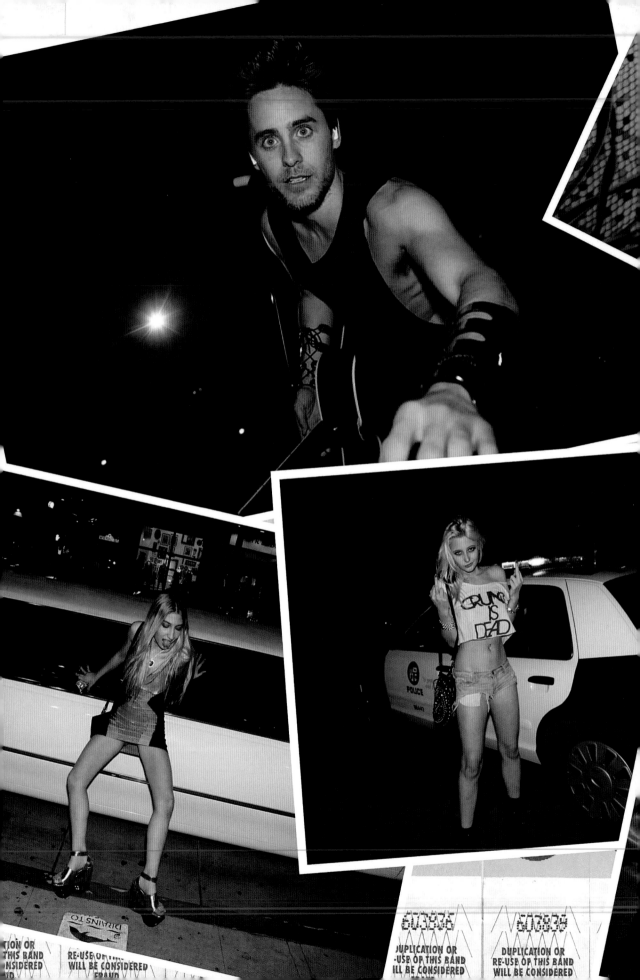

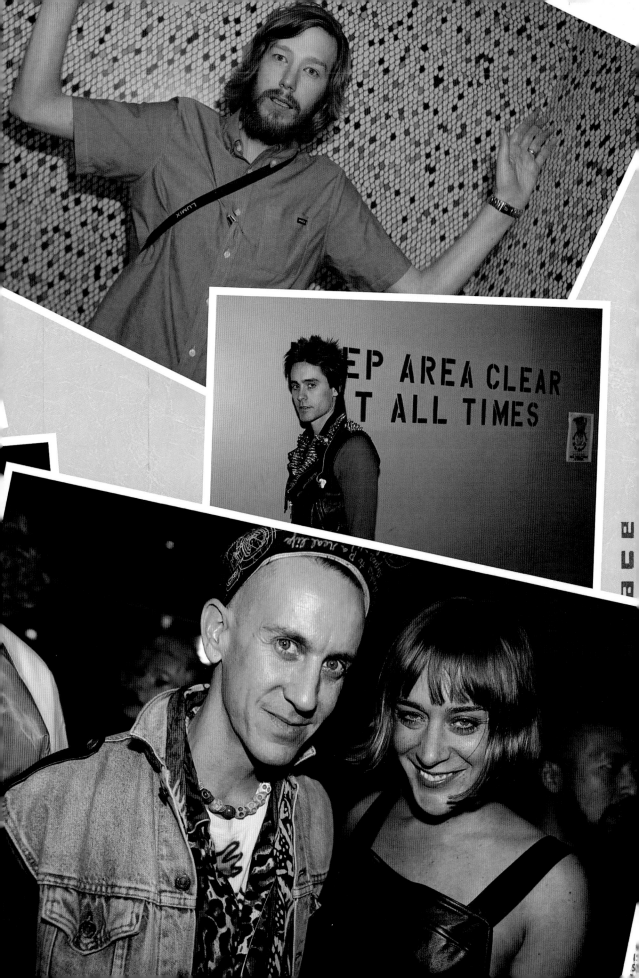

VIRGIL ABLOH and MATTHEW WILLIAMS in the BEEN TRILL days, playing the music they wanted to dance to and then dancing to it harder than anyone else. VIRGIL was able to take the energy of nightlife and youth culture of the 2000s that I feel in the photos in this book and take it to the next level, shaping it into a singular vision of the future that will inspire generations to come. I'm grateful we got to party together. RIP.

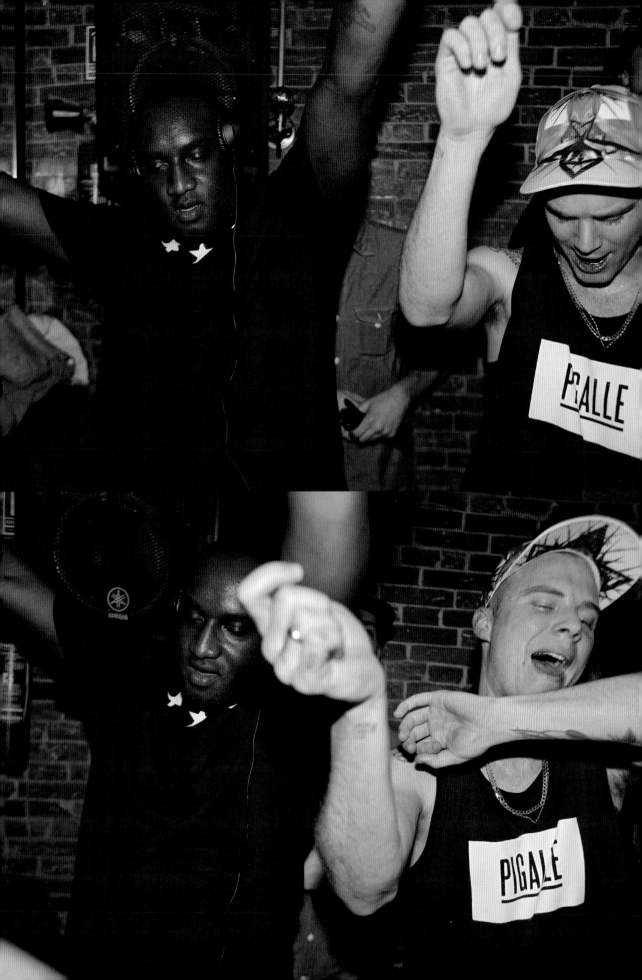

To everyone I ever photographed: THANK YOU... It's because of you that I do what I do. I would be nothing without all the colorful creative characters I've been lucky to meet all over the world. The guy at RITE AID who would sell me alcohol when I was in high school and also developed all my film for FREE! Everyone who let me sleep on their couch and supported me from the beginning. Thank you to the inventor of SOUR PATCH KIDS and all the factory workers. My MOM and DAD, my #1 fans who let me live my dream. SHEPARD and AMANDA FAIREY who opened many doors and made me climb over many walls covered in barbed wire and up billboards in the middle of the night. Thank you TO HOME DEPOT for the supplies, buckets, lengths of chain, etc... DANGEROUS DAN for making all the right moves in SYDNEY except that time you made me drive your BENTLEY. To CARL LISBERGER, one of my oldest friends, who could write a book on my life but instead wrote a TV show currently in development. Anyone who ever purchased a COBRASNAKE t-shirt or vintage item from THECOBRASHOP... you have amazing taste. LEYLA, your ice cream truck covered in crystals was my home away from home. Thank you SALVATION ARMY 50% off sale, I made millions from you. Thank you to my wholesale deadstock novelty sunglasses plug, you know who you are, I will never reveal your identity. FRANKI CHAN, remember COACHELLA 2004, sharing a twin bed with 4 people? All my photo bros: TODD SELBY, STRYDER, RON POZNANSKI, RONY ALWIN, FELISHA, JASON LANDIS, GAVRIEL, GLENN JAMN, CHRIS WEEKS, CHRIS POLK, SETH BROWARNIK. Club promoters worldwide, especially the ones that let me come to parties in shorts and sandals. Thank you to all the fruits and most of the vegetables for providing me with delicious juice. STEVEN aka TOASTYCAKES, a very talented friend who helps everyone but himself. PAT TENORE, thanks to you and RVCA I was able to produce some pretty insane t-shirts and hang with some epic surfers, skaters, and artists. JONNY MAKEUP, with his energetic spirit, traveling the world together, tricking me into spending lots of Euros on designer clothing. SARAH from COLETTE, thank you for selling THECOBRASNAKE merch in PARIS, sorry I slept in and missed your wedding. ABDI, who introduced me to the indie scene back in the early 2000s and took me to prom when I was a freshman. ANDRE, I took some amazing photos in your nightclubs from NYC to PARIS to TOKYO. CHRISTOPHER SCHWARTZ, my last studio manager, who helped me organize and make this book happen. RYAN WARD from LA WEEKLY, we had so much fun working on the "snake bites" column together. STEVE AOKI, my very successful brother who still makes me pay for dinner. MARVIN, NYLON magazine was the bible of the 2000s, thanks for having me shoot for you and taking me around the world to launch international editions. KEITH 82, thank you for hosting some of the most wild parties in Hollywood. JUSTIN VAN HOY, doing graphic design in heaven. Thank you to all my fellow COSTCO executive plus members, I'm honored to be part of our special club. Thank you to the nice gentlemen at the West Hollywood Santa Monica Blvd location of OUT OF THE CLOSET thrift store for your kind words and for increasing my personal body positivity by at least 75%. KELLY CUTRONE, with a passion for fashion you have helped me in more ways than you know. JACOB from RIZZOLI and BRIAN ROETTINGER, thanks for 100s of emails and ZOOMS to get this book made. ANDREW NEUHUES, too creative for his own good. AVERY from TORONTO, I'll never forget those slumber parties in your loft. KIM H, PAPER mag, for introducing me to all the NYC cool kids and beyond. JEREMY SCOTT, who gave me front row and backstage access to his life for many years. GOLDENVOICE for giving me something to blog about... from the EL REY to COACHELLA and beyond . JASON STEWART was the tallest man in the club, easy to spot and ask for drink tickets. KIMI— arts and crafts in the backyard, bringing the COBRASHOP to life. Everyone on TIKTOK who is helping make my photos go viral. Everyone that I didn't mention: THANK YOU! My memory is fuzzy but my photo archive is sharp.